POTTERY: Modern Wares 1920-1960

POTTERY
Modern Wares 1920-1960

Leslie Piña

Schiffer Publishing Ltd

77 Lower Valley Road, Atglen, PA 19310

Credits

What began as a fairly straight-forward, even simple, idea ultimately involved many people. Without the generous contributions of time, information, photographs, and objects from collectors, dealers, curators, librarians, and others, this book could not have come to fruition.

Many thanks to those who permitted us to take photographs of objects in their possession or care: Mitchell Attenson of Attenson's Antiques, Cynthia Barta of Studio Moderne, Mell Evers, Vickie Kaffeman of Second Hand Rose Antiques, Bob and Linda Kendall, Elise Kirschenbaum, Ralph and Terry Kovel, Era and Sandra Scofield, Eason Eige of the Huntington Museum of Art, Michael Flanagan of the Everson Museum of Art, Linda Lewandowski of the Hinkle Memorial Library, and those who wish to remain anonymous.

Special thanks to Victoria Peltz of the Cowan Pottery Museum at the Rocky River Public Library for lending Cowan Pottery photos by Larry Peltz and making others available, James Mitchell of the West Virginia Division of Culture and History for Fiesta photos by Michael Keller, and to Christie's New York for photos from auction catalogs. All photos not credited to these or other sources were taken by my son, Ravi Piña, who shudders each time he sees me walk in with a roll of film or hears me making travel plans.

I am grateful to author Dominique Dreyfus for information on Longwy, to Dale Pitman and Nancy Saada for helping to translate it into English, to Ralph and Terry Kovel for the use of their library, to Linda Lewandowski for her help with Glidden Archives at the Hinkle Memorial Library at Alfred, to

the staff at the George Arents Research Library at Syracuse University, and the staffs at the Cleveland Museum of Art Library and the Registrar's Office, the Cleveland Institute of Art Library, the Western Reserve Historical Society Library, Cleveland Public Library, Ursuline College Library, and others.

Thanks to Paula Bloch and Shirley Friedland for proofreading the manuscript, and to the editors and staff at Schiffer Publishing for their patience and improvements. Any remaining errors can be credited to me. Last, but definitely not least, tremendous thanks to Peter Schiffer, an encouraging publisher and an admirable man, who is almost as nice as Nancy.

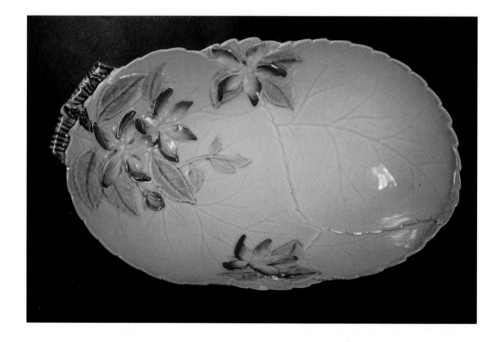

Published by Schiffer Publishing, Ltd.
77 Lower Valley Road
Atglen, PA 19310
Please write for a free catalog.
This book may be purchased from the publisher.
Please include $2.95 postage.
Try your bookstore first.

We are interested in hearing from authors
with book ideas on related subjects.

Contents

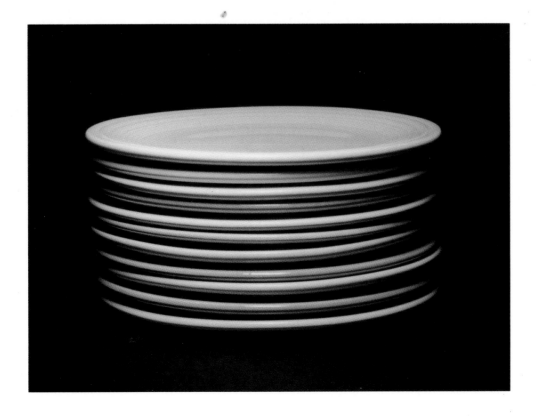

Introduction

From the Art Deco styles of the 1920s and 1930s to post-war Fifties Modern, American and European potteries often produced fantastic yet affordable tableware and artware in large quantities. Unlike one-of-a-kind studio pottery, these items were formed in a factory and either decorated by hand or glazed in fashionable colors. Ranging from inexpensive American tableware to sophisticated European art pottery, these widely and wildly varied examples of stoneware, earthenware, and special clay mixtures are sought after by collectors today. Fortunately, they are becoming more available as new names and patterns enter the marketplace. Their popularity and value (which sometimes defies logic) is largely determined by collectors on both sides of the Atlantic.

England was a leading producer of colorful tableware throughout the period, and names like Clarice Cliff and Susie Cooper are among the best known. Carlton Ware and Burgess & Leigh are other English names associated with colorful modern designs. French Longwy and Belgian Boch Frères with cloisonné-like thick enamel painting are less common and very collectible. Gustavsberg of Sweden, Zsolnay of Hungary, Amphora of Czechloslovakia, and Gouda of Holland each produced very distinctive modern decorative styles. Many pieces, commonly referred to as "Fifties Italian" or "Deco Czech" pottery, from Italy or Czechoslovakia are identified by country only rather than by company name.

American giant Homer Laughlin mass produced popular lines, notably Fiesta which has recently been reintroduced. Designs such as American Modern by Russel Wright, also made by the millions, altered the look of the American table and contributed to the modernization of the home. California potteries such as Vernon offered many lines of tableware, some with handpainted decoration. Sascha Brastoff and Glidden Parker headed companies that used figural and textural painting on large quantities of otherwise simple earthenware and stoneware. R. Guy Cowan, head of another American company, used mostly single-color glazes on molded figures and vessels; Roseville's Futura line was another example of molded Art Deco.

What makes these wares so appealing and what they all seem to share is a colorful, decorative, imaginative contemporary or modern look. What may have been radical and groundbreaking in its day has become familiar, and the designs and colors fit today's homes and lifestyles. Modernism of the 1920s or 1950s is fresh again seen through new eyes in the 1990s; because such large numbers were made in so recent a past, the thrill of discovery may be around the next corner.

The term "modern," like the word "new," can be difficult, even awkward, when used in an historical context. What was once new and modern no longer has the impact it had when introduced. One can analyze, study, and imagine, but a first impression can never be repeated or even fully understood at a later time. A consumer's reaction to Wright's American Modern dinnerware in the 1940s suggests a different meaning for modern than when the same dinnerware is seen today. Modernity is not limited to the twentieth century. Designs "in the modern taste" were presented to the eighteenth-century consumer just as each period in history saw the introduction of its modern styles. Modern is new and different from what had preceded it.

In the twentieth century, the term Modernism was coined to describe a specific style associated with an unadorned and functional aesthetic. As Katheryn Hiesinger wrote in the exhibition catalog *Design Since 1945*, "The triumph of functionalism as the universal modern aesthetic in the 1950s — and the ways in which the vacuum left by its decline and collapse has been filled — is to a large extent the history of design since 1945." The Bauhaus and International Style are representative of this Modernism; honesty, simplicity, and utility were its buzz words. Cubism as it was translated from painting to decorative arts was also an influence, but applied decoration or other distractions were avoided. As the style became more Americanized, themes of machinery, speed, and even a sprinkle of Hollywood space science fiction were incorporated. Eventually, the boundary between minimal Modernism and American Art Deco was crossed, and decoration returned to decorative arts.

On the other hand, modern without a capital 'm' is less specific and includes or overlaps several styles in the decorative arts. With pottery, modern in the sense of breaking with tradition seems to have begun at the turn of the century with Art Nouveau. Yet even such "new art" was frequently intertwined with Arts and Crafts (with its many historical references) and even some late Victorian reminiscences as deeply historical as Rococo. Really modern production pottery with either new historic twists or without any obvious precedent seemed to appear in the 1920s as Art Deco. (This is a bit later and a little different from French Art Deco studio pottery with its rich textural glazes or stylized figural painting.) The French, as well as the English, Swedish, Czechs, Americans, etc. produced the modern Art Deco pottery shown in this book. It was formed in factories in large numbers and made available to a wide audience, even though it was decorated by hand. The non-traditional, even radical, styles appealed to many but not to everyone. Consumer tastes probably placed the limits on its popularity and indirectly on the production of these wares. Economics was another issue, particularly when any hand labor was involved. Companies like Cowan Pottery in Ohio approached this problem by using single-color glazes on most of its

wares, but the Depression, an unforseen economic event, proved even Cowan's production techniques too costly.

However, other companies survived the 1930s, and some, like Homer Laughlin, with its introduction of colorful inexpensive Fiesta, flourished. Steubenville began to mass produce the now-classic but then-shocking "American Modern" in the late 1930s. After the war, Art Deco styles were neither new nor approproate, and the soft curves of American Modern were well-received through the 1940s and into the 1950s. Influenced by artists such as Jean Arp, Salvador Dalí, and Joan Miró, Fifties shapes resembled earlier modern forms with the bones removed or partially deflated, like Wright's flattened cups and folded serving bowls. Besides tableware, decorative ceramics, often called artware, were also produced. California potteries perpetuated the bright color trends that had been introduced earlier and they began to use inexpensive local talc in place of clays. Pieces by Sascha Brastoff and others were decorated with flamboyant and exotic, yet typically Fifties, figures and patterns. Although hand painted, most of these wares were, nevertheless, production pieces made in large quantities until another unforseen economic event, foreign competition, led to the eventual closing of many of the companies.

The focus on production pottery and exclusion of individual studio pottery in this book by no means implies any lack of merit of the latter. Studio pottery and studio potters of the period made valuable contributions to ceramics and to modern design. However, their method of production and consequent small output places these completely handmade wares in a category of their own.

No attempt is made to mention all modern production pottery from the 1920s through the 1950s. And, although the term pottery refers to several types of ceramics and manufac-

turing methods, it does not include porcelain or what is collectively called "china." With few exceptions (Cowan used a white porcelain-like clay), porcelain and china are not included in this book. The intent is to highlight select companies and mention others whose modern work represents the tastes, the techniques, and the times. Some, like Glidden Pottery of Alfred, New York, are not yet well known by collectors partly because little has been written about them. The French pottery Longwy has a very long history and its modern designs span the periods covered in this book. However, little information about the company has been available in English. Fiesta and American Modern, it can be argued, are already well-known; but to exclude such enormously successful and undeniably influencial designs would be unjust. Highlighting only a few companies is not to imply that they are necessarily the most important or most representative of the period or of the label "modern." These are some of the companies that introduced designs and made pottery that was popular in its day and is now of established or growing interest to collectors, both public (museums) and private. As information and publications about objects become available, the objects attract collectors' attention. After all, collecting involves more than possession or visual appeal. Knowing about works of art, designers, artisans, company histories, and even cultural contexts makes any collection more enjoyable and the collector more highly qualified. Enjoyment is what collecting is about — enjoyment of the object and in the knowledge gained. It is my hope that this book can provide a little bit of both.

Leslie Piña
Pepper Pike, Ohio

Part One:
From America

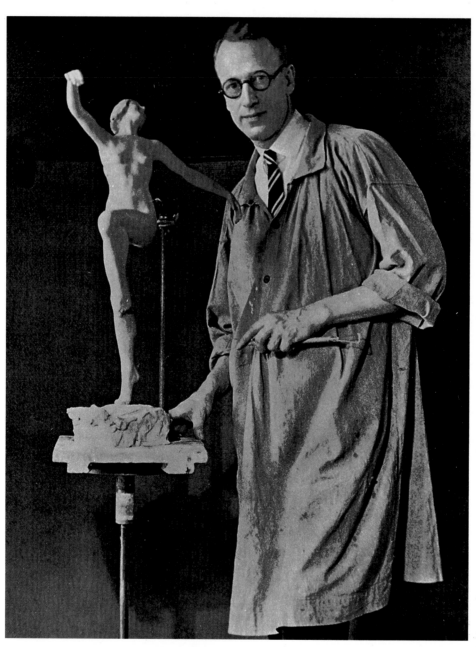

1.1 R. Guy Cowan from the 1929 catalog
*Courtesy of the Cowan Pottery Museum
housed in the Rocky River Public Library*

Chapter One
Cowan Pottery and other Ohio Potteries

In 1941, the CBS radio show "America in Transition" was broadcast from the Tenth Annual National Ceramics Exhibition at the Syracuse Museum of Fine Arts. Before being interviewed, R. Guy Cowan was described as "the man most responsible for the introduction and fostering of ceramic art in this country...famous throughout the world not only for his own ceramic art but for the art of dozens of his students who have gained permanent places in the art world..." In retrospect, it is clear that Cowan, the mentor, provided technical knowledge as well as artistic direction; Cowan, the employer, provided the facilities for other artists to experiment and develop creatively, while earning a livelihood. Respect for the art and the artist, for the materials, the history, and the people, ultimately brought Cowan and his pottery widespread acclaim. The pottery pieces contributed to the American home; the pottery designers contributed to American art and culture. The artists' experience at Cowan Pottery influenced their later work; their successes, in turn, increased awareness and enhanced the value of works done earlier at Cowan.

Reginald Guy Cowan (he preferred the name R. Guy) was born in 1884 into a second generation family of potters in a major American pottery center, East Liverpool, Ohio. Guided by his father Lewis Cowan, a pottery decorator who had headed the Steeles Decorating Shop in the 1870s, the young R. Guy Cowan became an accomplished production potter by the age of twelve.

The New York State School of Clayworking and Ceramics at Alfred University, in Alfred, New York, was established in 1900, and Charles Fergus Binns (1857-1934) was invited to be its first director. Binns was the son of Richard William Binns, director of the Royal Worcester Porcelain Works in Worcester, England. Shortly after Binns came to Alfred, Cowan enrolled to study ceramic engineering under him. Binns disapproved of painting decorative designs on ceramic pieces (contrary to the tradition of both their fathers). He had a fondness for Chinese aesthetics, which he articulated in a 1903 *Craftsman* article, "In Defense of Fire." By the time Cowan graduated from Alfred in 1907, he had not only received technical training from Binns, but also had acquired the basis for his style, which included a preference for glaze effects in the Chinese taste.

Rather than return to East Liverpool, Cowan chose to settle in Cleveland, where he could benefit from the Cleveland School of Art (Cleveland Institute of Art). While teaching (of all things) china decorating at East Technical High School, Cowan met another teacher, Bertha Bogue. They later married and had a son and two daughters.

Cowan's first studio was at East 97th and Euclid Avenue where he built a kiln in the backyard. The early studio work was of dark red clay covered with thick lead glazes and signed by hand. Horace Potter's Artcraft Studio, ten blocks away at East 107th and Euclid, was a gathering place for area artists. Cowan did some of his early experimentation there and enjoyed the contact with other local talent.

In 1912 Cowan moved his operation to 1360 Nicholson Avenue in Lakewood, a West Side suburb of Cleveland. In this larger studio equipped with three kilns, he began to produce "Lakewood Ware." He founded the Cleveland Pottery and Tile Company, and from 1912 to 1917 Cowan used red shale clay and hand-signed "Cowan Pottery" or "Lakewood Ware" in paint or incised at the bottom of each piece. His glaze experiments included irridescent lusters, notably a deep rose requiring pure coin gold in the mixture. For more traditional colors — blues, greens, and earth tones — he used metallic oxides.

While making pottery, Cowan taught in area schools. At this time he hired a Lakewood High School student, Richard O. Hummel, who worked part time at the Nicholson Avenue studio. Hummel later became a ceramic chemist and assistant superintendant at Cowan Pottery. When Cowan studied ceramic engineering at Alfred, he had not received formal art training. He took courses from Henry G. Keller at the John Huntington Polytechnic Institute in Cleveland and considered it a valuable experience.

In 1917, Cowan and Guy L. Rixford won first prize for pottery at the Chicago International Show at the Art Institute of Chicago, and then pottery production was interrupted by World War I. Because of his chemistry background, he served as a captain in the Army Chemical Warfare Service and worked on perfecting a charcoal filter for gas masks. Cowan became good friends with his commanding officer, Major Wendell Wilcox. After the armistice, Wilcox accompanied Cowan to Cleveland to manage his newly opened company.

A visit to the office of attorney Homer Johnson (father of architect Phillip Johnson) proved auspicious when shortly afterwards Cowan won the approval of Cleveland's art patrons and the Cleveland Chamber of Commerce (Johnson was its president). Cowan was encouraged to incorporate his business. Subscribers for the initial preferred stock offering included prominent Clevelanders Jeptha Wade, F. E. Drury, Jacob Cox, Mrs. Stevenson Burke, and Francis Prentice. The company's net worth was $5,000. In 1920 the new corporation purchased two acres at 19633 Lake Road in the neighboring suburb of Rocky River and built a new plant. Guy Cowan was president, A. E. Gibson vice-president, Wendell Wilcox treasurer and general manager, and C. S. Nicholson was secretary. By 1925 the new plant had been enlarged three times. While commerial success was attributed to Wilcox, artistic achievement was credited to Cowan.

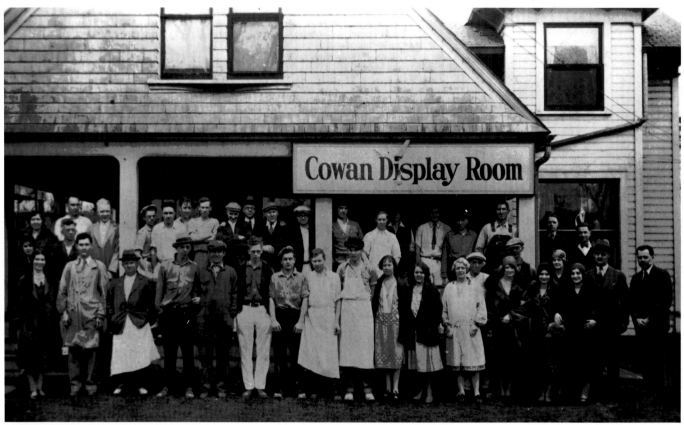

1.2 Workers in front of the Cowan Display Room on Lake Avenue in Rocky River. *Courtesy of the Cowan Pottery Museum*

Many of Cowan's master craftsmen were brought from England and paid up to $1.65 an hour, a good wage for the time.

No longer satisfied with the red pottery clay, Cowan developed a new white mixture of Maine feldspar, white silica from the Fox River Valley in Illinois, ball clay from Cornwall, England, china clay from the Staffordshire district of England, and powdered feldspar. Modern equipment was purchased. The clay mixture was ground with water in a quartz-lined mill, and an electric magnet extracted iron particles. Water was extracted through up to forty thicknesses of canvas and the mixture was kneaded in a machine, like bread dough.

To form a bowl, a plaster of Paris mold was made and clay was spread on the inside of the mold. The mold was then placed on a potter's wheel where a profile tool was used to shape the inside. The bowl was next placed on a lathe and the operator fashioned the outside curves.

Flower frogs were more complex, as parts were formed separately and assembled by hand. To mold wares, slip was made by liquifying the clay with water. Original molds were made of plaster or clay in as many as twenty pieces and then assembled like a puzzle. Figures often required wax models from which a plaster-of-Paris cast was formed. A clay model was made from this cast, remodeled, and then the final working patterns were done out of plaster-of-Paris. Molds were destroyed after the lot was successfully cast and fired.

The pieces were fired at up to 2,500 degrees Fahrenheit for twenty-four hours and left to cool for two days. The resulting bisques were then coated with a glaze mixture and re-fired at the appropriate cone for the particular glaze. Glazing and refiring was repeated up to four times on a single piece depending on the depth desired. The whiteness of this new clay body enabled glaze experimentation in pastel colors. However, limited edition ceramic sculpture was generally made of earthenware.

The Rocky River plant had a good gas well (the Lakewood well had given out) and was considered to be one of the best designed ceramic engineer-ing facilities in the United States at that time. Cowan soon had nine kilns, employed fifty master potters and artists (among whom was his grandfather), and became a tourist attraction of international reputation.

Charles Berry directed coast-to-coast distribution from Rocky River. Retail outlets for the commercial production included the department stores Wanamaker's of Philadelphia, Marshall Field of Chicago, Ovington of New York, and Halle Bros., Sterling and Welch, and Webb C. Ball of Cleveland. When Cowan introduced the famous flower figurines in 1925, the plant's capacity was pushed to the limit. By that time there were at least 1,200 retail outlets, each with limited distribution in order to provide a degree of exclusivity. Gift shops and florists, as well as large department stores, carried Cowan's commercial line. A total of 1,000 different items, of varying design and color, ranged in price from 50 cents to 40 dollars. Individual designs and limited editions, sometimes used for store displays, were priced as high as $500.

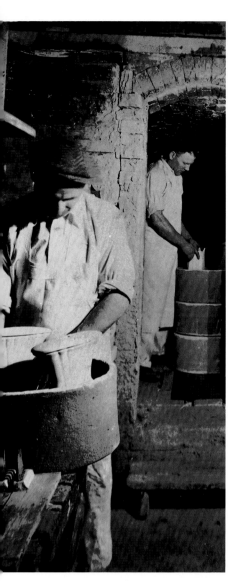

1.3 After the pottery is fired in kilns it is called bisqueware. *Courtesy of the Cowan Pottery Museum*

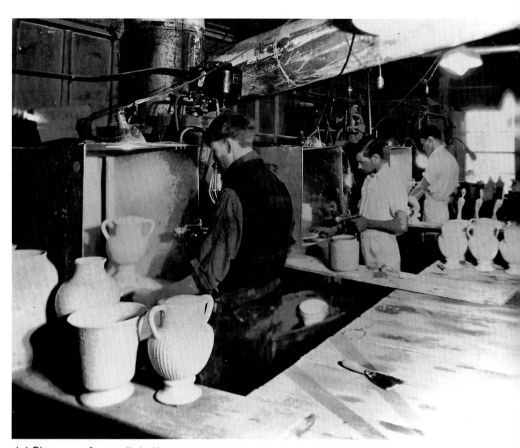

1.4 Glaze was often applied with a spray gun. The Cowan Studio was a pioneer in perfecting this technique, as well as in its use of the spray booth. *Courtesy of the Cowan Pottery Museum*

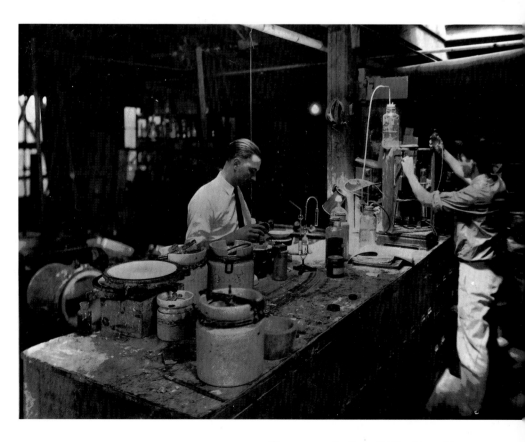

1.5 Richard Hummel created many glazes unique to Cowan that have not been duplicated since. *Courtesy of the Cowan Pottery Museum*

From 1928 to 1933 Cowan headed the ceramic department of the Cleveland School of Art, the institution that had initially lured him to Cleveland. Other instructors at the school also worked for Cowan:

Arthur E. Baggs (1886-1947) was a potter, ceramicist, and crystalline glaze expert who worked as a glaze chemist for Cowan from 1925 to 1928. He developed Egyptian Blue, the color of ancient mummy beads. Baggs won prizes in the 1927 and 1928 Cleveland May Shows, annual juried exhibits at the Cleveland Museum of Art, and received the Charles Fergus Binns Medal in 1927. He taught at the Cleveland School of Art and then headed the ceramics department at Ohio State University from 1928 to 1935.

Alexander Blazys (1894-1963) headed the sculpture department of the Cleveland School of Art and worked for Cowan in 1927. He was known for designs such as *Bird on a Wave*. *Blue Camel* won first prize in the 1927 May Show. Also in 1927, he exhibited his *Russian Peasants — Woman Dancing*, *Tambourine Player*, *Balalaika Player*, and *Accordion Player*. In the 1926 May Show, his first prize for sculpture had been for a bronze figure similar to *Woman Dancing*. *Moses*, also in the 1927 May Show, was similar to a wooden figure Blazys had in the 1926 May Show.

Edris Eckhardt (1907-) studied at the Cleveland School of Art, where she later taught sculpture and ceramics. She also studied in New York under Aleksander Archipenko and worked for Cowan.

Viktor Schreckengost (1906-) was born in Sebring, Ohio, into a line of potters at least as far back as his great grandfather. He studied under Walter Sinz and graduated from the Cleveland School of Art in 1929. He then went to Vienna and did postgraduate work under Michael Powolny. In 1930 he began working for Cowan three days a week while teaching at the Cleveland School of Art three days. (He later became chair of the Industrial Design department at the school.) Schreckengost designed an edition of twenty large punch bowls called *New York City on New Year's Eve (Jazz Bowl)* for a New York gallery, which Eleanor Roosevelt ordered for the governor's mansion in Albany, her Hyde Park home, and for the White House. These won first prize in the 1931 May Show (His *Sports Plates, Plaque No. 5*, and *Globular Vase* were also exhibited in this show), the first of more than fifty awards in sculpture, ceramics, and painting, including the Binns Medal in 1938. Before Cowan died in 1957 he gave Schreckengost the formula for his glazes. Schreckengost became one of the most versatile and accomplished twentieth-century American designers.

Elsa Vick Shaw (1891-1972) was a design instructor at the Cleveland School of Art. She worked in the Art Deco style at Cowan Pottery and designed the *Egyptian mural*.

Walter Sinz (1881-1966) taught in the sculpture department of the Cleveland School of Art from 1911 to 1952. He worked as a sculptor for Cowan from 1925 to 1930 and designed figurines for table settings and *Me and My Shadow*.

Thelma Frazier Winter (1903-1977) studied at the Cleveland School of Art until 1929 and was later hired to teach. She took first prize for pottery at the 1930 May Show for *Octagonal Plaque*. While working for Cowan from 1928 to 1930, she designed limited edition vases and plaques, made crackle-glazed plates, and worked with opalescent glazes with relief designs. Although Cowan is usually associated with one and two-color glazes, there were exceptions, such as Winter's underglaze painting on Luis Mora's *Indian Series* and Elsa Shaw's tile murals.

Other artists who worked for Cowan began while still studying at the Cleveland School of Art or right after graduating. Although the school was undoubtedly at the heart of the Cleveland art scene and the primary source for Cowan Pottery talent, some of Cowan's artists came from other parts of the country and the world.

Russell Barnett Aitken graduated from Cowan's program at the Cleveland School of Art in 1931 and did post-graduate work in Europe in 1932 and 1933. He may or may not have actually worked for Cowan. Aitken was a consistent prize winner at May Shows and designed *Trojan Plaque*, which was shown in 1932.

Elizabeth Anderson (Mrs. Eliot Ness) graduated from the Cleveland School of Art in 1927. She designed *Spanish Dancers*, which were in the 1928 May Show, and *Pierrot and Pierette*.

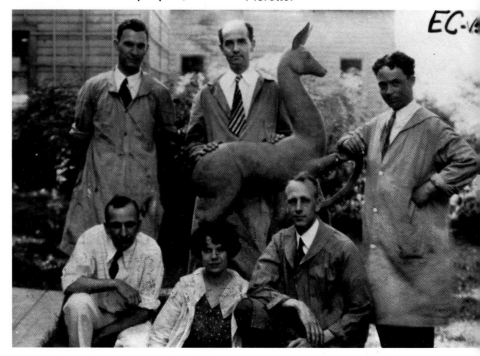

1.6 Cowan artists, top, left to right — Paul Bogatay, José Martin, Raoul Josset; bottom, left to right —Waylande Gregory, Thelma Frazier Winter, R. Guy Cowan. *Courtesy of the Cowan Pottery Musuem*

Whitney Atchley worked for Cowan while still a student at the Cleveland School of Art.

Paul Bogatay (1905-1972) studied under Cowan and graduated from the Cleveland School of Art in 1928; he won the Tiffany Foundation Fellowship in that year. Bogatay worked for Cowan from 1929 to 1930 designing limited editions and then moved to Columbus and taught at The Ohio State University for the next forty years. He won the Binns Medal in 1954.

Waylande De Santis Gregory (1905-1971) was born in Kansas, where he was initially trained in art. He worked in bronze and ceramics at the Art Institute of Chicago and in Florence. From about 1928 he was a leading Cowan artist and designed such pieces as *Burlesque Dancer*, *Diana*, *King and Queen Bookends*, *Persephone*, *Pan on a Toadstool*, *Boy and Fawn*, *Torso*, and *Alice in Wonderland*. A group of five pieces including *Salome* (also exhibited in New York in 1928), *Margarita*, and *Two Fawns* won first prize for ceramic sculpture in the 1929 May Show. *Nautch Dancer* and *Seahorse Fountains* were shown in the 1930 May Show. *Congo Head (Nubian Head)* and *Artichoke Vase* were in the 1931 May Show, and *Beaten Dog* won first prize for ceramic sculpture in that year. Gregory won the Binns Medal in 1939.

Richard O. Hummel was a chemist and ceramic technician who made clay bodies and developed glazes. He won second prize for ceramics in the 1930 May Show for an earthenware vase, and his *Flaring Bowl* was shown in the 1931 show.

Albert Drexel Jacobson (1895-1973), a modern sculptor, designed *Julia*, *Introspection*, *Giulia*, *Pelican Bookends*, and *Antinea*.

Raoul Josset, from Burgundy, France, had done decorative sculpture on the Pomone Building in the 1925 Paris Exposition and important war memorials around France. In 1929 Cowan invited Josset to Cleveland, and he made sports figurines and sculptures which were shown at a Halle Bros. special exhibit in 1930.

Paul Manship (1885-1966) a highly acclaimed sculptor known for his work in the Art Deco style, designed pieces such as *Europa* for Cowan during the last two years of operation.

José Martin was a French wood sculptor who, like Jossett, played an important part in the 1925 Paris Exposition and was invited to join Cowan in Cleveland. He also worked in the Art Deco style.

Luis Mora (1874-1940), a Southwest painter and sculptor, designed *Indian Brave*, *Seated Girl*, and *Woman with Flower Basket*.

Margaret Postgate was not a Cleveland resident, so she could not enter the May Show. Her Cowan designs include *Madonna*, *Three Marys*, and possibly *Push Pull* bookends.

Other artists who worked for Cowan include Dalzee, Alvin MacDonald, Joseph Motto, Elmer Novotny, Stephen Rebeck, Jack Waugh, Frank Wilcox and Edward Winter.

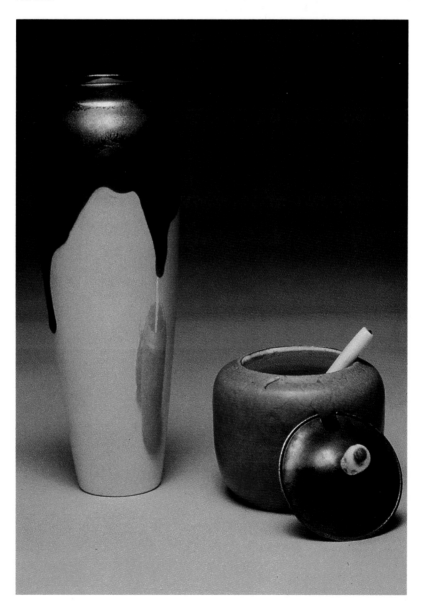

1.7 Lakewood Ware by R. Guy Cowan and Horace Potter Red clay vase with bright ocre with black drippy glaze together with a mustard jar of earthenware, silver, and ivory, circa 1915. Since Cowan gave his address as 10646 Euclid Ave. (the home of Arts and Crafts jeweler Horace Potter) in 1912, the top was most likely made by him. jar H. 3 1/2 in. *Courtesy of the Cowan Pottery Museum, photo Larry Peltz*

Besides his glaze experimentation, R. Guy Cowan designed *Female Figure and Bowl* (1925 May Show first prize for ceramics), *Chinese Bird Vase*, (1927 May Show first prize), *Dancing Figure*, and limited editions such as *Adam and Eve* in a terra cotta crackle glaze. The pair was exhibited in the 1928 May Show, the Pennsylvania Academy of Art in 1929, and the Art Institute of Chicago in the same year. Along with another limited edition, *Madonna and Child* (1928 May Show first prize), it was displayed in the Hall of Honor of the Philadelphia Museum of Art in 1929. His nude figurines *Swirl Dancer* and *Scarf Dancer* were among his other May Show designs. Cowan received the Binns Medal in 1931.

In 1927 the Society of Arts and Crafts of Boston *Bulletin* praised Cowan potters for creating designs that were appropriate to the modern world. They gave Cowan an exhibition in the society gallery in 1929. Arthur Baggs and Cowan were both given the special honor and title "master craftsmen" of the Boston Society of Arts and Crafts.

Ironically, in 1927, about the same time a society that promoted the lofty ideals of the Arts and Crafts movement was praising Cowan, an inferior line of inexpensive flower containers called "Lakeware" was introduced. This diversion from his self-consciously high standards is said to have contributed to his oncoming financial problems. Attempts to stay afloat were made in 1929 by collaborations with a national lamp manufacturer and with the Wahl Pen Co. for ceramic bookends, paperweights, and desk sets with pottery bases and Wahl pens. However, Cowan reorganized the company in August of 1929. With advice from Cleveland Museum of Art director, Frederic Allen Whiting, and financial backing from Clevelanders, Mr. and Mrs. F. F. Prentice, John L. Severence, Henry G. Dalton, William G. Mather, Mrs. E. B. Greene, Mr. and Mrs. E. P. Bole, Miss Mary Newberry, Mrs. Lyman Treadway, and Howard P. Eells Jr., Cowan reorganized into an art colony centered around pottery production rather than a commercial pottery plant. R. Guy Cowan was president, Howard Eells Jr. was chairman of the board, and Charles C. Berry was vice-president and general manager.

On January 1, 1930 Cowan began to market a special "R. Guy Cowan" line separate from the commercial "Cowan" line. They also introduced two new glaze colors, Cashmere and Arabian Nights, and liqueur sets with pairs of decanters and six glasses. Despite efforts to survive, and with the bad timing of an unscrupulous salesman who absconded with the commissions for a warehouse full of fictitious orders, Cowan became one more casualty of the Depression. According to a newspaper article (*The Cleveland Plain Dealer* 11-25-30), in November of 1930 Eells was appointed receiver for Cowan Potteries Inc. on action brought to Common Pleas Court by the Artcraft Printing Co. which claimed that Cowan Potteries owed them $1,303 and owed others $50,000.

Since the 1931 catalog had already been issued, the studio stayed open for one more year using remaining materials. Some of their most aesthetically successful pieces were produced in that year, perhaps because pressure to succeed commercially had been lifted. A 1932 newspaper item covering an exhibit at the Metropolitan Museum of Art highlighted Viktor Schreckengost's *Sports Plates* and R. Guy Cowan's *Bowls and Jugs*, products of the final days.

In December of 1931, the pottery closed, the building was converted to the Barrett Creamery Co., and the remaining stock was sold to the Cleveland department store Bailey Co. From 1932 to 1933 Cowan worked in Cleveland as a research engineer for Ferro Enamel, and then as a consultant to the Onandaga Pottery Co. in Syracuse, New York. He became a trustee for the Syracuse Museum of Fine Arts. His wife Bertha died in 1947, and Cowan suffered a heart attack and died in Tucson, Arizona in 1957. He is buried in Lakewood Cemetery in Cleveland.

In 1976 the Rocky River Public Library purchased an 800-piece collection of Cowan pottery from John Brodbeck of Cleveland Heights with funds given by Maude Michael in memory of her husband E. Earl Michael. On February 26, 1978 the Cowan Pottery Museum opened at the library. The collection is rotated, with the important pieces always on display. In 1989 The Cleveland Museum of Art held an exhibit, "Cleveland Art Comes of Age: 1919-1940." The show consisted of more than 100 works that had been exhibited during the first twenty-one years of the May Show. Of these, thirty-five were in the category of ceramics — all of which were credited to Cowan Pottery or to R. Guy Cowan. (CMA Press Release, 1989)

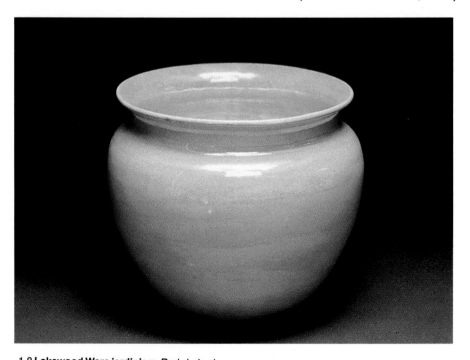

1.8 Lakewood Ware jardiniere Red shale clay with bright yellow glaze, H. 9 in. *Courtesy of the Cowan Pottery Museum, photo Larry Peltz*

References

Sources of information (occasionally conflicting and usually incomplete) about Cowan and the company include newspaper clippings, magazine articles, typed papers, and undated or untitled material from the Rocky River Public Library, the Cleveland Museum of Art Library, a microfilmed scrapbook at the Cleveland Institute of Art Library, and the Western Reserve Historical Society Library. These were used in an unpublished paper (Piña 1984) on Cowan. Some recently published works that also relied on these sources include the articles "Cowan Pottery and the Cleveland Museum of Art" by Henry Hawley (1989); "Cowan Pottery" by Donald Calkins (1991); a chapter in Ko*vels' American Art Pottery* (1993); and *Collector's Encyclopedia of Cowan Pottery* by Tim and Jamie Saloff (1993).

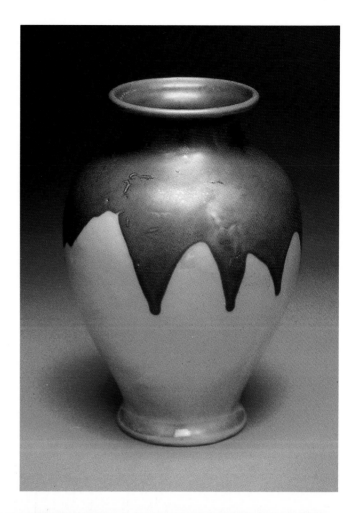

1.9 **Lakewood Ware vase** Red shale clay with midnight blue dripped glaze. *Courtesy of the Cowan Pottery Museum, photo Larry Peltz*

1.10 **Incised vase by Richard O. Hummel** Round vase with incised decoration of dark leaves on branches against a light neutral ground by Richard Hummel, ceramic chemist who later became assistant superintendant of Cowan Pottery, H. 5 in. *Courtesy of the Cowan Pottery Museum, photo Larry Peltz*

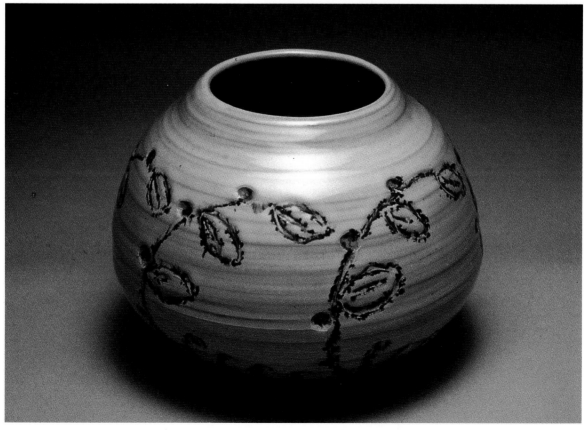

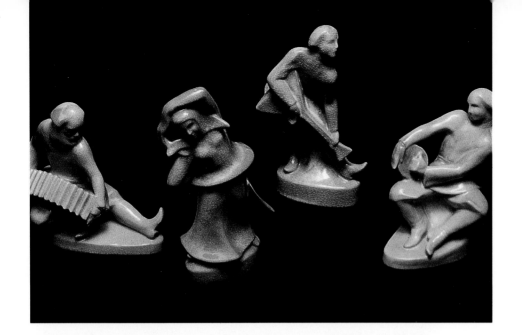

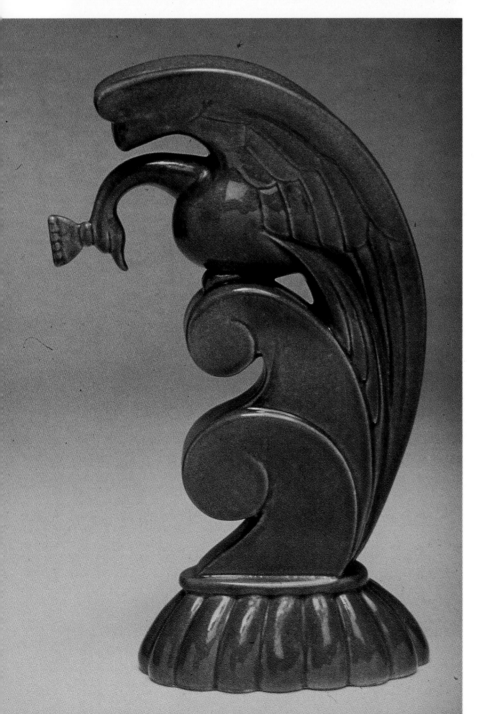

1.11 **Russian Peasants by Alexander Blazys**
Earthenware limited edition series, made in sets of four —*Accordion Player, Dancer, Balalaika Player,* and *Tambourine Player* —(this is not quite a matched set), designed by Alexander Blazys and exhibited in the 1927 May Show, with impressed circular mark COWAN RG. *Courtesy of the Cowan Pottery Museum, photo Larry Peltz*

1.12 **Accordion Player** from 1930 catalog.

1.13 **Bird on a Wave by Alexander Blazys**
Bright turquoise glaze with peacock bird on stylized wave, #749-B, designed about 1928 by Blazys, H. 14 1/2 in., with impressed circular mark COWAN RG. *LP, Courtesy of the Cowan Pottery Museum, photo Larry Peltz*

1.14 Jazz Bowl by Viktor Schreckengost
Famous earthenware bowl, with no two exactly alike, in an edition of 50, with carved sgraffito decoration in black slip over a white body covered with a bright Egyptian blue-green transparent overglaze, originally selling for $50 each, winner of first prize in 1931 May Show, H. 11 in. D. 16 in., signed VIKTOR SCHRECKENGOST. *Courtesy of the Cowan Pottery Museum, photo Larry Peltz*

1.15 Different view of Jazz Bowl

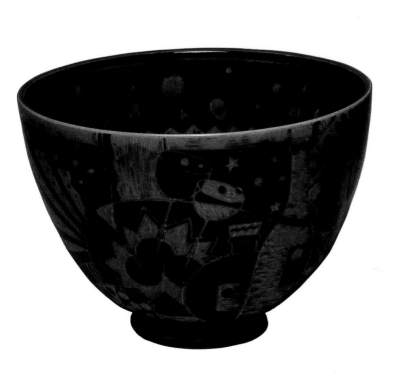

1.16 Punch bowl by Viktor Schreckengost
Also by Schreckengost, this identically shaped earthenware bowl is decorated with different designs but in the same colors as the more famous and valuable *Jazz Bowl*, signed VIKTOR SCHRECKENGOST. *Courtesy of the Cowan Pottery Museum, photo Larry Peltz*

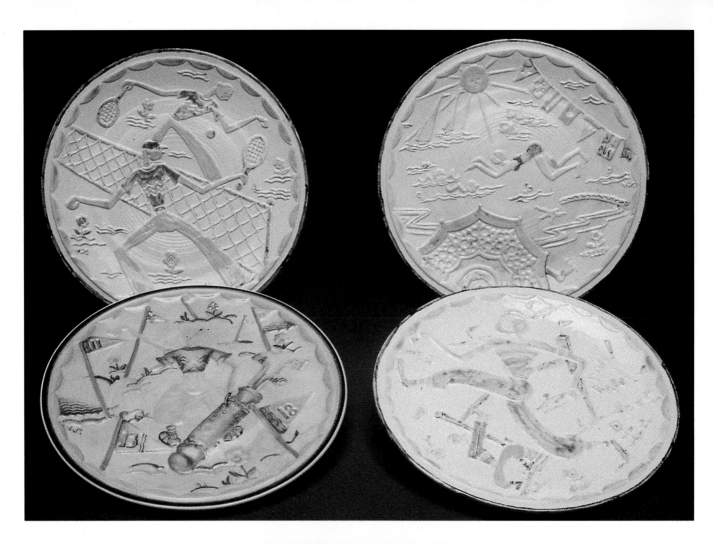

1.17 Sports Plates by Viktor Schreckengost Earthenware plates, with bas relief polychrome decorations, each depicting a different sport — tennis, swimming, golf, and football — and exhibited in the 1931 May Show, D. 11 in., some marked. *Courtesy of the Cowan Pottery Museum, photo Larry Peltz*

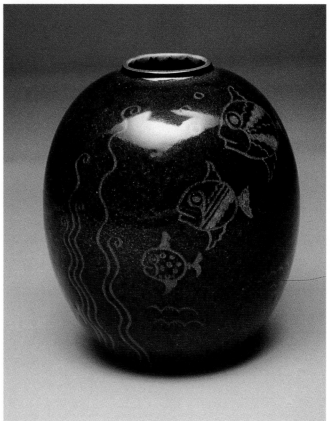

1.18 Fish vase by Viktor Schreckengost Almost spherical vase in shades of teal with "dry point" decoration of fish. *Courtesy of the Cowan Pottery Museum, photo Larry Peltz*

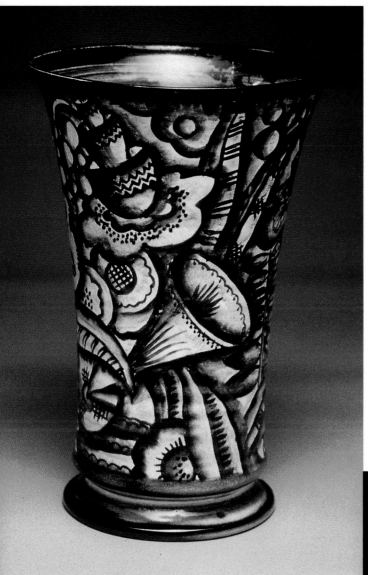

1.19 Vase by Viktor Schreckengost
Tapered cylindrical vase with black and white abstract Art Deco design painted by Schreckengost in 1930, H. 11 1/2 in. *Courtesy of the Cowan Pottery Museum, photo Larry Peltz*

1.20 Vase by Thelma Frazier Winter Spherical vase with extended narrow neck in black with white incised textural pattern, H. 10 in., with impressed circular mark *Courtesy of the Cowan Pottery Museum, photo Larry Peltz*

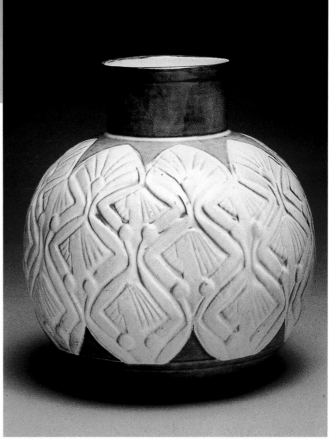

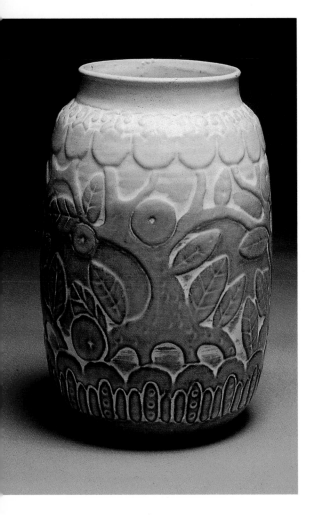

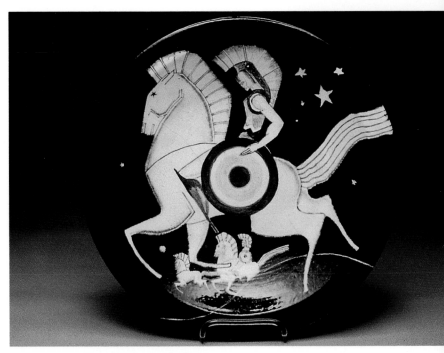

1.22 Trojan Plaque by Russell Barnett Aitken
Large charger depicting a warrior on horseback in black and white, exhibited in the 1932 May Show, D. 17 in. *Courtesy of the Cowan Pottery Museum, photo Larry Peltz*

1.21 Vase by Thelma Frazier Winter Buff colored slightly bulbous cylindrical vase with stylized relief design, H. 10 in. *Courtesy of the Cowan Pottery Museum, photo Larry Peltz*

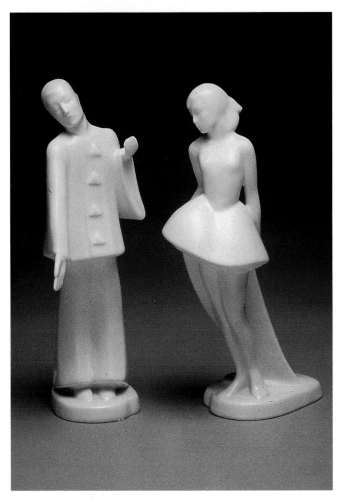

1.23 Pierette and Pierrot by Elizabeth Anderson Limited edition molded earthenware characters #791 and #792, glazed in ivory, H. 8 1/2 in., with impressed circular mark COWAN RG. *Courtesy of the Cowan Pottery Museum, photo Larry Peltz*

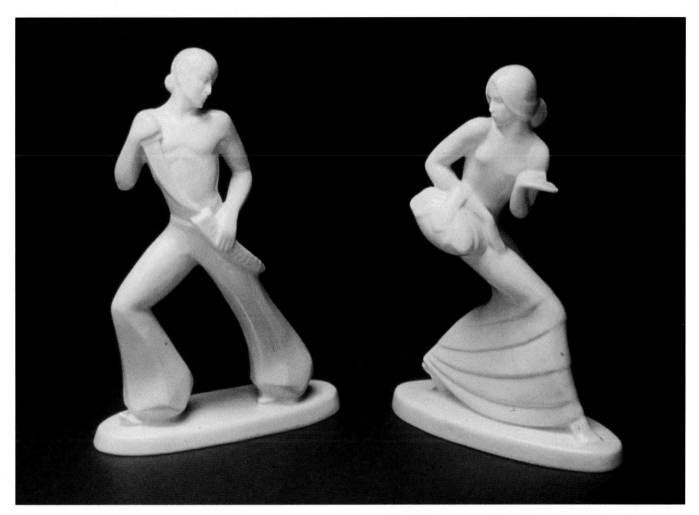

1.24 **Spanish Dancers by Elizabeth Anderson** Earthenware limited edition figures exhibited in the 1928 May Show, male #794 and female #793 are glazed in ivory but also came in a hand painted version, H. 8 1/2 in., with impressed circular mark COWAN RG. *Courtesy of the Cowan Pottery Museum, photo Larry Peltz*

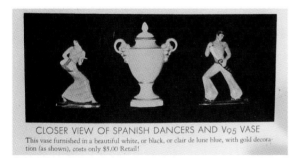

CLOSER VIEW OF SPANISH DANCERS AND V95 VASE
This vase furnished in a beautiful white, or black, or clair de lune blue, with gold decoration (as shown), costs only $5.00 Retail!

1.25 Page from 1930 catalog picturing *Spanish Dancers.*

1.26 **Male Spanish Dancer** Designed and painted with brown bell-bottom trousers and melon skin by Elizabeth Anderson in 1928, shape #974, H. 9 in., impressed COWAN. *Courtesy of Ralph and Terry Kovel*

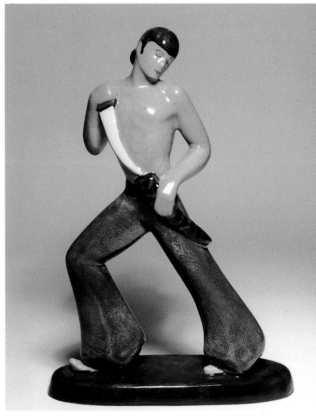

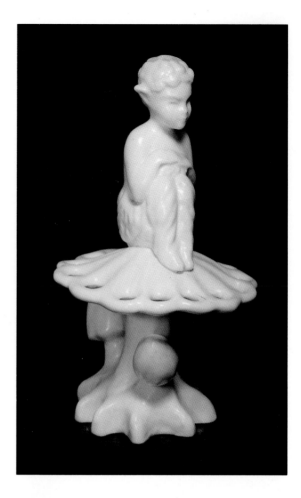

1.27 Vase by Whitney Atchley Slightly waisted vase mounted on a cylindrical foot and decorated in black vertical lines on a tan and dull green ground, H. 8 in., signed WHITNEY ATCHLEY. *Courtesy of the Cowan Pottery Museum, photo Larry Peltz*

1.29 Pan on a Toadstool Flower frog figurine of Pan seated on a large toadstool, glazed in ivory, designed by Waylande Gregory in 1930, H. 9 1/4 in., with impressed circular mark COWAN RG and COWAN. *Courtesy of Ralph and Terry Kovel*

F9. Retails for $5.00
Suitable for almost any bowl.

1.30 Pan on a Toadstool, retail $5.00, from 1930 catalog.

1.28 Salome by Waylande Gregory Earthenware limited edition Art Deco sculpture of Salome glazed in plum, shown in 1928 exhibit of Cowan Pottery in New York and winner of first prize in 1928 May Show, H. 18 1/2 in. *Collection and courtesy of the Everson Museum of Art*

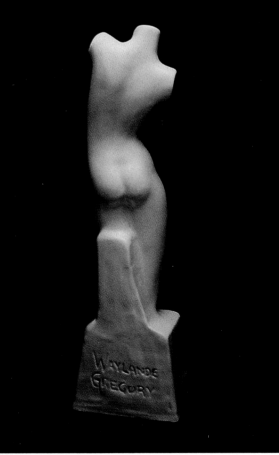

1.31 Boy and Fawn by Waylande Gregory
Peachy orange glaze on limited edition earthenware figurine of a boy and fawn, H. 16 in., signed WAYLANDE GREGORY. *Courtesy of the Cowan Pottery Museum, photo Larry Peltz*

1.32 Torso by Waylande Gregory Limited edition earthenware figure of the posterior view of a nude armless female torso glazed in ivory, H. 17 in., with impressed circular mark COWAN RG. *Courtesy of the Cowan Pottery Museum, photo Larry Peltz*

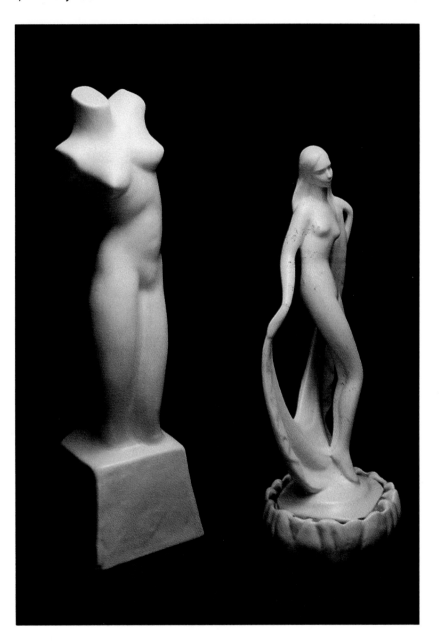

1.33 Torso and Persephone Frontal view of *Torso* with another Waylande Gregory limited edition, *Persephone*, also of earthenware and glazed in ivory, H. 15 in. *Courtesy of the Cowan Pottery Museum, photo Larry Peltz*

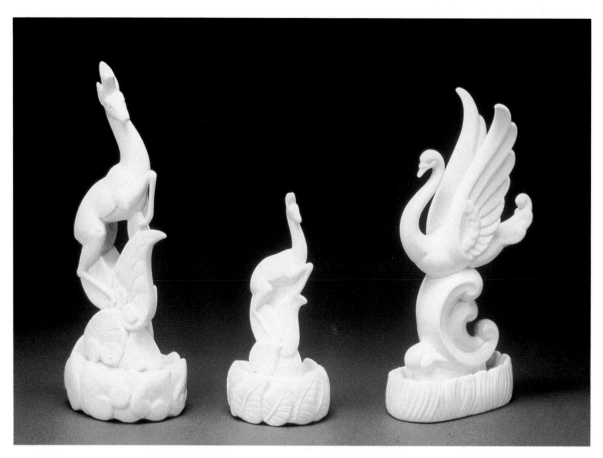

1.34 **Animal flower frogs by Waylande Gregory** *Courtesy of the Cowan Pottery Museum, photo Larry Peltz*

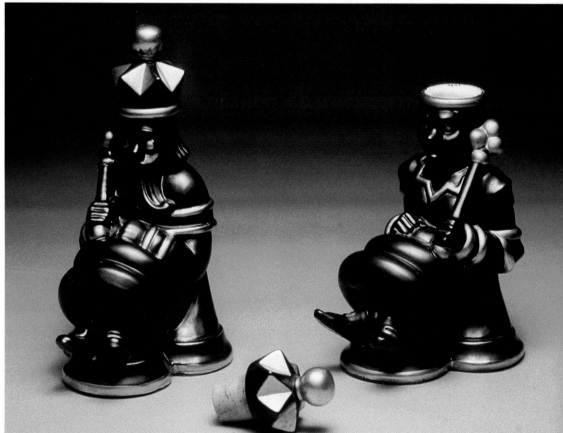

1.35 **Bookend decanters by Waylande Gregory** Seated *King* and *Queen* decanters glazed in black with gold stoppers in the form of crowns, H. 10 in., with impressed circular mark COWAN RG and COWAN. *Courtesy of the Cowan Pottery Museum, photo Larry Peltz*

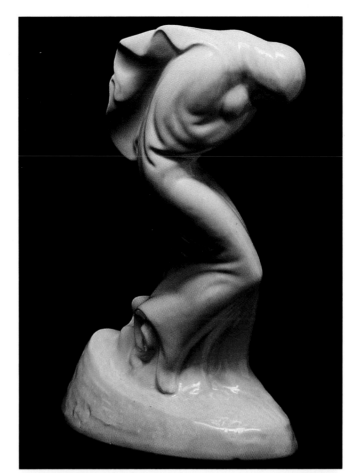

1.36 **Margarita by Waylande Gregory** Earthenware limited edition of 50, *Margarita* was one of five ceramic sculptures by Gregory to win first prize in the 1929 May Show, H. 16 in., with impressed circular mark COWAN RG and COWAN. *Courtesy of the Cowan Pottery Museum, photo Larry Peltz*

1.37 **Art Deco angels candelabrum by Waylande Gregory** Stylized figures of three nudes in silvery metallic glaze mounted on black candle holders, H.10 in., with impressed circular mark COWAN RG. *Courtesy of the Cowan Pottery Museum, photo Larry Peltz*

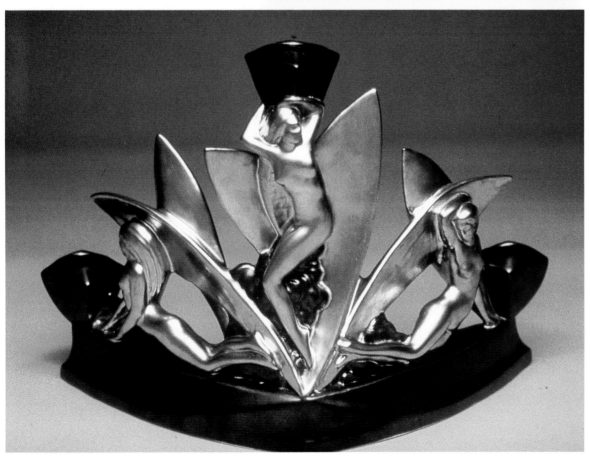

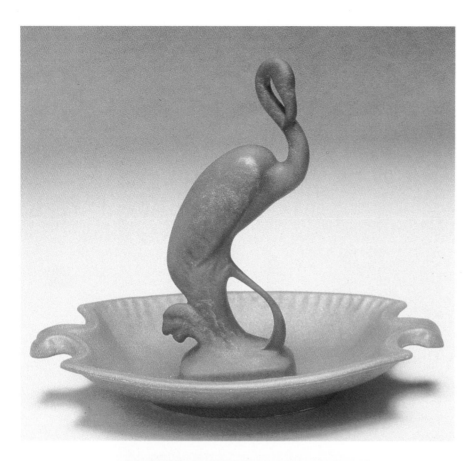

1.38 **Flamingo flower frog** Waylande Gregory design of a flamingo placed in a long shallow bowl for flower arrangements, glazed in a soft coral, bird H. 11 in., bowl L. 15 in., with impressed circular mark COWAN RG and COWAN. *Courtesy of the Cowan Pottery Museum, photo Larry Peltz*

1.39 Workers removing the flamingo and other pottery from plaster molds after the slip (liquid clay) has dried. *Courtesy of the Cowan Pottery Museum*

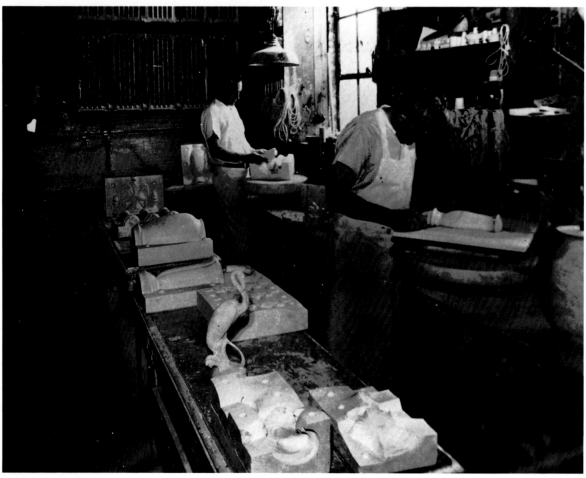

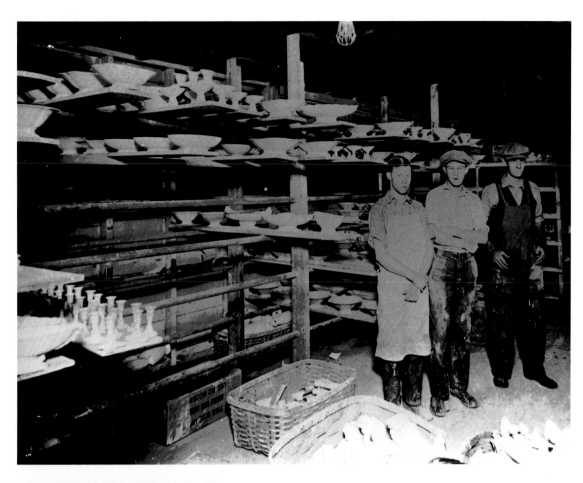

1.40 Bowls left to dry on racks; the pieces at this stage are called greenware. *Courtesy of the Cowan Pottery Museum*

1.41 **Artichoke vase by Waylande Gregory** Earthenware in a limited edition of 100 and exhibited in the 1931 May Show, this example in turquoise, H. 12 in. *Courtesy of the Cowan Pottery Museum, photo Larry Peltz*

1.42 **Congo (Nubian) Head and Burlesque Dancer** *Burlesque Dancer* designed by Waylande Gregory in a limited edition of 50 and *Nubian Head,* both of earthenware glazed in a rich black, Head H. 14 1/2 in., Dancer H. 18 in., each with impressed circular mark COWAN RG and COWAN. *Courtesy of the Cowan Pottery Museum, photo Larry Peltz*

1.43 **Antinea and Introspection by A. Drexel Jacobson** Black glazed *Introspection* H. 8 3/8 in. with bust of *Antinea* made in a limited edition of 100 in 1928, H. 13 1/2 in. *Courtesy of the Cowan Pottery Museum, photo Larry Peltz*

1.44 **Pelican bookends** A. Drexel Jacobson 1930 design of stylized pelican heads to use as bookends, #864 glazed in black and metallic copper, H. 5 3/8 in. C*ourtesy of Ralph and Terry Kovel*

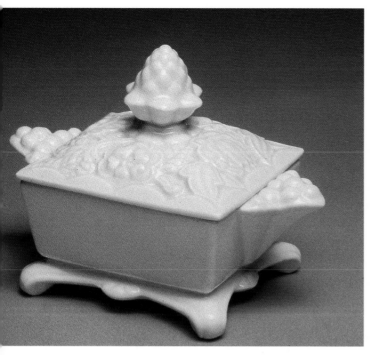

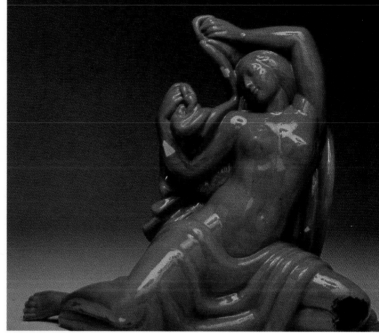

1.46 **Europa by Paul Manship** *Europa* was a popular theme with many ceramic artists of the period. This version is an earthenware limited edition, and this example is glazed in Chinese orange. H. 15 1/2 in., with impressed circular mark COWAN RG and signed PAUL MANSHIP. *Courtesy of the Cowan Pottery Museum, photo Larry Peltz*

1.47 **Mary by Margaret Postgate** Coral glazed earthenware figure #861 of *Mary* kneeling, in a limited edition of 50 designed in 1929, H. 10 in., base L. 14 1/2 in., with impressed circular mark COWAN RG. *Courtesy of the Cowan Pottery Museum, photo Larry Peltz*

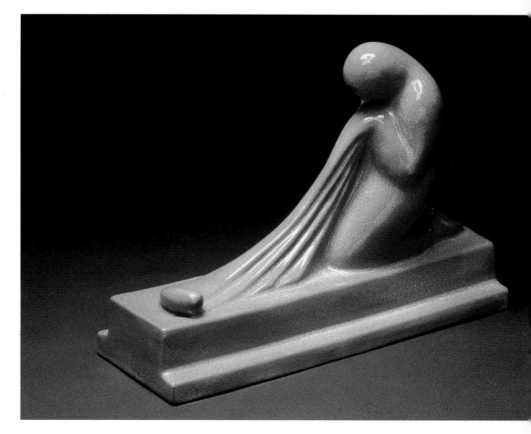

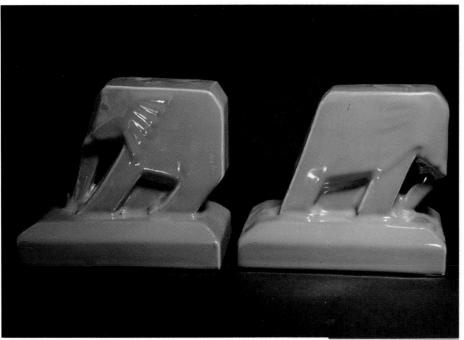

1.48 **Push Pull** Elephant bookends, *Pull* #841 and *Push* #840 designed by Margaret Postgate or Waylande Gregory, glazed in bright turquoise, or peacock, H. 4 3/4 in., L. 6 in. *Courtesy of Ralph and Terry Kovel*

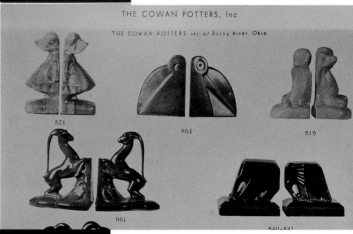

1.50 Page from 1930 catalog with *Push Pull*

1.49 Two *Pull* elephants in ivory (also made in a third color, black). *Courtesy of the Cowan Pottery Museum, photo Larry Peltz*

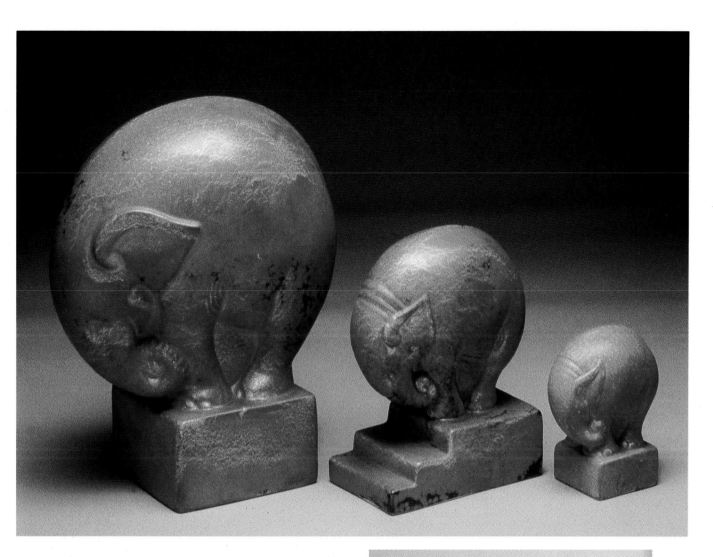

1.51 **Elephants** Margaret Postgate, 1930, designs of round elephants in three sizes, smallest 5 1/2 in. glazed in vivid Chinese orange. *Courtesy of the Cowan Pottery Museum, photo Larry Peltz*

1.52 *Elephants* from 1930 catalog page

THE COWAN POTTERS, Inc.

Top row, left to right D-1 (8½") E4-E5 (10½") E-1 (9")
Middle row, left to right E-3 (7¼") E-961 (7¼")
Bottom row, left to right E-521 (7¼") E-2 (7½")

Some Book-Ends—Old and New

D-1	Introspection, black or Egyptian blue	$12.50 pair
E4-E5	King & Queen (bottle bookends), Oriental red or ivory	10.00 pair
E-1	Kicking Horse, black or Egyptian blue	10.00 pair
E-3	Goats, black or Oriental red	10.00 pair
E-961	Unicorns, Oriental red or Foliage	5.00 pair
E-521	Sunbonnet Girls, Verde Green or Ivory	5.00 pair
E-2	Elephants, Arabian Night Blue or Oriental Red	7.50 pair

Don't forget the "Scotty's" on page 6 at $5.00 the pair, or our well-known "Boy and Girl", E-519, (not illustrated) at $5.00 the pair, ivory only.

[14]

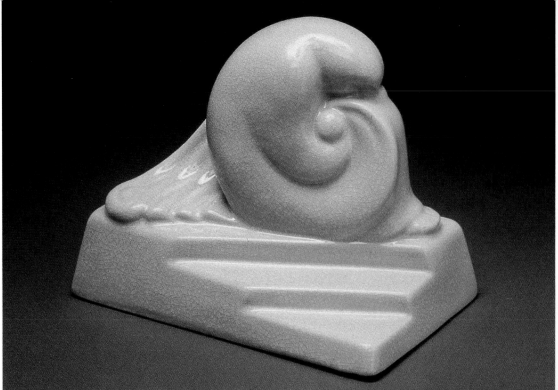

1.53 Madonna by Margaret Postgate
Highly stylized earthenware figure in a limited edition of 150 in 1929, this example in pastel peach, H. 7 in., with impressed circular mark COWAN RG *Courtesy of the Cowan Pottery Museum, photo Larry Peltz*

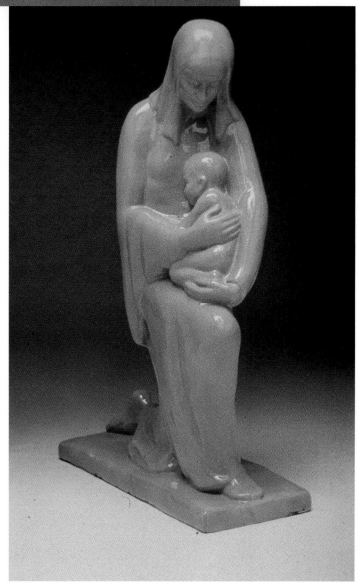

1.54 Madonna and Child by R. G. Cowan
Earthenware limited edition of 25 and first prize winner for ceramic sculpture in the 1928 May Show, also shown in Chicago and at the Ceramic Nationals in Syracuse in 1932, this example glazed in coral, L. 19 in., with impressed circular mark COWAN RG *Courtesy of the Cowan Pottery Museum, photo Larry Peltz*

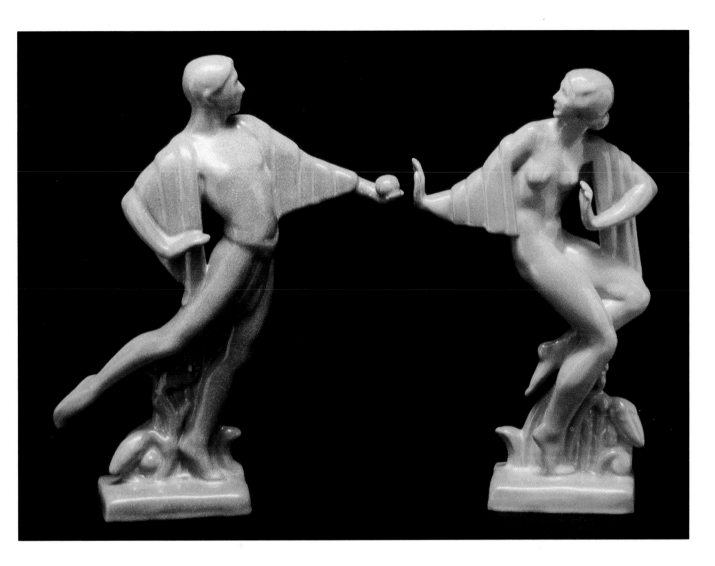

1.55 Adam and Eve by R. G. Cowan
Earthenware limited edition of 25, in the 1928
May Show and exhibited at the Art Institute of
Chicago and the Pennsylvania Academy of Art
in 1929, H. 13 1/2 in. *Courtesy of the Cowan
Pottery Museum, photo Larry Peltz*

1.56 Adam and Eve from 1929 catalog.

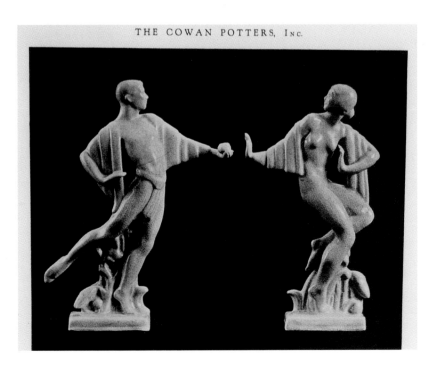

THE COWAN POTTERS, Inc.

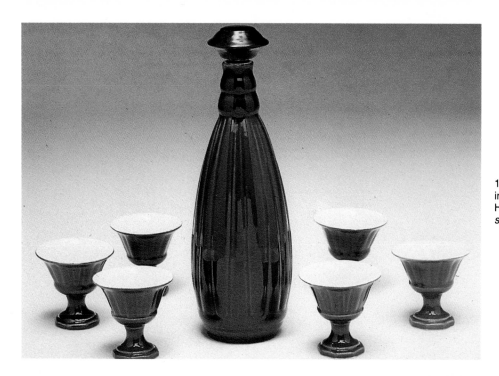

1.57 Liquor set by R. Guy Cowan Introduced in 1930 with a pair of decanters and six glasses, H. 10 in. *Courtesy of the Cowan Pottery Museum, photo Larry Peltz*

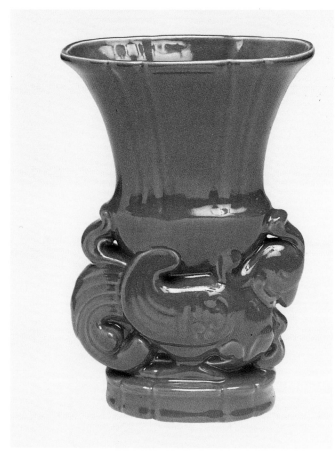

1.59 Chinese Bird vase by R. G. Cowan #V-747 vase with stylized bird in the style of an archaic Chinese bronze, first prize winner of 1927 May Show, this example glazed in peacock, H. 11 in., with impressed circular mark COWAN RG and COWAN. *Courtesy of the Cowan Pottery Museum, photo Larry Peltz*

1.58 Aztec Man lamp base Stylized symmetrical figure with metallic glaze, in the style of or designed by Waylande Gregory, and representative of geometric and angular Art Deco, in contrast to the curvilinear and more naturalistic Art Deco flower frogs, H. 12 in., with impressed circular mark COWAN RG. *Courtesy of the Cowan Pottery Museum, photo Larry Peltz*

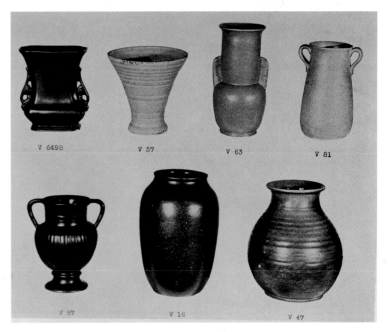

1.61 *Logan vase*, top left, from 1929 catalog.

1.60 **Logan vase** Winner of the (Mr. and Mrs. Frank H.) Logan Medal and $25 prize in 1924, it has come to be called the *Logan vase*, black glaze, #649-B, H. 8 in., with impressed circular mark COWAN RG and COWAN. *Courtesy of the Cowan Pottery Museum, photo Larry Peltz*

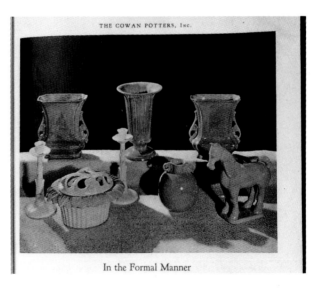

1.62 *Logan vase* from 1931 catalog.

1.63 Pink vase #V-932, designed in 1929 and mounted on a ceramic stand intended to look like a Chinese wooden one, vase H. 8 in., with impressed circular mark COWAN RG and COWAN. *Courtesy of Ralph and Terry Kovel*

1.64 Ivy jar in black, H. 8 in. *Courtesy of the Cowan Pottery Museum, photo Larry Peltz*

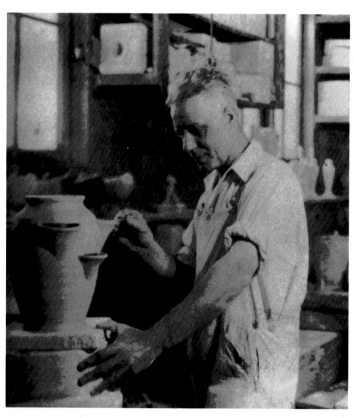

1.65 R. Guy Cowan adding the final touches to an ivy jar introduced in 1930, adapted from the design of an Italian strawberry jar. *Courtesy of the Cowan Pottery Museum*

36 POTTERY: Modern Wares

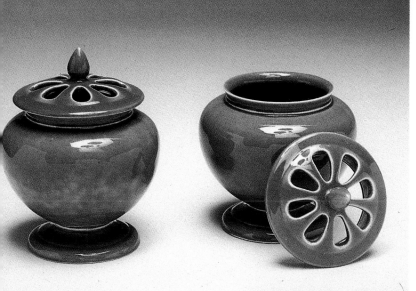

1.66 Covered vases #934 with cut-out or pierced design on the lids, blue glaze, circa 1929, H. 7 in., with impressed circular mark COWAN RG. *Courtesy of the Cowan Pottery Museum, photo Larry Peltz*

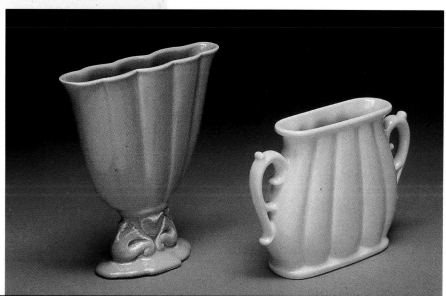

1.67 Mantle vases, left in pastel green, right yellow, H. 5 in. *Courtesy of the Cowan Pottery Museum, photo Larry Peltz*

1.68 Table arrangement with candle holders and bowls. *Courtesy of the Cowan Pottery Museum, photo Larry Peltz*

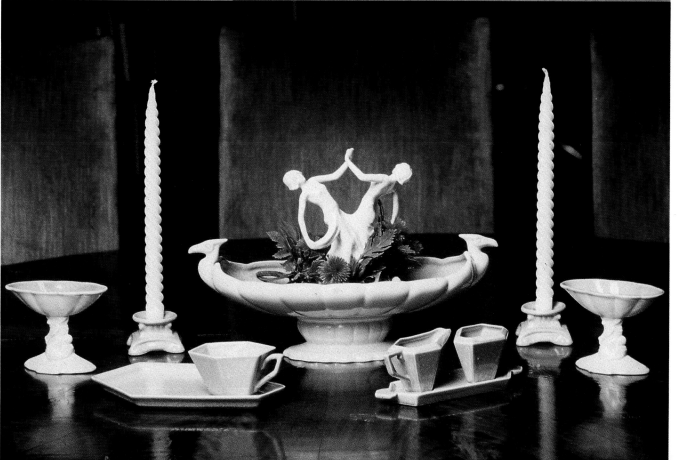

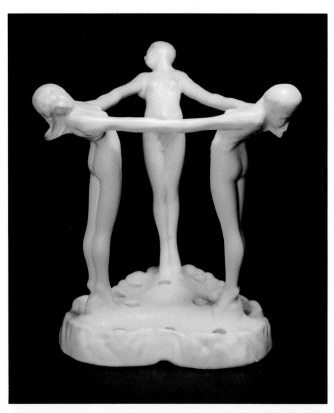

1.69 Three nude dancing maidens, flower frog glazed in ivory, H. 6 1/2 in. *Courtesy of Ralph and Terry Kovel*

1.70 **Flower frog figurines** *Swirling Scarf Dancer,* right, first prize in the 1925 May Show, together with three other similar figures, glazed in ivory, with impressed circular marks COWAN RG. *Courtesy of the Cowan Pottery Museum, photo Larry Peltz*

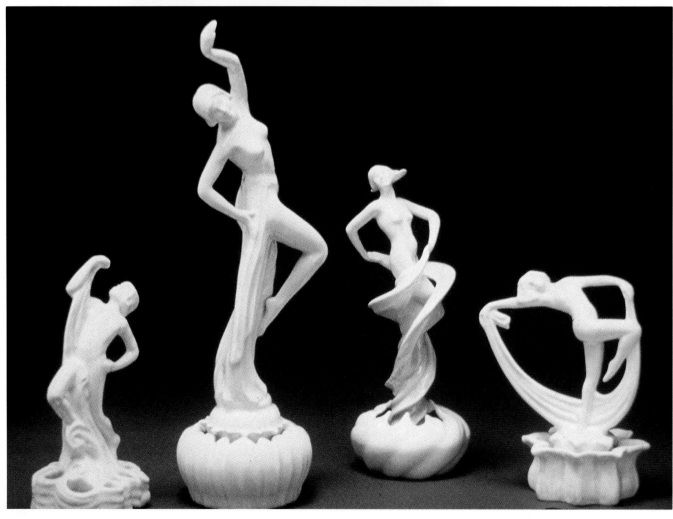

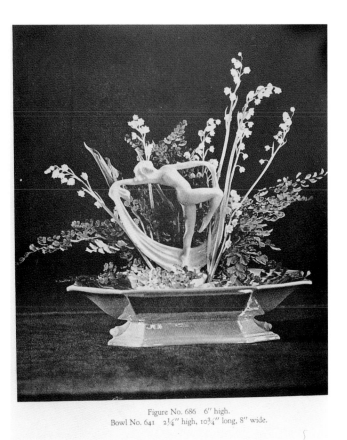

Figure No. 686 6" high.
Bowl No. 641 2¼" high, 10¾" long, 8" wide.

1.71 Page from 1930 catalog with *Swirling Scarf Dancer.*

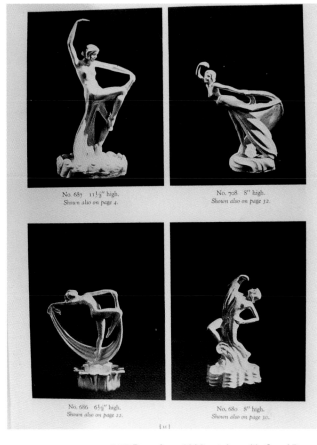

No. 687 11½" high.
Shown also on page 4.

No. 708 8" high.
Shown also on page 32.

No. 686 6½" high.
Shown also on page 22.

No. 680 8" high.
Shown also on page 30.

1.72 Page from 1926 catalog with *Scarf Dancers.*

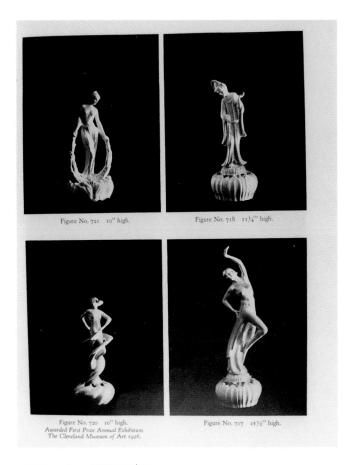

Figure No. 721 10" high.

Figure No. 718 11¾" high.

Figure No. 720 10" high.
*Awarded First Prize Annual Exhibition
The Cleveland Museum of Art 1926.*

Figure No. 717 15½" high.

1.73 Page from 1926 catalog.

Figure No. 685 7½" high, 6½" wide.
Bowl No. 690 3½" high, 15½" long, 8" wide.

THE loops formed by the arms and draperies of these two dancing figures and the irregularly placed holes in the base makes possible a wide variety of interesting flower arrangements of which this is typical. In the illustration columbine and sweet peas are used. The effective use of a low fluted bowl becomes possible with such figures.

The cost of the flowers shown is less than fifty cents, and the setting is one of great distinction, smartness and beauty.

1.74 Page from 1926 catalog.

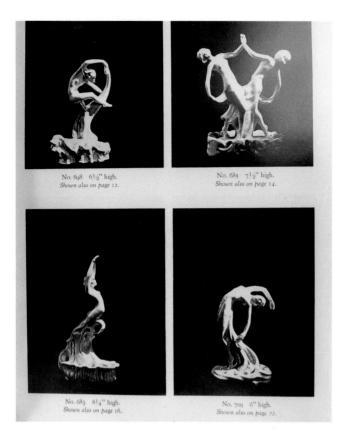

No. 698 6½" high.
Shown also on page 12.

No. 685 7½" high.
Shown also on page 14.

No. 683 8¼" high.
Shown also on page 16.

No. 709 6" high.
Shown also on page 22.

1.75 Page from 1925 catalog.

1.76 Page from 1930 catalog.

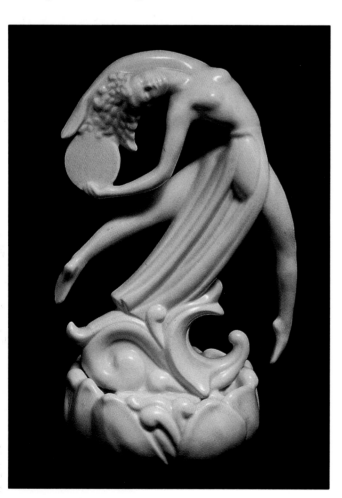

1.77 Graceful, flowing, curvilinear Art Deco design of dancing figure intended as a flower frog. H. 10 in. *Courtesy of the Cowan Pottery Museum, photo Larry Peltz*

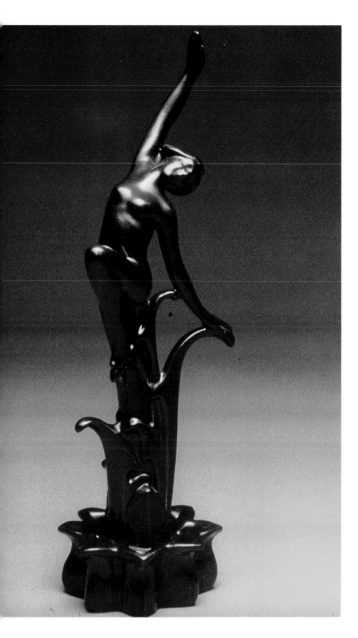

1.78 Flower frog figurine in vertical design, glazed in black, H. 15 in. *Courtesy of the Cowan Pottery Museum, photo Larry Peltz*

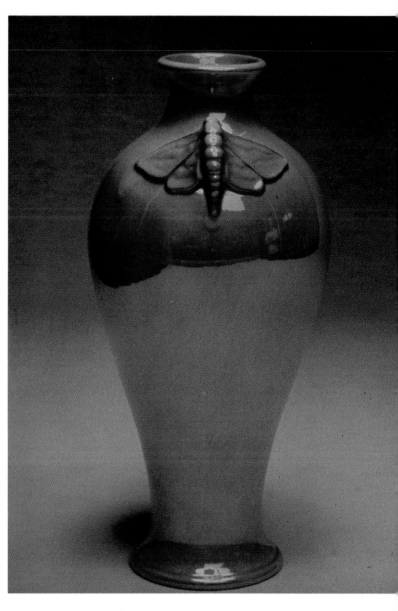

1.79 Lamp base in the shape of a vase with a molded moth motif, high gloss orangy glaze, H. 12 1/2 in. *Courtesy of the Cowan Pottery Museum, photo Larry Peltz*

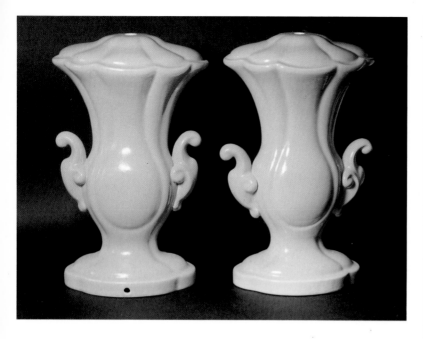

1.80 Pair of robin's-egg-blue lamp bases, #V-93, in the form of covered vases with applied scroll handles, circa 1930, H. 11 1/2 in. impressed COWAN.

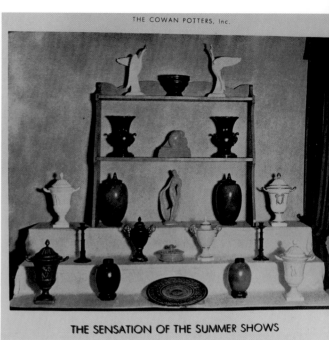

THE SENSATION OF THE SUMMER SHOWS

1.82 Page from 1930 catalog.

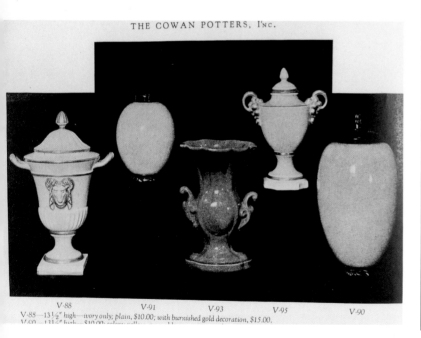

THE COWAN POTTERS, I'NC.

V-88 V-91 V-93 V-95 V-90
V-88—13½" high—ivory only; plain, $10.00; with burnished gold decoration, $15.00.

1.81 Vases in same design as lamp bases from 1931 catalog.

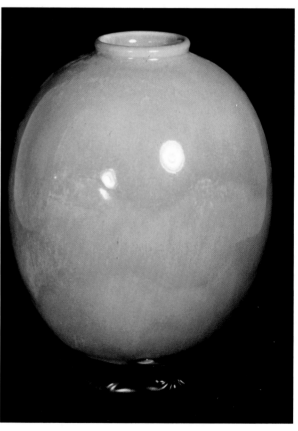

1.83 Mottled pink glossy glazed lamp, #V-91, circa 1930, on ceramic Chinese style stand, H. 7 in., with impressed circular mark COWAN RG and COWAN. *Courtesy of Ralph and Terry Kovel*

42 POTTERY: Modern Wares

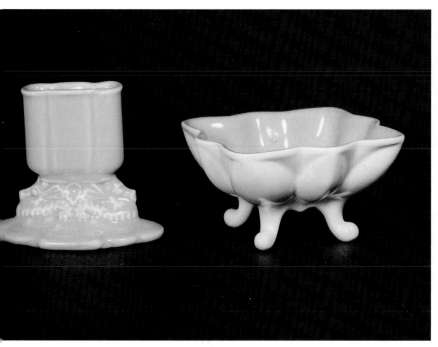

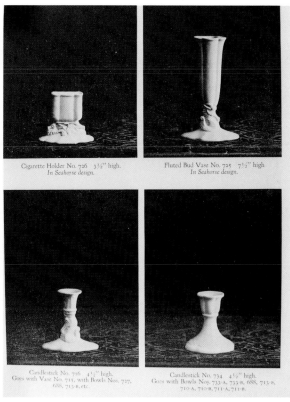

1.84 Green cigarette holder #726, circa 1926, H. 3 1/2 in., with four-legged bowl in ivory with pink interior, W. 4 1/2 in., both with impressed circular mark COWAN RG. *Courtesy of Ralph and Terry Kovel*

1.85 Cigarette holder in 1926 catalog.

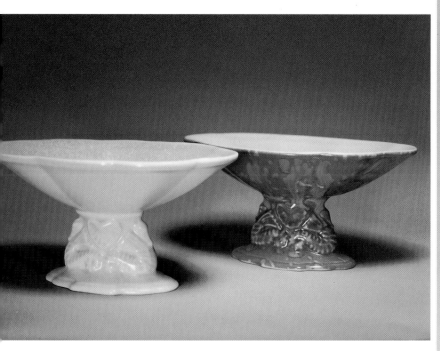

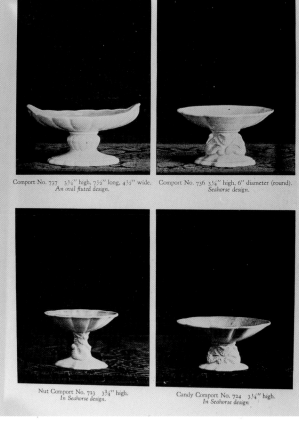

1.86 Seahorse comports in white with pink interior (left) and mottled blue with lavender interior (right), H. 4 in. W. 6 1/2 in., with impressed circular mark COWAN RG.

1.87 Seahorse comports in 1926 catalog.

Cowan and other Ohio Potteries 43

1.88 Art Deco footed bowls with black exterior and green interior, small D. 5 3/8 in., large #845-B, D. 13 in., each circa 1929 and with impressed circular mark COWAN RG and COWAN.

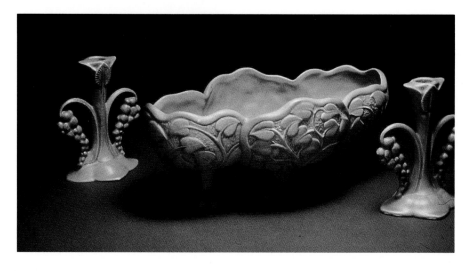

1.89 Pink bowl, L. 16 in. and candlesticks, H. 7 1/2 in. *Courtesy of the Cowan Pottery Museum, photo Larry Peltz*

1.90 Ivory candelabra and blue single candleholders. *Courtesy of the Cowan Pottery Museum, photo Larry Peltz*

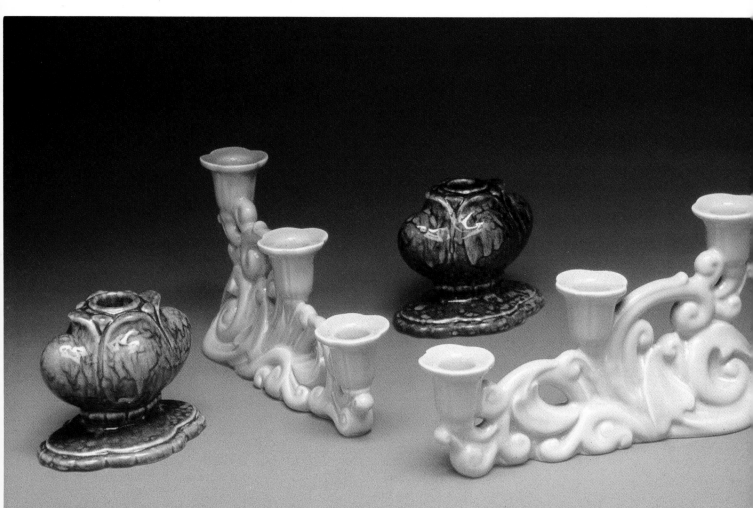

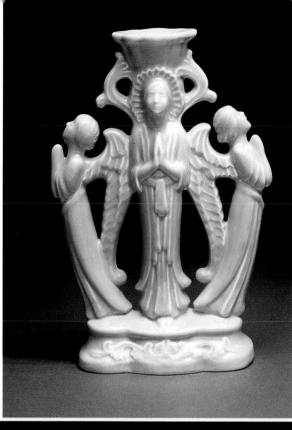

1.91 **Byzantine angel candleholder** #746 in light turquoise with three angels, circa 1928, H. 9 in. *Courtesy of the Cowan Pottery Museum, photo Larry Peltz*

1.92 Assorted candleholders. *Courtesy of the Cowan Pottery Museum, photo Larry Peltz*

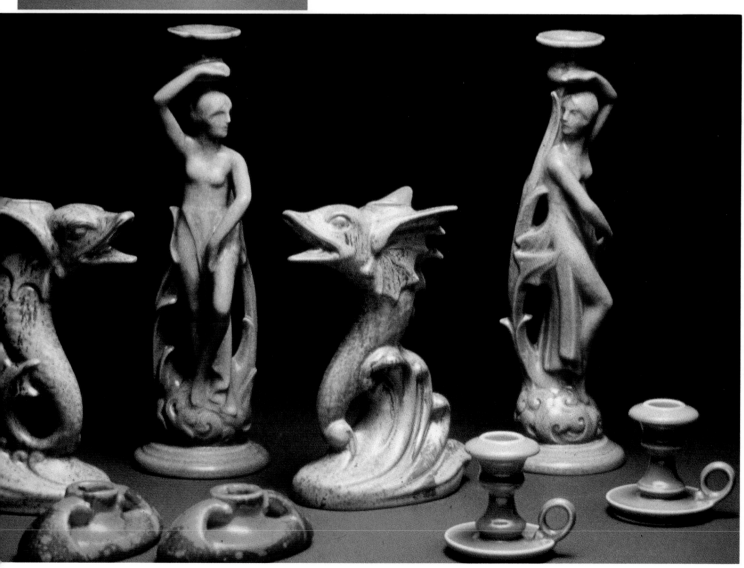

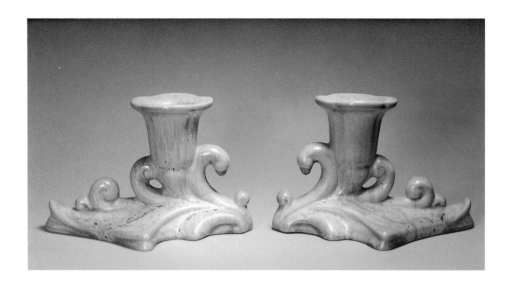

1.93 Candleholders in mottled green, or verde, #782, circa 1928, L. 5 in., H. 3 in., impressed COWAN.

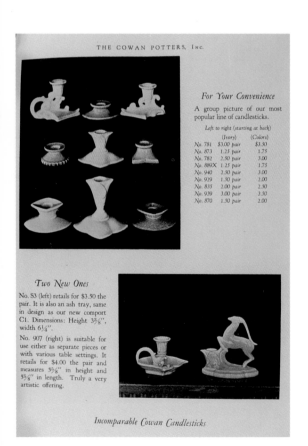

THE COWAN POTTERS, Inc.

For Your Convenience

A group picture of our most popular line of candlesticks.

Left to right (starting at back)

	(Ivory)	(Colors)
No. 781	$3.00 pair	$3.50
No. 873	1.25 pair	1.75
No. 782	2.50 pair	3.00
No. 889X	1.25 pair	1.75
No. 940	2.50 pair	3.00
No. 929	1.50 pair	2.00
No. 835	2.00 pair	2.50
No. 939	3.00 pair	3.50
No. 870	1.50 pair	2.00

Two New Ones

No. S3 (left) retails for $3.50 the pair. It is also an ash tray, same in design as our new comport C1. Dimensions: Height 3⅜", width 6¼".

No. 907 (right) is suitable for use either as separate pieces or with various table settings. It retails for $4.00 the pair and measures 5⅜" in height and 5⅝" in length. Truly a very artistic offering.

Incomparable Cowan Candlesticks

1.94 Candleholders from 1930 catalog.

1.95 **Radio lady** #853 circa 1929 with wide draped cape, H. 9 in., with impressed circular mark COWAN RG. *Courtesy of the Cowan Pottery Museum, photo Larry Peltz*

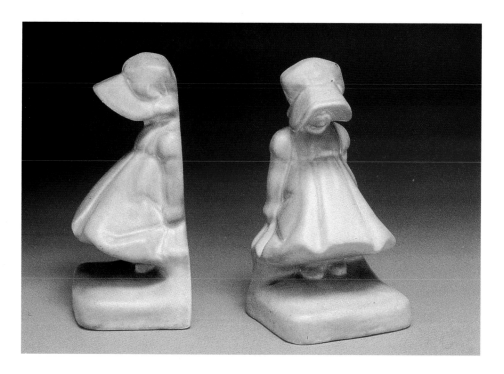

1.96 **Sunbonnet girl** bookends #521 of storybook type figures of little girls, H. 7 in. *Courtesy of the Cowan Pottery Museum, photo Larry Peltz*

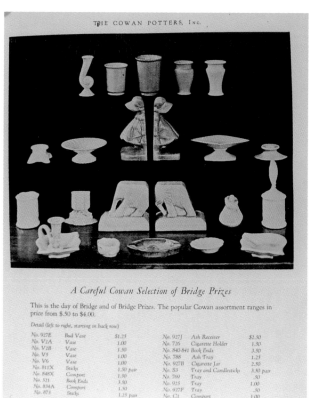

1.97 **Sunbonnet girl** in 1929 catalog.

1.98 **Alice in Wonderland** door knobs with polychrome decoration depicting subjects from the book. *Courtesy of the Cowan Pottery Museum, photo Larry Peltz*

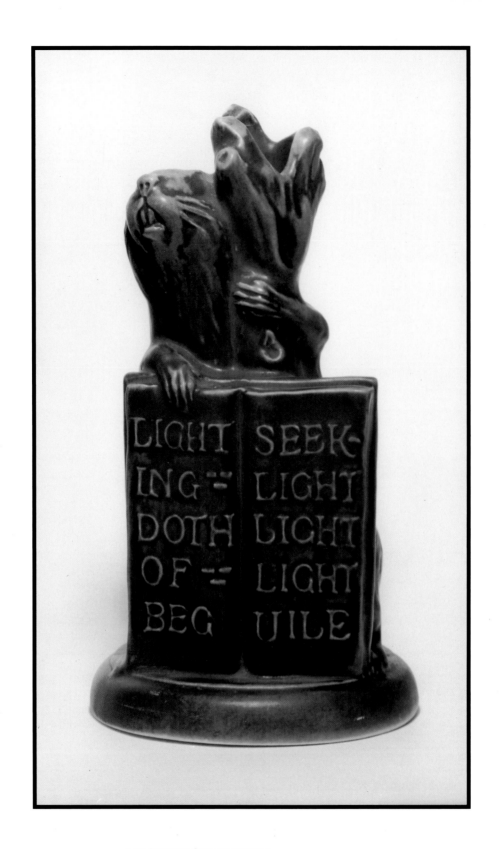

1.99 Rowfant Club groundhog
Little groundhog holding a book, commissioned by the Rowfant Club and designed by Frank Wilcox, with molded inscription, "Light Seeking Light Doth Light of Light Beguile," glazed in very dark green, H. 9 1/4 in., written in ink at the base ROWFANT CLUB 1925 #64 OF 156 COPIES R. G. COWAN. *Courtesy of Ralph and Terry Kovel.*

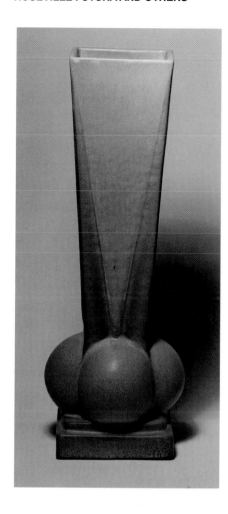

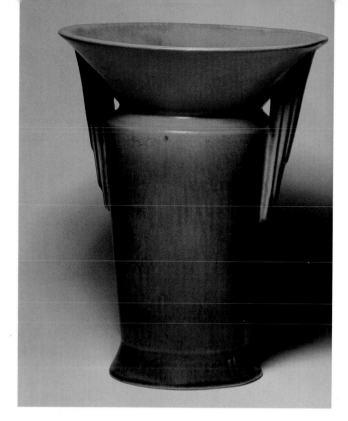

1.101 Roseville Futura #426 Art Deco vase
Pumpkin color flared bowl-shaped mouth on a
tapered cylindrical vase in dull green, connected
by straight reeded handles, 1928, H. 8 in. *Mary
Brandwein collection, courtesy of the Everson
Museum of Art*

1.100 Roseville Futura #393 Art Deco vase
The Roseville Pottery Company, in Zanesville,
Ohio, operated from 1892 to 1954. The Futura
series is the most desirable of several Art Deco
lines made by Roseville. The shapes and col-
ors are modern and sophisticated as exempli-
fied by this deep ochre and rusty tan four-sided
tall narrow vase, the base shaped with four half
spheres resting on a square platform, 1928, H.
12 in. *Mary Brandwein collection, courtesy of
the Everson Museum of Art*

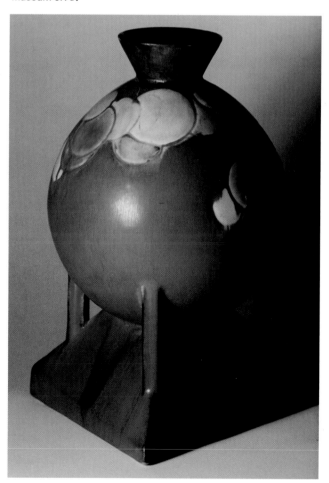

1.102 Roseville Futura #404 Art Deco vase
Blue globe-shaped vase with multi-colored
circles, mounted on a pyramidal base with four
straight handles, 1928, H. 8 in. *Mary Brandwein
collection, courtesy of the Everson Museum of
Art*

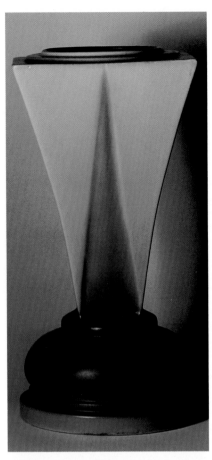

1.103 **Roseville Futura #392 Art Deco vase**
Deep green and light turquoise four-sided vase with flared top and squat globular or bun shaped base, 1928, H 10 in. *Mary Brandwein collection, courtesy of the Everson Museum of Art*

1.104 **Roseville Futura #386 Art Deco vase**
Tiered rectangular vase resembling a form used in architecture as well as other decorative arts, such as Paul Frankl's "skyscraper" bookcases, decorated with a pink and green diamond motif, with two straight handles, 1928, H. 8 in. *Mary Brandwein collection, courtesy of the Everson Museum of Art*

1.105 **Roseville Futura Art Deco vase**
Accordion-pleated vase tapered to a circular base in dull green and pink, 1928, H. 8 in. *Mary Brandwein collection, courtesy of the Everson Museum of Art*

1.106 Roseville Futura Art Deco vase
Four-sided vase with tapered sides, mounted on a circular base in pink with dark green geometric motif, 1928, H. 8 in. *Mary Brandwein collection, courtesy of the Everson Museum of Art*

1.107 Roseville Futura group

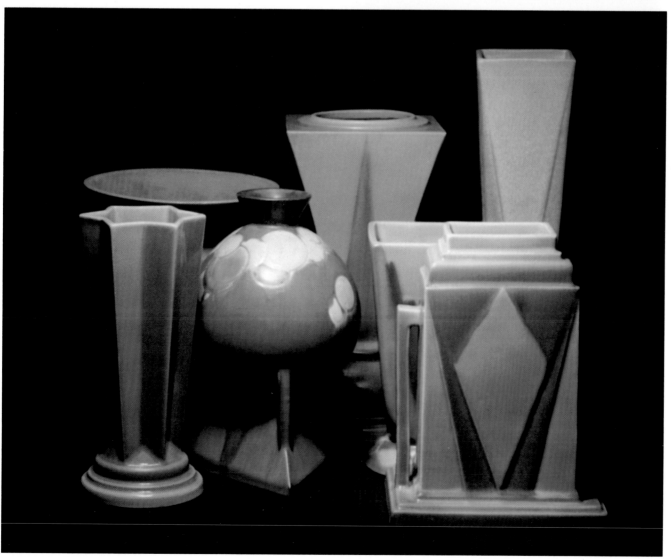

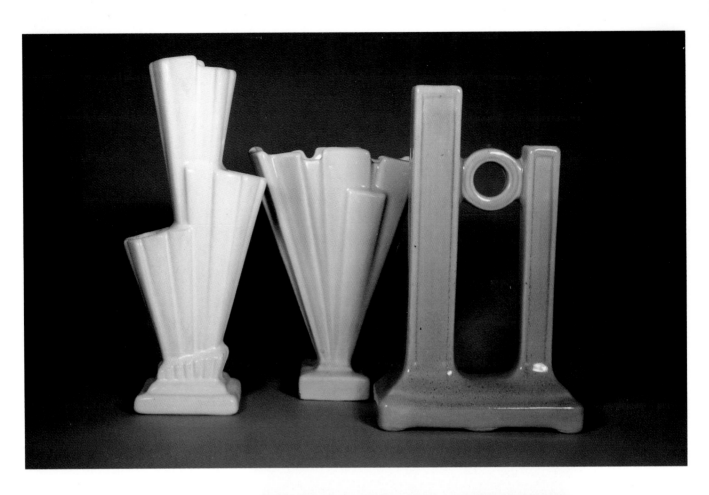

1.108 Weller Lorbeek Art Deco vases
Weller, another important Zanesville, Ohio pottery (1872 to 1948), also made several Art Deco lines. These single-color modernistic vases are called Lorbeek. Left, white, H. 8 1/2 in; center, pink, H. 6 1/2 in.; and right, green, H. 8 in. *Courtesy of Studio Moderne*

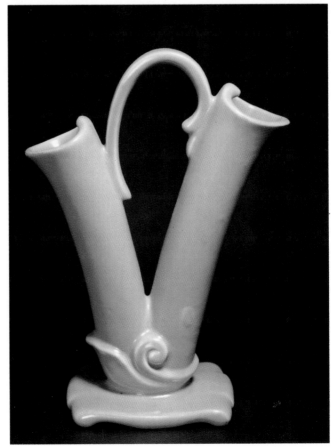

1.109 Weller Softone vase Where the angularity of the preceding vases resembled Roseville Futura, the softer curved shape, pastel color, and semimatte glaze of this Softone vase from the 1930s is more like a Cowan Pottery design. H. 9 in. impressed WELLER. *Courtesy of Ralph and Terry Kovel*

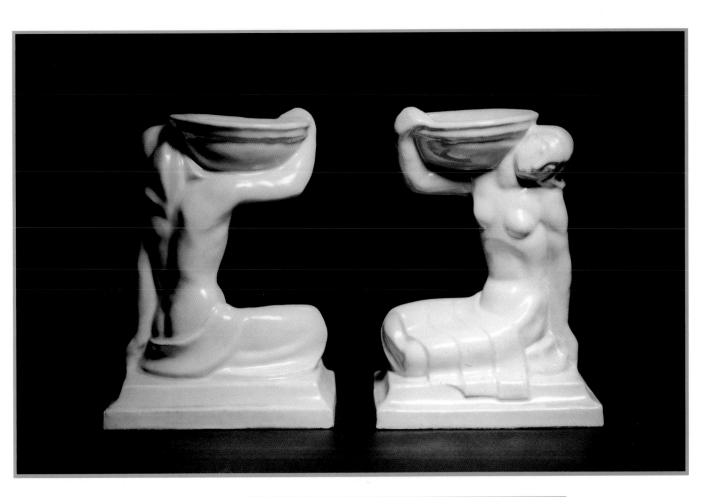

1.110 American Encaustic Art Deco figurines Among the many potteries in Zanesville, Ohio was the American Encaustic Tiling Co., which operated from 1875 to 1935. Although they specialized in tiles, they also produced artware, such as these molded figurines resembling those made by Cowan. H. 7 in., impressed AETCO. *Courtesy of Ralph and Terry Kovel*

1.111 Rookwood Art Deco vase No discussion of Ohio art pottery could be complete without mentioning Rookwood of Cincinnati (1880 to the 1950s). Although best known for their earlier and often exceptional hand painted vases, this modern molded example, with a stylized fish and single turquoise glaze, is consistent with the later fashion for simpler designs. H. 7 1/2 in., impressed Rookwood mark with XXXI for 1931 and the numbers 6215. *Collection of Mitchell Attenson*

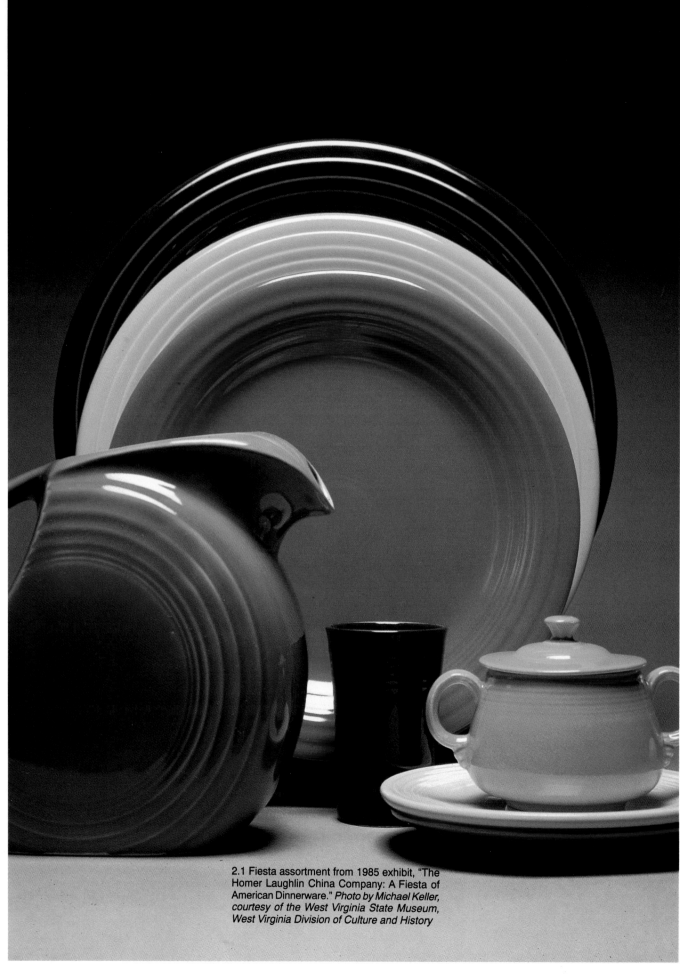

2.1 Fiesta assortment from 1985 exhibit, "The Homer Laughlin China Company: A Fiesta of American Dinnerware." *Photo by Michael Keller, courtesy of the West Virginia State Museum, West Virginia Division of Culture and History*

Chapter Two
Homer Laughlin's Fiesta

In March 1985, the West Virginia Department of Culture and History gave the public a visual treat at the Cultural Center in Charleston. Homer Laughlin's well-known and well-loved Fiesta line was about to celebrate its golden anniversary with the opening of a two-year exhibit, "The Homer Laughlin China Company: A Fiesta of American Dinnerware." Most of the following historical information was summarized from Jack Welch, "The Homer Laughlin China Company," which was reprinted in a promotional package accompanying the exhibit.

The Homer Laughlin China Company began in East Liverpool, Ohio in response to a City Council competition. A $5,000 prize was offered to the first entrepreneur to start a four-kiln factory for the manufacture of white pottery (preferred over the common yellow pottery from local clays). On September 1, 1873, the brothers Homer and Shakespeare Laughlin took the prize and opened their factory on September 1, 1874. A slow, problem-plagued beginning turned around and they won a medal in the 1876 Philadelphia Centennial for the best whiteware in the exhibition. Shakespeare Laughlin sold his share of the company in 1877, leaving Homer to deal with intense foreign competiton, especially from England. An early logo depicting an American eagle attacking a British lion symbolized this struggle.

The development in 1886 of a translucent and vitreous true china was a milestone achievement. Formal china dinnerware made available to a mass market became the key to Laughlin's early success. In 1897 Homer Laughlin, by then a wealthy man, sold the business to his bookkeeper, W. E. Wells, and Louis J. Aaron and his sons Marcus and Charles. The new team enlarged the factory in 1889 and again in 1891, resulting in a total of 32 kilns. The next expansion took the plant across the Ohio River to Newell, West Virginia. A newly acquired three-mile-long tract of land supported the factory expansion plus a water system, new streets, subdivision with building lots, and a 100-acre recreational park with a lake, zoo, and theater.

By 1905 a new metal suspension bridge was completed in order to connect the two halves of the company on each side of the river. The 15 acres of plant floor space at the new factory made it the largest pottery plant constructed in its day. It boasted 62 firing kilns and 48 decorating kilns with a daily capacity of 300,000 finished pieces by 1907. A 1914 expansion added another 16 kilns.

If Homer Laughlin's first major breakthrough was the development of affordable true china, the company's second was the construction of tunnel kilns. Until then, only bottle kilns were used, with the inherent need to shut down and cool for unloading. Continuous firing of the new tunnel kiln, with the wares passing through progressively hotter then cooler sections over a 55-hour period, increased efficiency 500 per cent. Plant number six was 290 by 800 feet plus a basement, followed by two more plants with number eight measuring 300 by 1,200 feet. Some of the earliest plants on the Ohio side were outdated and phased out. Peak employment at the five Newell plants in the 1920s was 3,500 people.

In 1927, renowned English ceramicist Frederick Hurten Rhead (1880-1942) was hired to improve the artistic quality of the dinnerware. Born in Staffordshire, England, Rhead came to the United States in 1902. Before joining Homer Laughlin, he was art director of Weller Pottery in Zanesville, Ohio; worked at University City Pottery in St. Louis, Missouri; and Arequipa near San Francisco, California; ran his own studio called Rhead Pottery in Santa Barbara, California; and worked for American Encaustic Tiling Company in Zanesville from 1917 to 1927. He began at Homer Laughlin by designing traditional lines such as "Newell" and "Virginia Rose." His most famous design is, of course, the geometric and almost Art Deco line of 1935 named "Fiesta." Even more dramatic than the modern shapes with concentric circles were the vivid colors. Brilliant Chinese red-orange (called red), royal or cobalt blue, yellow, medium green (one of five shades of green used during the years of production), and ivory were not new or even particularly Art Deco colors (although the uranium used to make the red until 1943 gave it a unique quality), but when combined, the results seemed new. Red was the original anchor color, followed by blue and then the others, to create the desired contrasting palette. Ivory, added in 1936, was the last of the original colors. A sixth color, turquoise, was introduced in 1937. The ideal combination of richly colored glazes on a surface of streamlined circles and ridges invited new pieces into the line. Tom and Jerry mugs, egg cups, tumblers, three sizes of flower vases, compotes, and candleholders were some of the new items.

Early marks were either impressed in the clay or stamped in black ink. If imitation indicates success, then the Fiesta line was an instant winner. In order to assure the consumer that they were purchasing the original, the word "genuine" was added to the ink stamp. One way to distinguish genuine Fiesta from its imitators is by looking at the rings. The spaces between genuine Fiesta rings gradually get smaller, whereas rings on copies are generally equally spaced. Unmarked pieces include salt and pepper shakers, most cups and juice glasses, and later pieces from the 1960s on, such as plates.

According to Bob and Sharon Huxford (*Collector's Encyclopedia of Fiesta, 7th ed.*), the original blue, green, and ivory were replaced by forest green, rose, chartreuse, and grey in 1951, and turquoise and yellow remained in the line. In 1959 the original red-orange was reintroduced, complete with uranium oxide. Medium green returned, but rose, grey, chartreuse and dark green were dropped. However, according to Lois Lehner

(*Lehner's Encyclopedia of U. S. Marks on Pottery, Porcelain, & Clay*), blue, rose, grey, chartreuse, and olive green were added in 1943.

In 1939 a bake and serve Fiesta Kitchen Kraft line included pie and cake plates, cake server, covered casseroles, mixing bowls, and refrigerator sets. In 1969 the original Fiesta was restyled and the Fiesta Ironstone line was introduced and made in only three colors: mango red, turf green, and antique gold. Ironstone sugar bowls are without handles, cup handles are only partial rings, and formerly straight bowl sides are tapered. It was phased out in 1972. Another popular Rhead design, Harlequin, was added in 1938 and sold exclusively at Woolworth stores. Although not marked, it can be identified by color and shape. Phased out in 1964, Harlequin was reissued in 1979.

After Rhead died in 1942, other designers and art directors made significant contributions. Don Schreckengost (brother of Viktor) was art director during the company's peak, when in 1948 over ten million dozen dishes were produced. Schreckengost was responsible for "Jubilee" and a line of fine china called "Triumph." However, this giant of a company, responsible for bringing affordable, good quality, mass produced dinnerware to the American public for more than a century, is best known for its carnival-colored Fiesta line. In 1986 its reintroduction celebrated the 50th anniversary of a consuming and collecting phenomenon. The original line is said to have been purchased by more Americans than any dinnerware line in U. S. history (Russel Wright's American Modern [see Chapter Three] was produced for only twenty years).

The 1986 colors are black, white, cobalt blue, rose, and apricot, and the original molds are being used again with a few modifications. For example, plates, soup bowls, and salad bowls are slightly larger, while some accessory pieces are slightly smaller. Periwinkle blue, turquoise, and yellow were added in 1989. Most of the following examples of Fiesta are in the original colors.

2.2 The West Virginia State Museum, which held the Fiesta exhibit, was also the site of the 1986 reintroduction of the Fiesta line. *Photo by Michael Keller, courtesy of the West Virginia State Museum, West Virginia Division of Culture and History*

PRICE LIST
(Per Piece) January 2, 1962

WARE	Green Turquoise Yellow	Red
Ash Trays	$.50	$.60
Casseroles, Cov'd.	3.30	4.05
Chop Plates, 13"	2.00	2.50
Creams	1.05	1.40
Deep Plates, 8"85	1.05
Disc Water Jugs, 2 qt. ..	3.00	3.80
Fruits, Large, 5½"50	.60
Nappies, 8½"	1.25	1.70
Pepper Shakers75	.95
Plates, 10"	1.05	1.35
Plates, 9"85	1.10
Plates, 7"65	.85
Plates, 6"55	.65
Platters, 12"	1.90	2.30
Salad Bowls, Ind.	1.10	1.40
Salt Shakers75	.95
Sauceboats	1.60	2.10
Sugars, Cov'd.	1.80	2.25
Tea Cups80	1.00
Tea Saucers40	.50
Tea Pots, Medium 6 Cups	3.00	3.60
Tom and Jerry Mugs80	1.05

2.3 Fiesta 1962 price list. *Collection of Ralph and Terry Kovel*

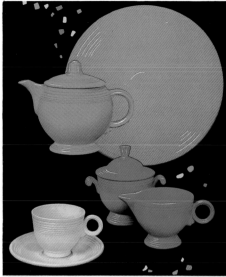

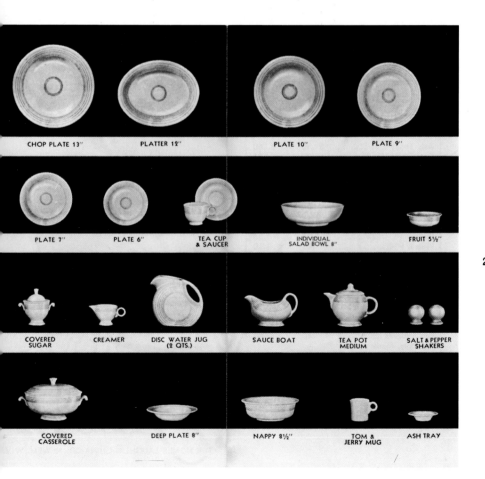

2.4 Illustrations for 1962 price list.

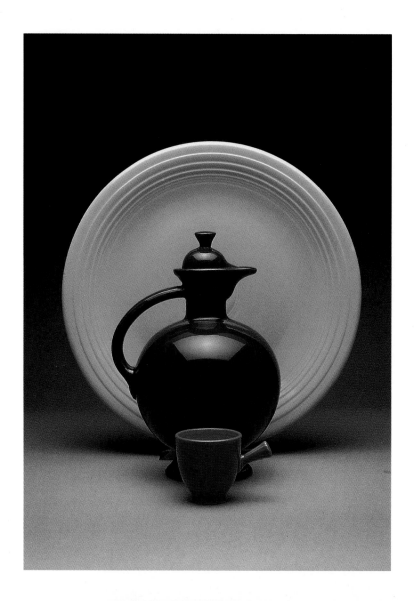

2.5 This chop plate, carafe, and demitasse cup were pictured on the cover of the article by Jack Welch which was included in the promotional package accompanying the 1985 exhibit. *Photo by Michael Keller, courtesy the West Virginia State Museum, West Virginia Division of Culture and History*

2.6 Postcard from the 1985-86 exhibit with sugar bowl, salt and pepper shakers, carafe, creamer, and chop plate. *Photo by Michael Keller, courtesy of the West Virginia State Museum, West Virginia Division of Culture and History*

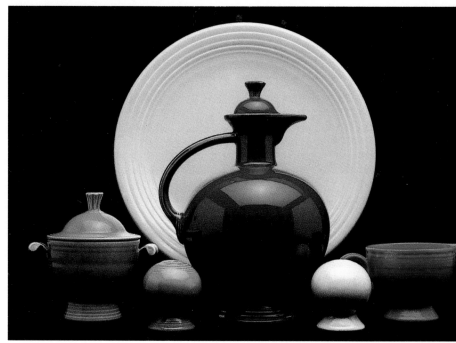

2.7 Dinnerware and serving pieces. *Photo by Michael Keller, courtesy of the West Virginia State Museum, West Virginia Division of Culture and History*

2.8 Relish tray. *Photo by Michael Keller, courtesy of the West Virginia State Museum, West Virginia Division of Culture and History*

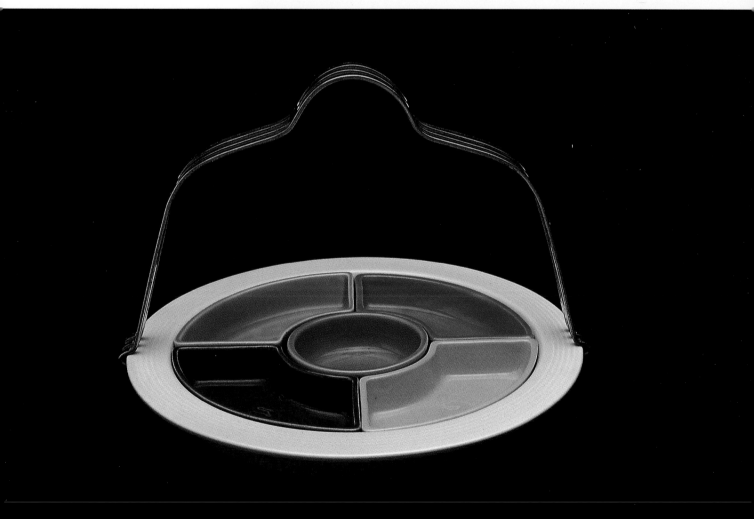

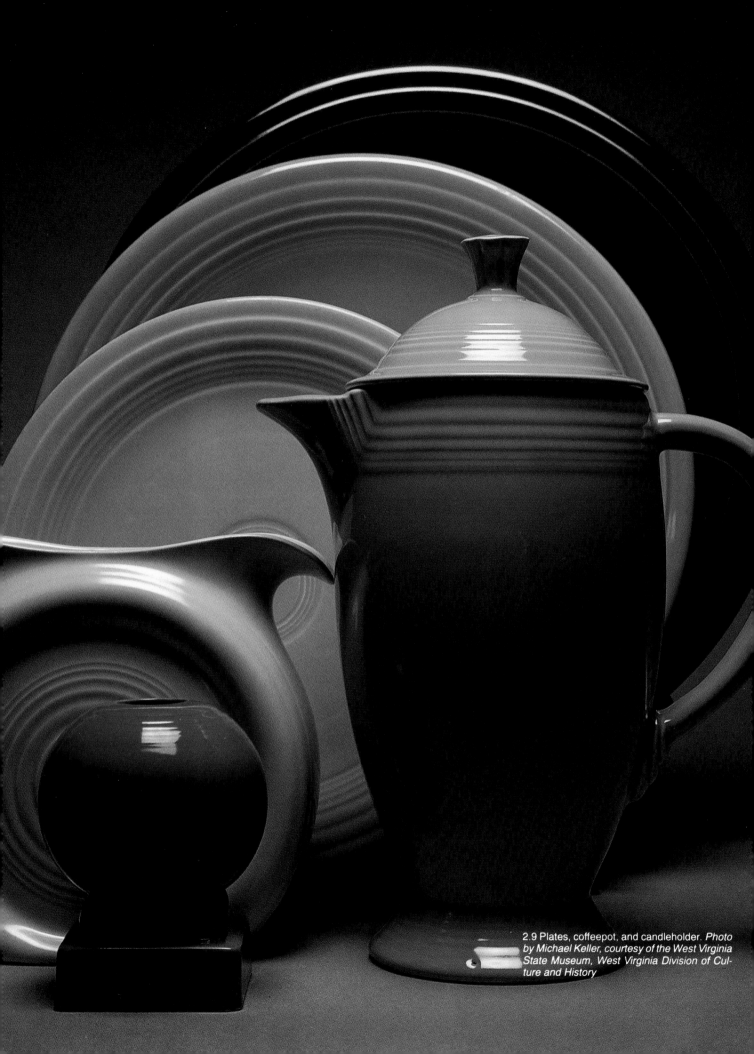

2.9 Plates, coffeepot, and candleholder. *Photo by Michael Keller, courtesy of the West Virginia State Museum, West Virginia Division of Culture and History*

2.10 Dinner plates in original red, blue, yellow, and green, D. 9 1/2 in., ink stamp GENUINE FIESTA HLCo. U.S.A. (Stacking Fiesta must be a natural way to photograph pieces, because these photos, by Ravi Piña, were taken months before seeing Michael Keller's work.)

2.11 Left, 6-in. plates; center, 9-in. plates; right, 5-in. fruit bowls, all in original colors, ink stamp GENUINE FIESTA HLCo. U.S.A.

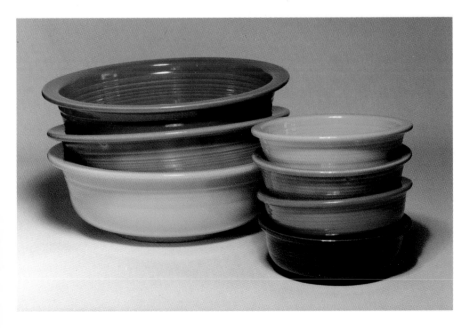

2.12 Left, 8 1/2-in. nappy, yellow impressed FIESTA MADE IN U.S.A.; right, 5-in. fruit bowls, impressed FIESTA MADE IN U.S.A. HLCo.

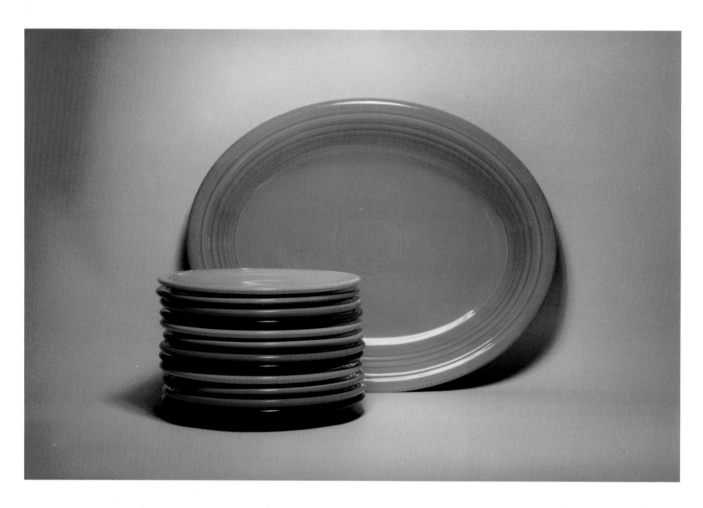

2.13 Serving platter in turquoise, L.
12 1/2 in., with ink stamp GENUINE FIESTA
HLCo. U.S.A. small plates in original colors.

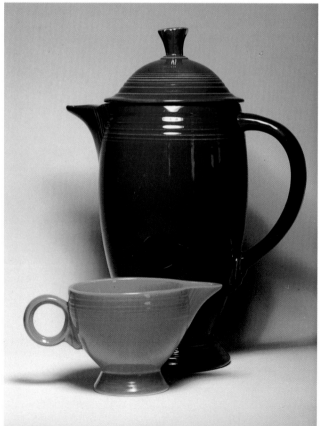

2.14 Blue coffeepot, H. 10 1/2 in., impressed
FIESTA MADE IN U.S.A., with red creamer, L.
6 in.

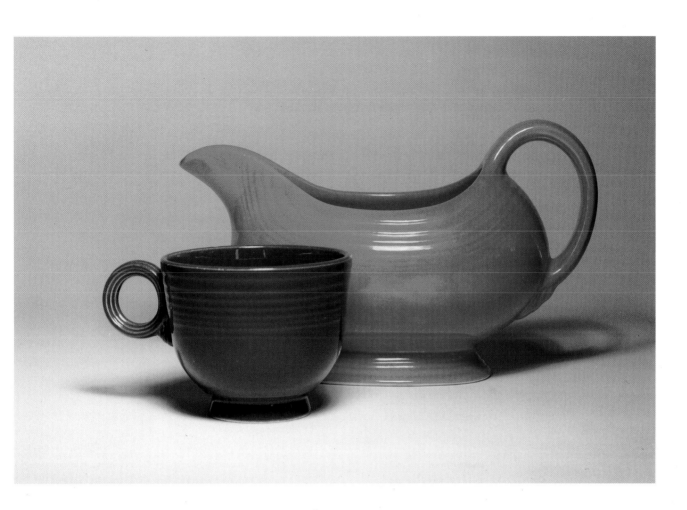

2.15 Blue unmarked cup, with red gravy or sauce boat, L. 8 1/2 in., impressed FIESTA MADE IN U.S.A.

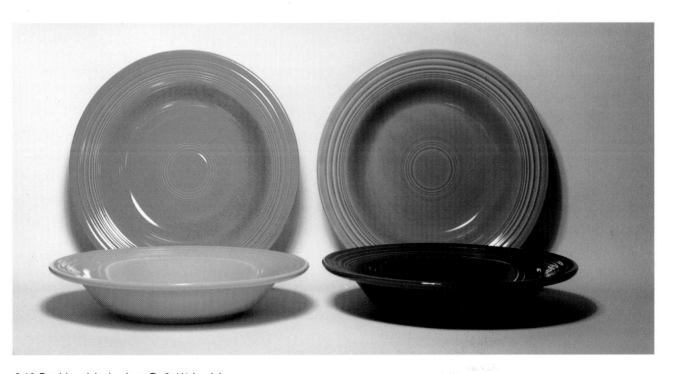

2.16 Bowl in original colors, D. 8 1/4 in., ink mark GENUINE FIESTA HLCo. U.S.A.

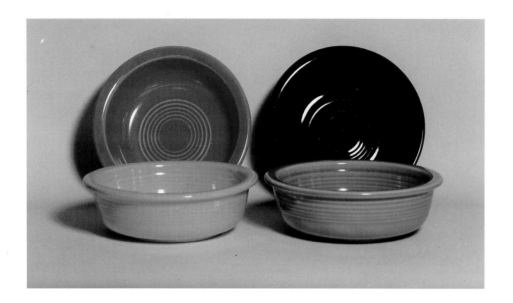

2.17 Red, blue, yellow, and green nappies, D. 8 3/4., ink mark FIESTA HLCo. U.S.A.

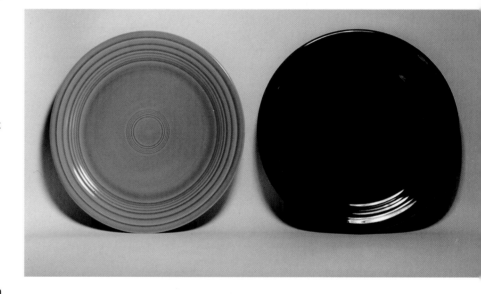

2.18 Green and blue plates, D. 9 1/2 in., ink mark GENUINE FIESTA HLCo. U.S.A.

2.19 Orange and yellow 9 1/2-in. plates with ink mark.

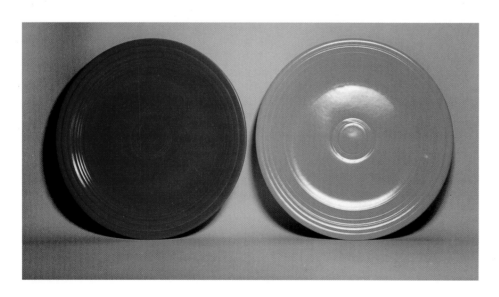

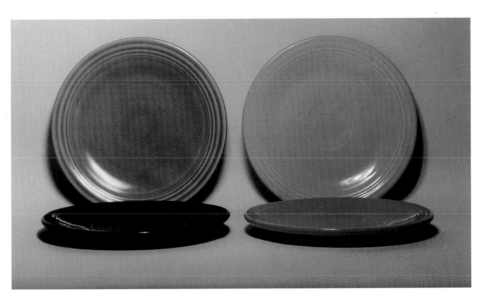

2.20 Plates, D. 6 1/4 in., ink mark GENUINE FIESTA HLC. U.S.A.

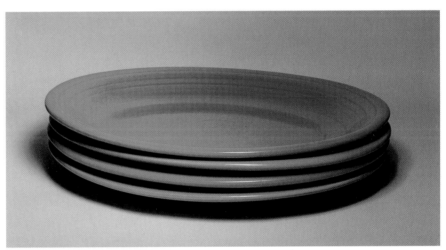

2.21 Oval serving plates in red (unsigned), yellow, and green with ink mark, L. 12 1/2 in.

2.22 Green creamer, L. 6 in., and sugar, both impressed FIESTA MADE IN U.S.A.; and celery or utility tray, L. 10 1/2 in., with ink mark GENUINE FIESTA HLCo. U.S.A.

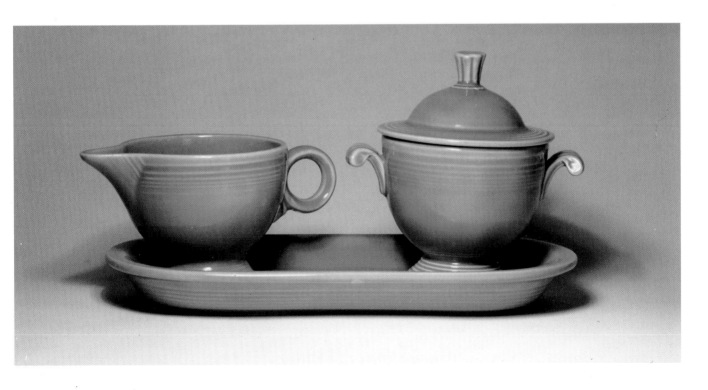

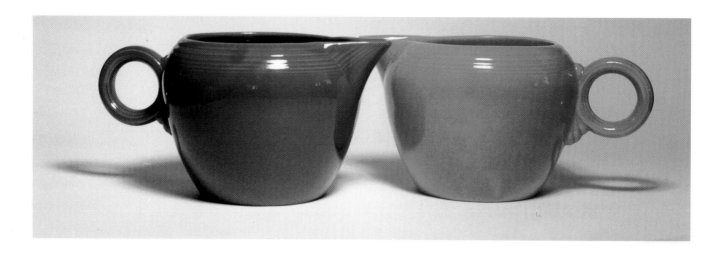

2.23 Blue and red 2-pint jugs, L. 8 1/2 in., impressed HLCo. FIESTA MADE IN U.S.A.

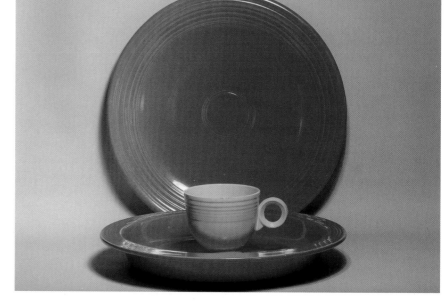

2.24 Top, red 10-in. plate with ink mark GENUINE FIESTA HLCo. U.S.A.; bottom, red bowl, D. 10 7/8 in., impressed FIESTA HLCo. U.S.A., with ivory cup.

2.25 Red unmarked platter, L. 12 1/4 in., and turquoise fruit bowl, D. 11 3/4 in., impressed FIESTA HLCo. U.S.A.

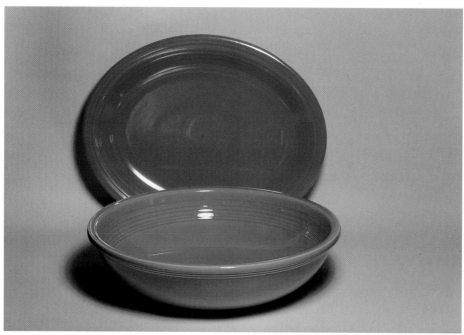

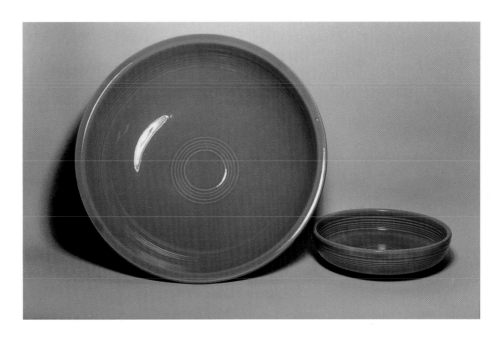

2.26 Turquoise fruit bowl, D. 11 3/4 in., and green dessert bowl, D. 6 in., both impressed FIESTA HLCo. U.S.A.

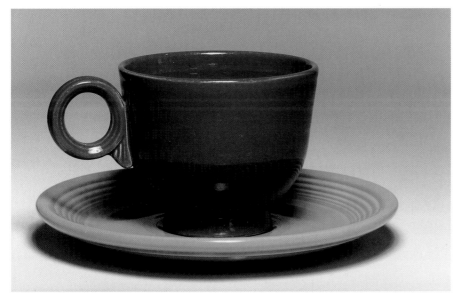

2.27 Blue cup and green saucer, unmarked.

2.28 Cups and saucers in original colors. The red is more of an orange.

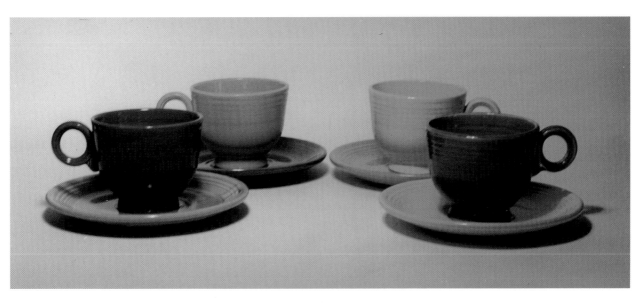

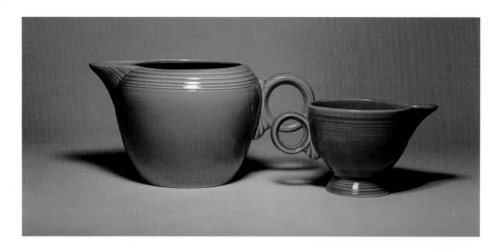

2.29 Green 2-pint jug with creamer, both with impressed mark.

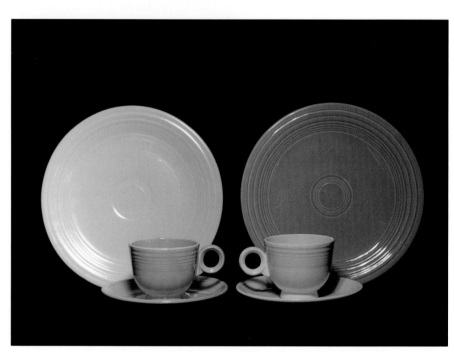

2.30 Cups and saucers with dinner plates. The chartreuse saucer has ink mark GENUINE FIESTA HLCo. U.S.A.

2.31 Cups and saucers in turquoise, ivory, and chartreuse.

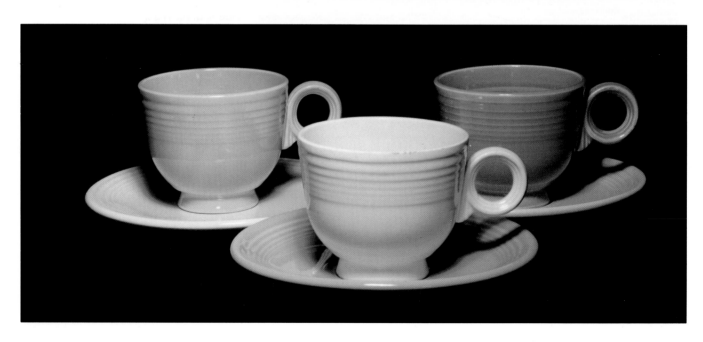

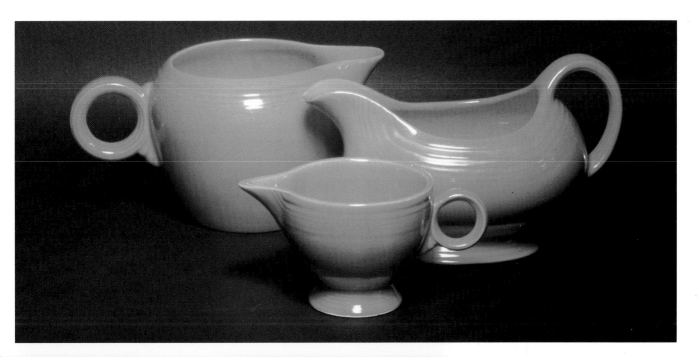

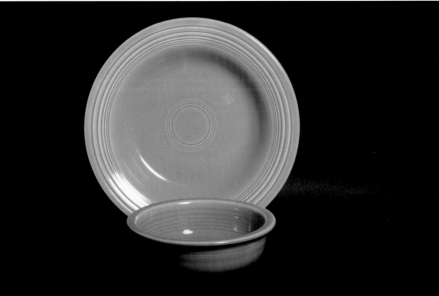

2.32 Left, orange 2-pint jug, L. 8 1/2 in.; center, regular creamer, L. 6 in.; and right, sauceboat, L. 8 1/4 in. with impressed marks.

2.33 Turquoise fruit bowl, D. 5 1/2 in., impressed HLCo. FIESTA MADE IN U.S.A., with green deep plate, D. 8 1/4 in., with ink mark GENU-INE FIESTA HLCo. U.S.A.

2.34 Ivory nappy, D. 9 1/4 in., impressed FIESTA HLCo. U.S.A.

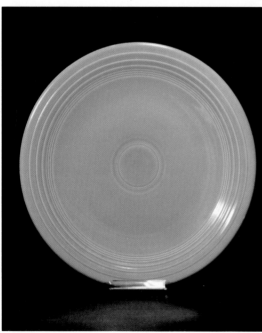

2.35 Ivory, turquoise, and one chartreuse plate, D. 9 1/2 in., ink mark GENUINE FIESTA HLCo. U.S.A.

2.36 Turquoise chop plate, D. 14 1/2 in., ink mark GENUINE FIESTA HLCo. U.S.A. *Courtesy of Mell Evers*

2.37 Ivory casserole (without cover), D. 10 in., with sauceboat, D. 8 in., both with impressed mark. *Courtesy of Second Hand Rose Antiques*

2.38 Left, orange bulb candleholder, H. 5 in.; center left, orange shaker, H. 2 7/8 in.; center right, turquoise fruit bowl, D 5 1/2 in.; right, covered sugar, H. 3 3/4 in., all with impressed mark, except for shaker. *Courtesy of Second Hand Rose Antiques*

2.39 Green bowl (left), D. 9 1/2 in., unmarked, with green cream soup bowl, D. 6 1/2 in., impressed FIESTA HLCo. U.S.A. *Courtesy of Second Hand Rose Antiques*

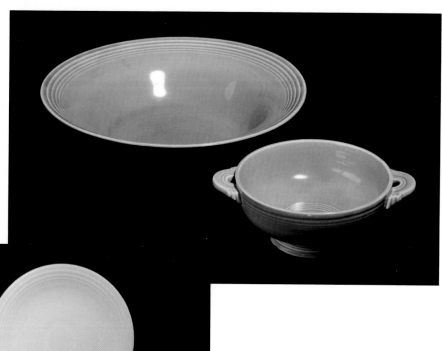

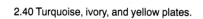

2.40 Turquoise, ivory, and yellow plates.

2.41 Harlequin plates, D. 8 in.

2.42 Fiesta Casual Hawaiian 12-point Daisy, produced 1962-1968, D. 10 1/4 in., marked GENUINE FIESTA HLCo. U.S.A. CASUAL. *Courtesy of Ralph and Terry Kovel*

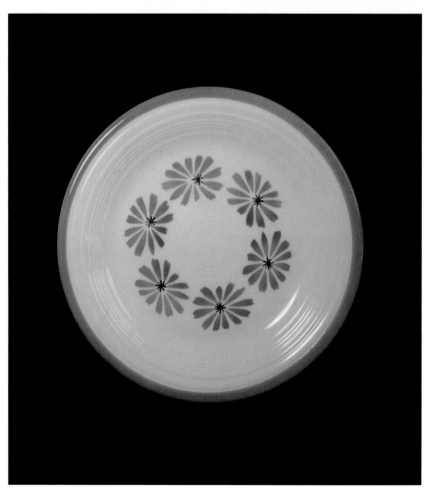

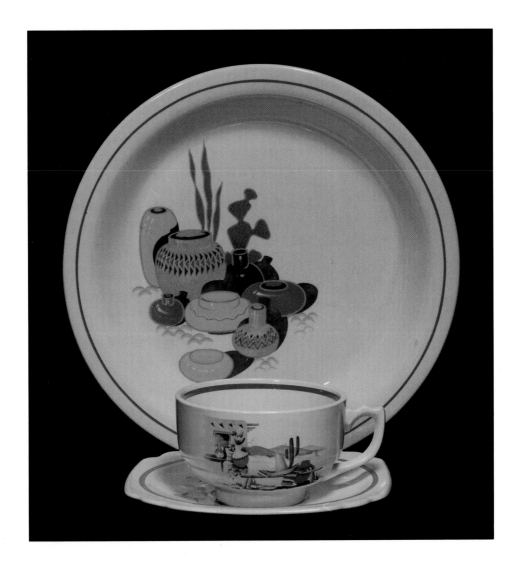

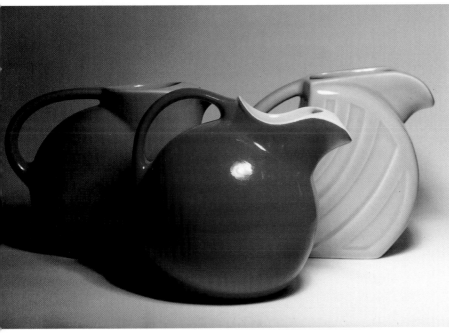

2.43 Fiesta **Mexicana** pattern, introduced in 1937, with colorful decals depicting Mexican pottery; and **Hacienda** showing outdoor desert scene with sombrero and other cultural symbols, on an ivory ground with a red line inside the edge (which came in other colors); Hacienda square saucer with scalloped corners and cup, both unmarked, and Mexicana shallow bowl, D. 9 1/2 in., marked KITCHEN KRAFT OVEN SERVE U.S.A. *Courtesy of Mell Evers*

2.44 Water pitchers resembling Fiesta.
Left, Hull blue pitcher, H. 6 3/4 in., W. 8 1/2 in., marked HULL CHINA CO. MADE IN U.S.A.; center, Hall red pitcher, H. 6 1/2 in., W. 8 1/4 in., stamped in gold HALL'S SUPERIOR QUALITY KITCHENWARE MADE IN U.S.A.; and right, yellow Alamo pitcher, H. 7 1/2 in., W. 9 in., with black ink stamp ALAMO POTTERY INC. SAN ANTONIO. *Courtesy of Ralph and Terry Kovel*

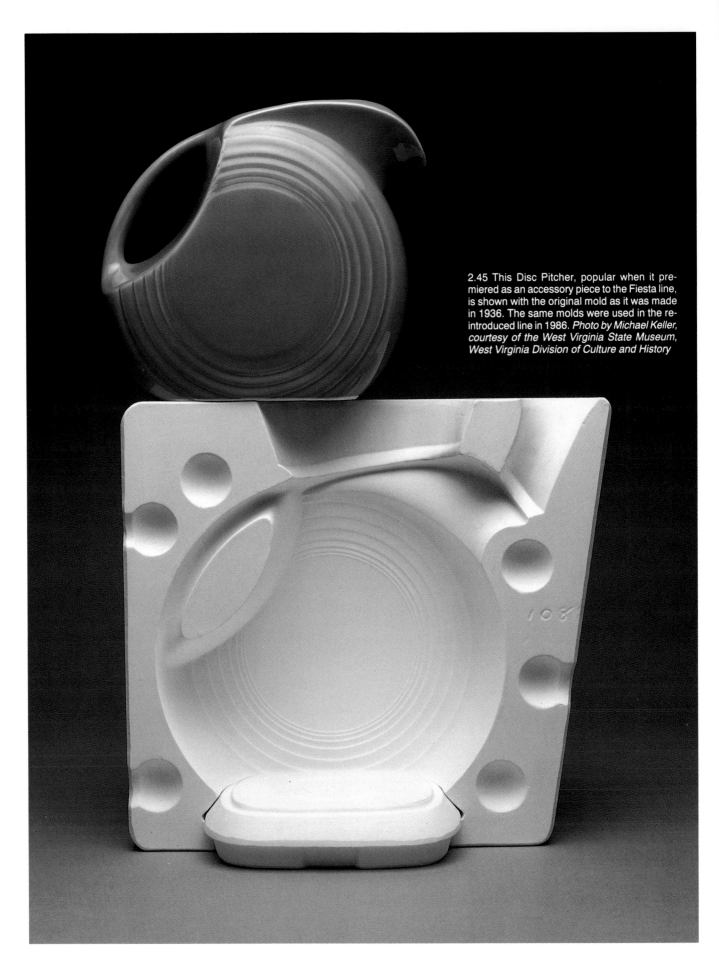

2.45 This Disc Pitcher, popular when it premiered as an accessory piece to the Fiesta line, is shown with the original mold as it was made in 1936. The same molds were used in the reintroduced line in 1986. *Photo by Michael Keller, courtesy of the West Virginia State Museum, West Virginia Division of Culture and History*

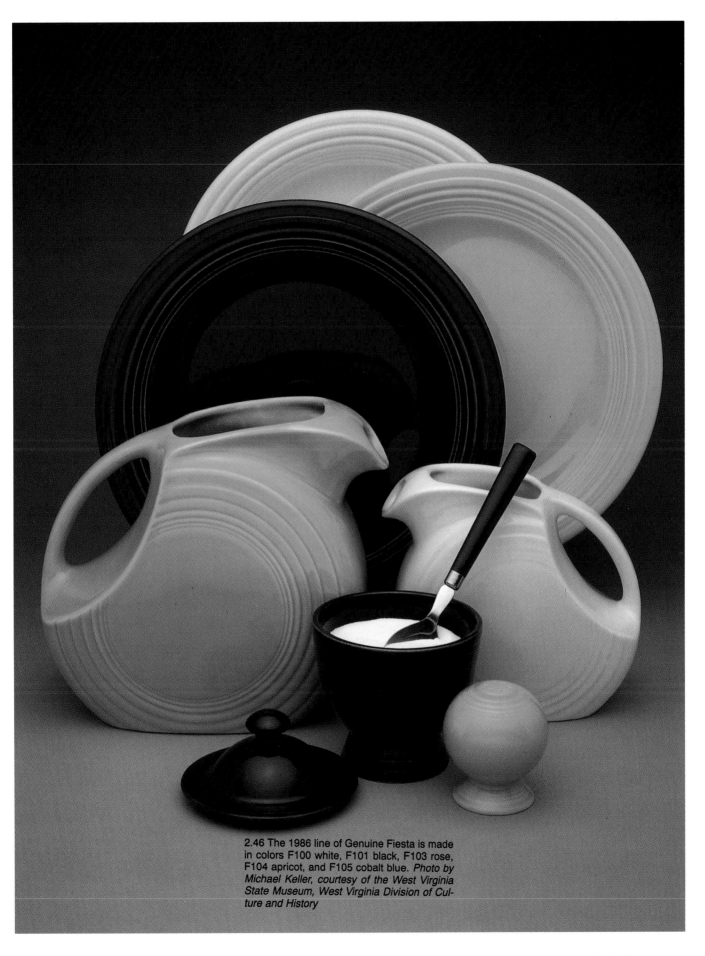

2.46 The 1986 line of Genuine Fiesta is made in colors F100 white, F101 black, F103 rose, F104 apricot, and F105 cobalt blue. *Photo by Michael Keller, courtesy of the West Virginia State Museum, West Virginia Division of Culture and History*

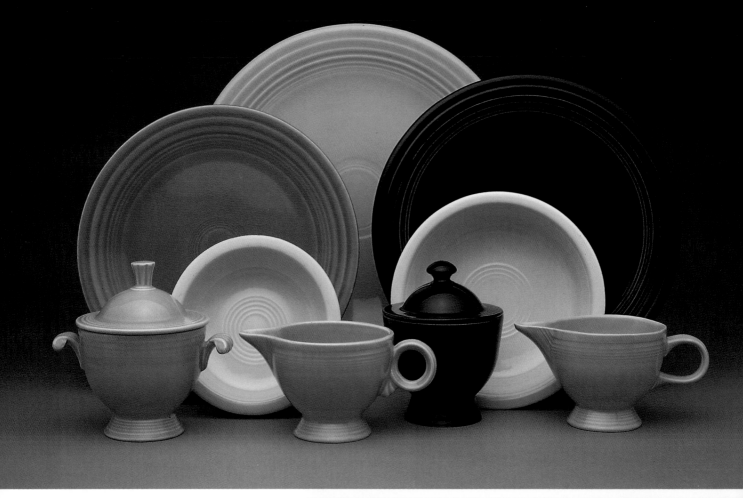

2.47 Original Fiesta pieces are mixed with new. *Photo by Michael Keller, courtesy of the West Virginia State Museum, West Virginia Department of Culture and History*

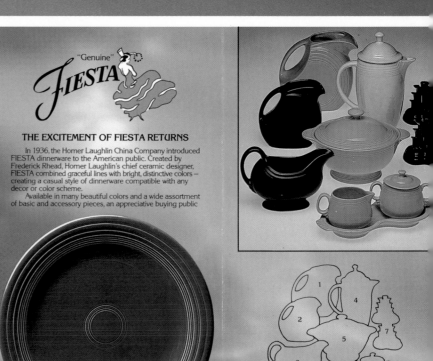

"Genuine" FIESTA

THE EXCITEMENT OF FIESTA RETURNS

In 1936, the Homer Laughlin China Company introduced FIESTA dinnerware to the American public. Created by Frederick Rhead, Homer Laughlin's chief ceramic designer, FIESTA combined graceful lines with bright, distinctive colors — creating a casual style of dinnerware compatible with any decor or color scheme.

Available in many beautiful colors and a wide assortment of basic and accessory pieces, an appreciative buying public made FIESTA a best-seller in its field. Even after its production ceased, FIESTA'S continued popularity made it one of the most sought after collectibles on the market.

Now, by popular request, the Homer Laughlin China Company is proud to re-introduce Genuine FIESTA dinnerware... retaining the same graceful lines, in colors designed to complement today's modern lifestyle. Perfect for all occasions, FIESTA dinnerware will complement any decor and add emphasis to any tablesetting.

Though other color-glazed imitations abound in today's marketplace, don't settle for anything less than the original quality and enduring value of Genuine FIESTA from the Homer Laughlin China Company.

FIESTA... the dinnerware that turns your table into a celebration.

1. Large Disk Pitcher
2. Small Disk Pitcher
3. Sauce Boat
4. Covered Coffee Server
5. Covered Casserole
6. Covered Sugar/Cream and Tray
7. Pyramid Candlestick

2.48 Front of Homer Laughlin promotional flyer for new Fiesta.

2.49 Inside new Fiesta flyer.

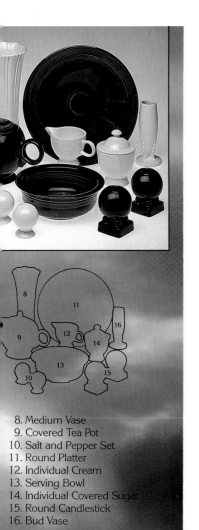

8. Medium Vase
9. Covered Tea Pot
10. Salt and Pepper Set
11. Round Platter
12. Individual Cream
13. Serving Bowl
14. Individual Covered Sugar
15. Round Candlestick
16. Bud Vase

"Genuine"

FIESTA

exclusive product of
The Homer Laughlin China Co.
Made in the U.S.A.

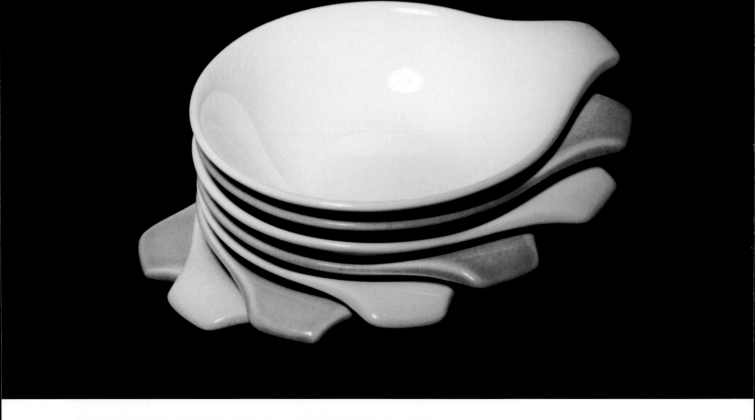

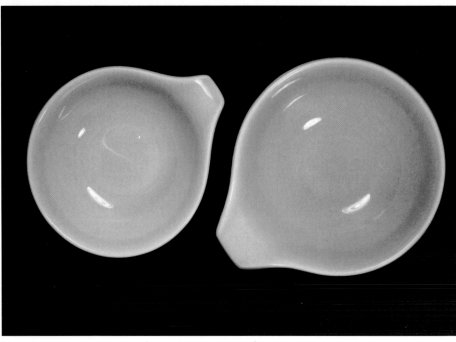

3.1 Stack of eight American Modern #317 fruit bowls in white and granite grey with single lug handle, L. 6 1/4 in., impressed RUSSEL WRIGHT MFG BY STEUBENVILLE.

3.2 Left, #305 lug soup bowl, L. 7 in.; right #317 lug fruit bowl, L. 6 1/4 in.

78 POTTERY: Modern Wares

The Index to the Russel Wright Archives in the George Arents Research Library at Syracuse University is 60 typed pages. It includes correspondence, contracts, patents, manuscripts, published books and articles, other written items, photographs, samples of colors and materials, original drawings and designs, and three-dimensional models. Books and chapters have been written about Wright and his designs. The dozens of boxes holding these Archives, which cover more than 55 linear feet of shelf space, will surely generate more books and chapters, because Russel Wright was one of the stars of twentieth century design. The sheer volume of the Archives is enough to excite and frighten any researcher, so it is probably best to take small bites and focus on one subject at a time. Pottery was only one of many materials with which Wright worked, and American Modern dinnerware was his most successful pottery design financially, if not artistically. Examples of American Modern and the similar Iroquois Casual were featured in contemporary museum exhibits and revived more recently in exhibits and catalogs representing modern form. They are included in this book for the same reason, but also because collectors have been recognizing the value — aesthetic, historic, and even monetary — of these and other mid-century American designs.

Russel Wright was born in Lebanon, Ohio in 1904. His mother, Harryet Morris Crigler, and his father, Willard Wright, a local judge, brought him up in the religious Society of Friends; he was a Quaker. As a young boy, he loved to model and paint; as a young man, he had the good fortune to take classes with Frank Duveneck at the Cincinnati Academy of Art in 1920. He continued at the Academy in 1921 and 1922 and then spent about a year at the Art Student's League in New York where he won first and second prizes in the Tiffany War Memorial Competition. His father enrolled him in Princeton University in 1922, hoping

that Russel would get serious and become an attorney, but he only stayed for two years.

Stage and costume design occupied Wright for the next seven years. He met Mary Einstein in Woodstock, New York while designing backgrounds, and they were married in 1927. In 1930 Wright began to manufacture his designs for serving accessories in wood and metal. He was a member of the short-lived (1928-1932) Manhattan-based American Union of Decorative Artists and Craftsmen (AUDAC) where he met and exhibited with the current and future leaders of cutting-edge modern American design. In 1935 and 1936 he designed modern blonde furniture for Conant Ball in Gardner, Massachusetts. In 1937 he designed the revolutionary American Modern dinnerware for Steubenville Pottery (founded in 1879) which won the American Designers' Institute award in 1941 for best ceramic design. By mass-producing inexpensive dinnerware and marketing it to a large middle class, Wright was a significant player in the changeover from a more formal, traditional style to a casual modern interior and lifestyle. He also contributed to an increased awareness of style in the American home.

Wright had a banner year in 1939. He sold the manufacturing business and set up an industrial design

office (while attending the New York University School of Architecture, which he had entered in 1938). In 1939 he and designer-businessman Irving Richards started the distributing company, Raymor, specifically to handle his designs. Raymor became a very large distributor of a variety of decorative arts and crafts, handling items such as Glidden Pottery of Alfred, New York [Chapter Four] and modern pottery from Italy [Chapter Eight]. The 1939 New York World's Fair included five exhibits that Wright designed, enhancing his growing and glowing reputation. Yet, of all his accomplishments, the one that reached the most people and for which Wright is best known is his American Modern Dinnerware, launched in 1939.

In 1940 Wright initiated a merchandising program called "American Way," a cooperative of 65 designers, artists, craftspeople, and manufacturers in ten different categories of home furnishings. Between 1945 and 1956 he designed several important lines of pottery and glass for major companies. In 1951 he won the Home Fashions League "Trail Blazer" award for table service and upholstery fabric. Wright was a charter member of the

3.3 American Modern #302 dinner plates in granite grey, chartreuse, and pink, D. 10 in., impressed RUSSEL WRIGHT MFG BY STEUBENVILLE.

Society of Industrial Designers and its president from 1951 to 1952. He and Mary wrote *A Guide to Easier Living* (Simon and Schuster, 1951) in which their philosophy of domestic living, namely furnishing and maintaining the home, was well-received by the American public. The breadth of Wright's accomplishments is staggering. Ann Kerr's abbreviated chronology and the thirty-three pages of clients and their products in the Syracuse Archives can only suggest the versatility and scope of his career which peaked in the 1940s and continued with varying degrees of success until 1967 when Russel Wright Associates Design Studio closed. Despite his success and significance to American design, Wright "never resolved the conflicting demands of standardization and individual expression, American tradition and international innovation, or financial gain and artistic integrity." (von Eckhardt, 68) He died in 1976.

American Modern dinnerware, one of the most successful and certainly the best known of Wright's creations, was called radical in the late 1930s. Three years passed before Wright could convince a company to produce the line, and when he succeeded it was not without personal financial support. The then-bankrupt Steubenville Pottery agreed to produce Wright's design, but they were in no position to absorb the cost. Two years were spent solving manufacturing problems due to the strange shapes, the complex glazes with their mottled underglaze to create the muted color effects, and the breakability of the ware. Another year was needed to plan a marketing scheme to promote a radically new look for a Depression-weary public that was about to go to war. It was one thing to envision and sketch a novel design; it was another matter to make it succeed. Wright was determined to make it work, and in the beginning paid handsomely for newspaper ads and other promotional items.

When the line was finally completed and first offered to the trade, buyers were less than enthusiastic, but when consumers saw the first American Modern, it became clear whose tastes would prevail. Surprised but delighted retailers could hardly keep up with the demand. Magazines such as *House Beautiful*, *House and Garden*, *Mademoiselle's Living*, and *Bride's Magazine* were chosen for advertising campaigns because of their appeal to upper income households. Yet middle income consumers were every bit as enthusiastic. An inexpensive, 16-piece starter set was made popular, with the intent that more costly service pieces would be added later. Soon, there was no need for Wright to personally promote the line. According to a company report by Frances Johnson in 1951, some of the best advertising campaigns were not designed or financed by Wright, but by the retailers themselves. Oddly, the name "Russel Wright," which was not a brand name, began to be used as though it were a brand name by store copywriters. Normally, stores only used a manufacturer's brand name if the manufacturer shared the cost of the ad, but a new precident was set

3.4 American Modern #303 cup in teal blue, H. 2 in., L. 5 in., unmarked; and chartreuse #304 saucer, D. 5 3/4 in., unmarked.

3.5 Cups and saucers.

with the use of "Russel Wright" to promote a product. Thousands of advertisements were placed by stores, eliminating the need for Wright to promote himself. Stores nationwide ran half and full page ads in which the name Russel Wright was often larger than the name of the store. Neither the manufacturer nor Wright was asked to share the advertising costs because of the prestige accorded the name.

According to Johnson in 1951, designs for 44 different product types had been produced by 71 different manufacturers. Twelve million pieces of dinnerware were stamped "Russel Wright" annually and used by a range of consumer groups, the largest being young white collar workers. Steubenville Pottery was producing more than seven of the twelve million pieces annually, according to a letter from a Steubenville executive.

The story of a near-riot at Gimbel's china department is worth repeating. In 1947, Gimbel's ran a small newspaper ad for American Modern. The next morning, a line had

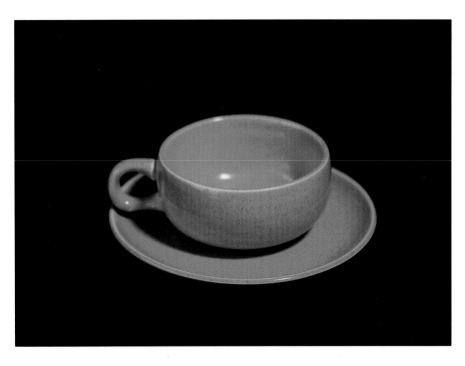

3.6 Pink #303 cup and #304 saucer.

3.7 Granite grey #303 cup, unmarked, and #304 saucer, marked RUSSEL WRIGHT MFG BY STEUBENVILLE, with child's #321 cup and saucer, saucer marked.

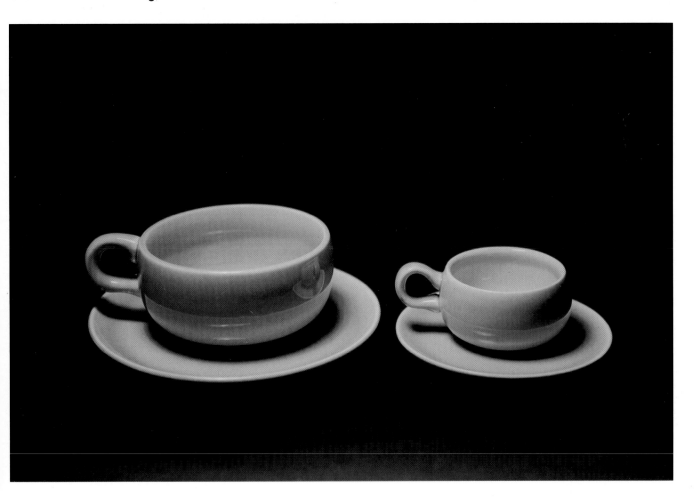

formed around the block and, when the store opened, several people were injured. It was estimated that 100 customers rushed each salesperson, and orders were written without any current stock. Soon supermarket-style shopping was adopted by otherwise fine department stores solely for the sale of American Modern. Another anecdote refers to sales of "seconds" (the most interesting thing being that they indeed sold seconds). A Baltimore fish market, Smitty's, sold its shipment of dinnerware three or four times each year directly from the railroad car in which it was shipped. Response was so good, and so predictable, that police were invited in advance for crowd control.

More than 80,000,000 pieces of American Modern dinnerware were made from 1939 to 1959. The original colors were Bean Brown, Chartreuse, Coral, Curry, Granite Grey (the most appropriate color to place food on, according to Wright), Seafoam Blue, and White. In 1950 the Bean Brown (which went from a rust to a burnt umber) was replaced by Black Chutney and a new color, Cedar Green, was added. In 1955 colors Cantaloupe and Glacier Blue were introduced. In the late 1940s a color called Steubenville Blue was occasionally made.

3.8 American Modern #320 water pitcher in white, H. 10 1/2 in., impressed RUSSEL WRIGHT MFG BY STEUBENVILLE.

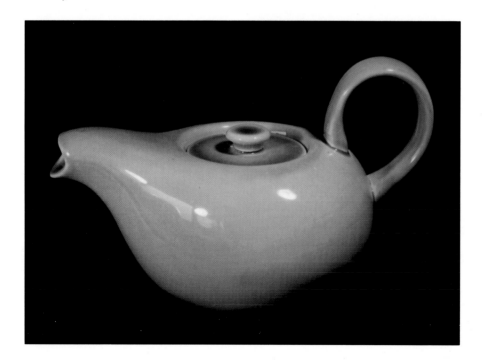

3.9 American Modern #316 teapot in chartreuse. H. 5 1/4 in. L. 10 in., impressed RUSSEL WRIGHT MFG BY STEUBENVILLE USA.

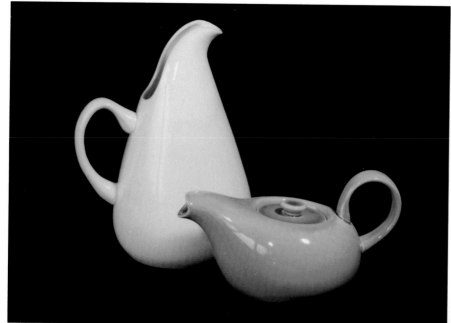

3.10 Water pitcher and teapot.

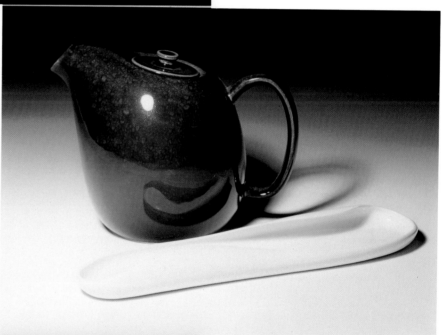

3.11 #322 coffee pot in bean brown, 8 x 8 1/2 in; with #308 celery dish in glacier white. *Courtesy of the Huntington Museum of Art*

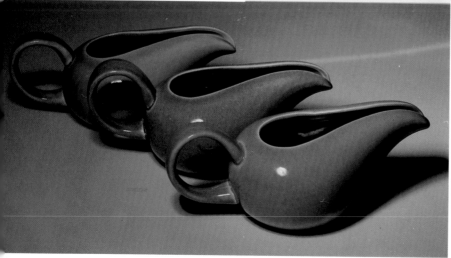

3.12 American Modern #315 creamer in chartreuse, granite grey, and pink, L. 7 in., H. 2 1/2 in., impressed RUSSEL WRIGHT MFG BY STEUBENVILLE.

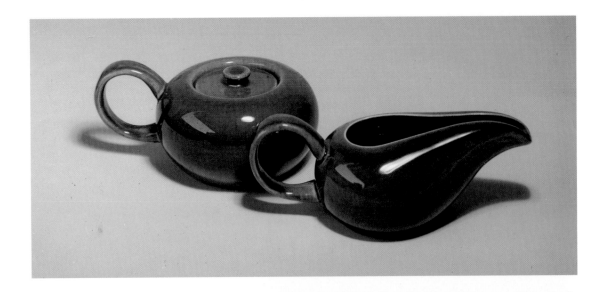

3.13 #314 sugar, L. 6 1/2 in., H. 3 in., and #315 creamer, L. 7 in., H. 2 1/2 in., both in seafoam with impressed mark.

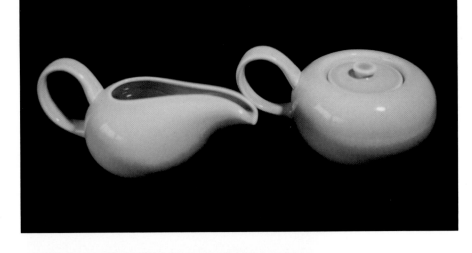

3.14 Creamer and sugar in granite grey.

3.15 Creamer and sugar with teapot in chartreuse.

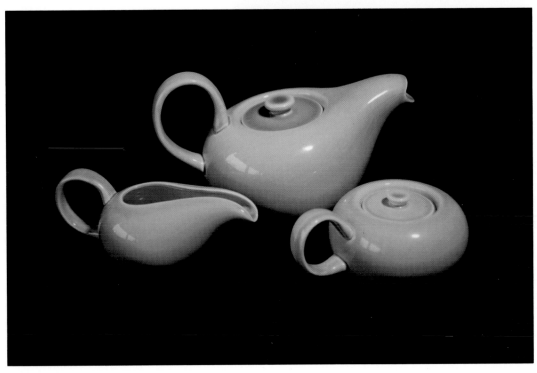

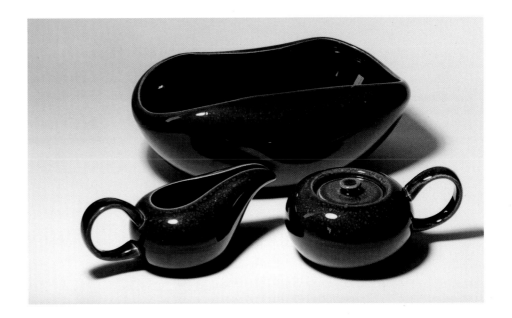

3.16 Creamer and sugar with #307 salad bowl in bean brown, bowl L. 11 1/4 in., impressed RUSSEL WRIGHT MFG BY STEUBENVILLE USA. *Courtesy of Second Hand Rose Antiques*

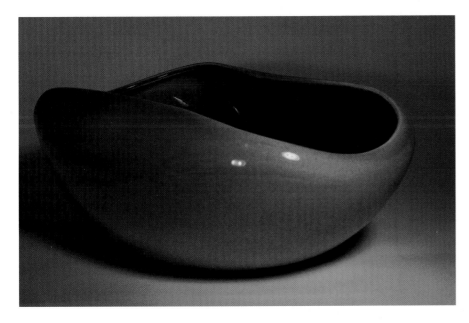

3.17 #307 salad bowl in granite grey.

3.18 American Modern #318 open vegetable bowl in seafoam.

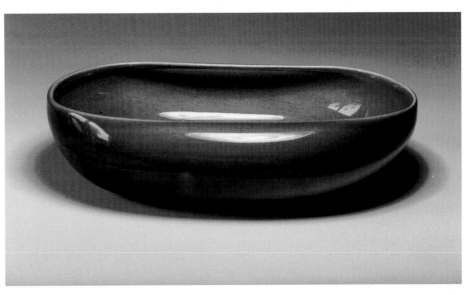

The following chronology highlights some of Russel Wright's pottery and glassware events:

1937 designed American Modern
1939-59 American Modern made by Steubenville Pottery Co., Steubenville, Ohio and distributed by Raymor
1941 award for best ceramic design by American Designers' Institute
1945 Bauer Art Pottery introduced
1946 through the mid-1960s Iroquois Casual made by the Iroquois China Co., Syracuse, New York and distributed by Garrison Products, New York
1946-48 designed some glass for the Fostoria Glass Co., Moundsville, West Virginia
1948 through about 1953 Paden City Highlight made by Paden City Pottery, Paden City, West Virginia, distributed by Justin Tharaud, New York from 1951-53
1949 Sterling hotel china made by the Sterling China Co., offices in East Liverpool, Ohio, factory in Wellsville, Ohio
1949 Imperial Glass Co., Bellaire, Ohio made clear, colored, and seed glass tumblers called Flair, and pink, green, smoke, and ruby glasses called Pinch to go with Casual China

1950 American Modern adds colors Black Chutney and Cedar Green
1951 until about 1955 Harker White Clover made by the Harker Pottery Co., East Liverpool, Ohio. This was the first applied decoration designed by Wright, though Sterling and Iroquois added their own decoration to his forms. This apparent compromise indicated a "willingness to accomodate popular taste rather than strive to shape it" and seemed to reflect Wright's lack of direction during those years. (Hennessey 68)
1951 American Modern line expanded
1951 American Modern glassware in coordinating colors and shapes made by the Old Morgantown Glass Guild, Morgantown, West Virginia
1951-1952 Iroquois Casual redesigned and colors added
1952 Harker White Clover Good Design Award from the Museum of Modern Art
1955-1962 Knowles Esquire made by Edwin M. Knowles Pottery Co., East Liverpool, Ohio with decoration designed by Wright
1955 American Modern adds colors Canteloupe and Glacier Blue
1963 porcelain dinnerware made by Schmidt International (Yamato Porcelain Co., Tajmi, Japan)

The following numbered items are from a Steubenville Pottery order form for American Modern. Items in () are from Kerr pp. 181-182.

300 bread & butter plate 6 1/4 in.
301 salad plate 8 in.
302 dinner plate 10 in.
303 cup
304 saucer
305 handle soup bowl
306 chop plate
307 salad bowl
308 celery dish
(309 divided relish)
(310 relish rosette)
(311 carafe/stoppered jug)
312 covered casserole 12 in.
(313 icebox jar)
314 sugar
315 creamer
(316 teapot 6 x 10 in.)
317 dessert bowl
318 vegetable bowl
319 platter 13 1/4 in.
320 water pitcher
(321 child's cup and saucer)
322 coffee pot 8 x 8 1/2 in.
323 pepper/salt
324 covered veg. bowl 12 in.
325 ash tray
326 gravy boat 10 1/12 in.
327 pickle dish
328 small baker/vegetable bowl 10 3/4 in.
329 hostess set with cup, new for 1951
330 coffee cup cover, 1951
331 covered ramekin, 1951
332 divided vegetable dish, 1951
333 three-piece double stack server, 1951
334 water mug, 1951
335 covered pitcher, 1951
336 teapot
337 sauceboat 8 3/4 in.
338 child's plate
339 child's cup
340 child's bowl
(341 covered butter)

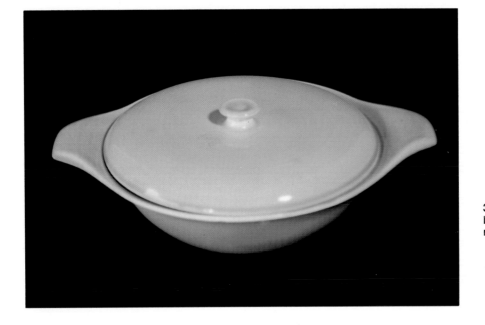

3.19 American Modern #324 covered vegetable bowl in chartreuse, L. 12 in., with impressed mark.

3.20 American Modern #332 divided vegetable platter in granite grey, L. 13 1/2 in., with impressed mark.

3.21 Coral divided vegetable.

3.22 American Modern #327 pickle dishes, (or to place under gravy boat), in granite grey, L. 11 in., with impressed mark.

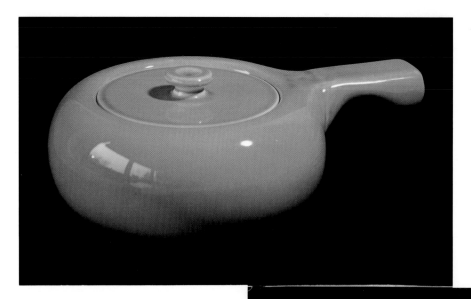

3.23 American Modern #312 covered bean pot or casserole in chartreuse, L. 12 in., with impressed mark.

3.24 American Modern #319 platter in granite grey, L. 13 1/4 in.

3.25 #302 dinner plate, 10 in.; #301 salad plate, 8 in.; #300 bread and butter plate, 6 1/4 in.; and #325 coaster/ashtray, 3 1/2 in., all in chartreuse and signed except for coaster.

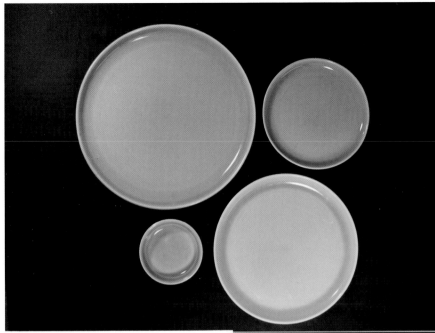

3.26 Dinner, salad, bread and butter plates, and coaster.

3.27 American Modern #306 chop plate in chartreuse, 13 in., with impressed mark.

3.28 American Modern small baker or vegetable dish in chartreuse, L 8 in., with #323 salt and pepper shakers.

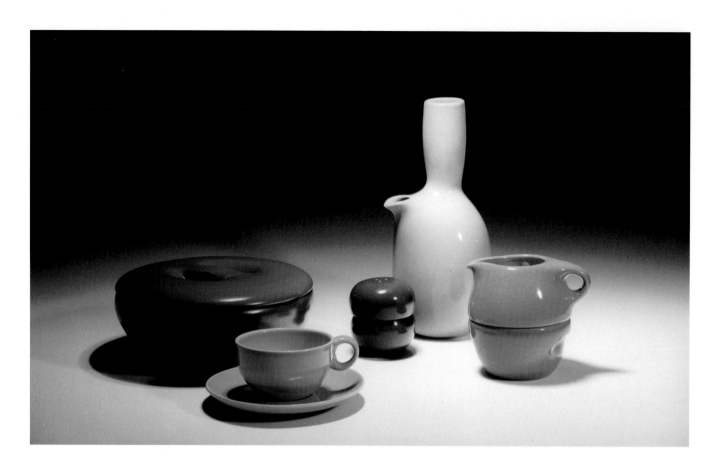

3.29 **Iroquois Casual** by Iroquois China. Top left, original design covered casserole in nutmeg, D. 10 in; bottom left, coffee cup and saucer in avacado yellow; center, stacking salt and pepper shakers in charcoal; top right, carafe in sugar white; bottom right, stacking sugar and creamer in canteloupe. *Courtesy of the Huntington Museum of Art*

Other companies made pottery wares designed by Wright. Iroquois China (1905-1969) made Iroquois Casual dinnerware in curved sculptural forms similar to American Modern beginning in 1946, but the body was considered to be a true china and therefore more durable. The glazes were less mottled and came in colors named lemon yellow, avocado yellow, lettuce green, oyster, sugar white, pink sherbet, canteloupe, nutmeg, ice blue, parsley, ripe apricot, charcoal, aqua, and brick red. In addition to Iroquois Casual, Iroquois China made two other modern collectible dinnerware lines in the 1950s and 1960s, both designed by Ben Seibel and called Impromptu and Informal.

3.30 **Iroquois Casual** covered butter dish shaped like a hot-dog bun with pinched sides and no corners in ice blue, L. 7 3/4 in., marked IROQUOIS CASUAL CHINA BY RUSSEL WRIGHT. *Collection and courtesy of the Everson Museum of Art*

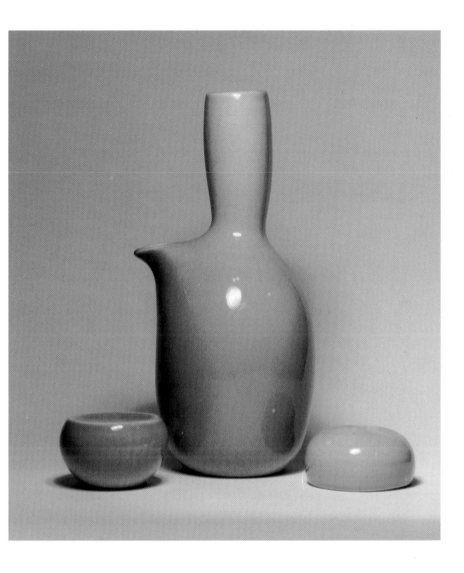

3.31 **Iroquois Casual** ice blue carafe-vase with a spout extending from the rounded shoulder and a long narrow neck, H. 10 in., marked IROQUOIS CASUAL CHINA BY RUSSEL WRIGHT; together with ice blue stacking salt and pepper shakers shaped like little hamburger buns, D. 3 in. *Collection and courtesy of the Everson Museum of Art*

3.32 **Iroquois Casual** hostess party plate with cup in pink sherbet, marked. *Gift of Courtney Spore. Collection of the Everson Museum of Art*

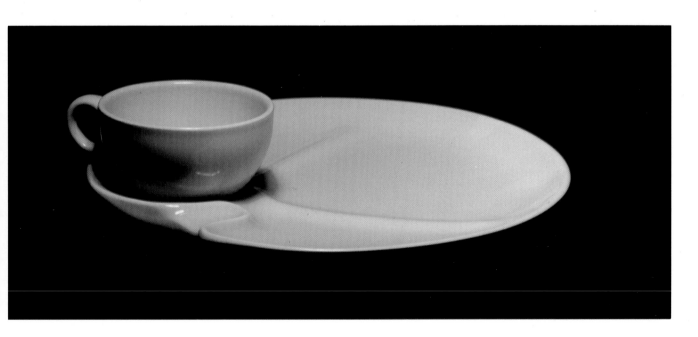

3.33 **Iroquois Casual** redesigned covered casserole (the little knob on top was added) looking like a squat pumpkin in canteloupe color, D 10 1/2 in., marked. *Gift of Mr. and Mrs. Victor Cole. Collection of the Everson Museum of Art*

3.34 Casserole bottom showing divisions.

3.35 **Iroquois Casual** bowl on stack of three sizes of plates and a water pitcher. *Courtesy of the Huntington Museum of Art*

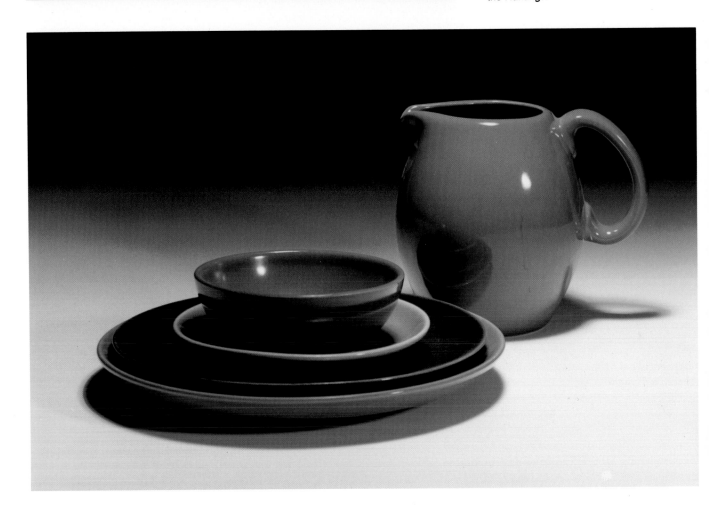

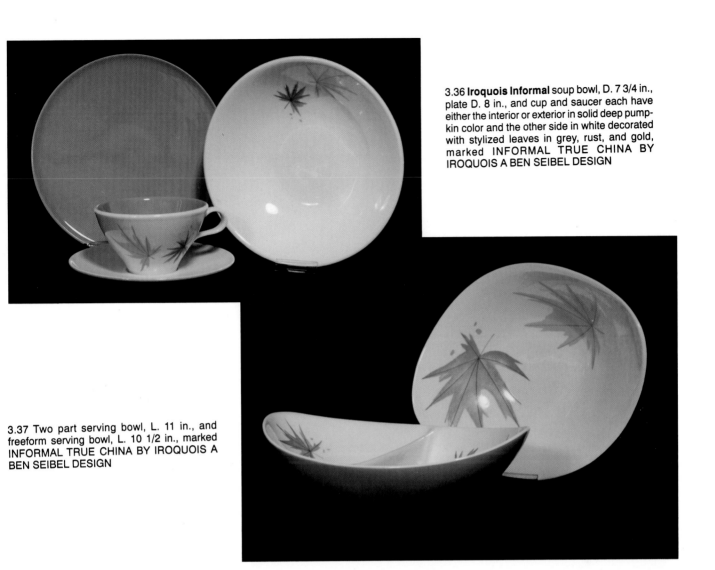

3.36 **Iroquois Informal** soup bowl, D. 7 3/4 in., plate D. 8 in., and cup and saucer each have either the interior or exterior in solid deep pumpkin color and the other side in white decorated with stylized leaves in grey, rust, and gold, marked INFORMAL TRUE CHINA BY IROQUOIS A BEN SEIBEL DESIGN

3.37 Two part serving bowl, L. 11 in., and freeform serving bowl, L. 10 1/2 in., marked INFORMAL TRUE CHINA BY IROQUOIS A BEN SEIBEL DESIGN

Wright pottery designs were made by other companies such as Paden City Pottery in Paden City, West Virginia which made a Wright pattern called Highlight from 1951 to 1953. The Highlight pattern won the Home Furnishings Award by the Museum of Modern Art in 1951. This pottery was closed in 1963. Edwin Knowles Pottery Co. (1900-1963) of East Liverpool, Ohio, produced Russel Wright designs, as did the Sterling China Co. with offices in East Liverpool and a factory in Wellsville, Ohio.

3.38 **Highlight** vegetable bowl with cover that doubles as a platter, in nutmeg, produced by Paden City Pottery, Paden City, West Virginia from 1951 to 1953 and distributed by Justin Tharaud & Son of New York. Marked PADEN CITY POTTERY RUSSEL WRIGHT. *Courtesy of the Huntington Museum of Art*

3.39 Ceramic clock face designed by Russel Wright for Harker Pottery of East Liverpool, with mechanical portion by General Electric. *Courtesy of the Huntington Museum of Art*

3.40 Salad plate designed by Russel Wright and made by Edwin M. Knowles Pottery Co. (1900-1963) of East Liverpool circa 1956 with abstract linear design. D. 8 1/4 in., marked RUSSEL WRIGHT BY KNOWLES MADE IN U. S. A. *Courtesy of Ralph and Terry Kovel*

3.41 **Sterling China**, with offices in East Liverpool and factory in Wellsville, Ohio, produced this Russel Wright design in 1949. Though usually undecorated, this white oval platter, cup, saucer, and bouillon bowl are deco-rated with stylized leaves. Platters came in 7 1/8, 10 1/2, 11 3/4, and 13 5/8 inches, mark STERLING CHINA BY RUSSEL WRIGHT MADE IN U.S.A. *Courtesy of the Huntington Museum of Art*

3.42 Left, Sterling 10-oz. teapot; center, freeform ashtray; right, 3-oz. cream. *Courtesy of the Huntington Museum of Art*

Many companies imitated Russel Wright's dinnerware designs. The Santa Anita Potteries in Los Angeles made a pattern called California Modern from about 1939 to 1957 which is similar in color to American Modern and in glaze to Iroquois Casual. Another close imitation was Ballerina dinnerware made by Universal Potteries in Cambridge, Ohio from 1947 to 1956. The original colors were called dove grey, jade green, jonquil yellow and periwinkle blue. In 1949 chartreuse and forest green were added. Burgundy, charcoal, and pink were new in 1955.

References

The summary of Wright's career and pottery designs is from material in the Archives of the George Arents Research Library; William Hennessey, *Russel Wright: American Designer*, and Ann Kerr, *Collector's Encyclopedia of Russel Wright Designs*.

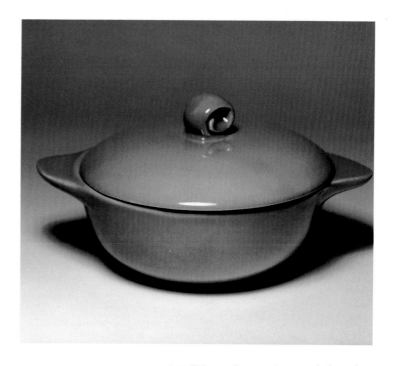

3.43 This small covered casserole in a glaze similar to Iroquoise Casual and color like American Modern granite grey is called California Modern and was made in Los Angeles by Santa Anita Potteries from about 1939 to 1957. D. 7 in., marked CALIFORNIA MODERN SANTA ANITA WARE MADE IN CALIFORNIA.

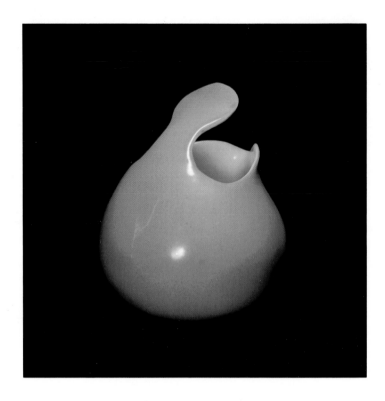

3.44 This unmarked Fifties freeform pitcher with unusual handle on top was undoubtedly inspired by Russel Wright shapes of both American Modern and Iroquois Casual; rusty orange glaze mottled with tiny brown specks with white interior, H. 8 in., D. 6 1/2 in. *Courtesy of Mell Evers*

3.45 **Ballerina** dinner plate made by Universal Potteries in Cambridge, Ohio from 1947 to 1956. D. 10 in., marked UNIVERSAL OVEN PROOF BALLERINA (with drawing) UNION MADE IN U. S. A. *Collection of Elise Kirschenbaum*

3.46 Forest green Ballerina dinner plate, marked. *Collection of Elise Kirschenbaum*

Chapter Four
Glidden Pottery: Oven to table wares

Glidden Pottery was one bridge between the less accessible realm of the studio potter and an affordable, available, functional ware suited to a post-war American lifestyle. Rather than the softer clay body used for other modern tableware, such as the very popular Fiesta line made by Homer Laughlin or American Modern designed by Russel Wright for Steubenville, Glidden's ware was hard and durable. This warm-toned, versatile stoneware, blended from New York, Kentucky, and Tennessee clays, was suited for oven-proof casseroles and tableware as well as decorative vases that rivaled many hand-thrown studio pieces.

The shapes, as with other modern pottery of the period, were novel yet functional. Squared plates with rounded corners and covered casseroles with duck-bill handles were to become symbols of post-war ceramic design. Glidden's hand-painted and incised decorations, whether figurative or geometric, used stylization with a carefree sophistication. Glazes were neither simple nor predictable. Color names —"Boston Spice" or "High Tide" — were often patterns comprised of mottled textures or with contrasting bands and stripes. Although made in standard numbered shapes and named color patterns, no two pieces of Glidden were really identical. This best of two worlds — high quality, often with the look and feel of studio work, plus production methods that could turn out large quantities at affordable prices — are what made Glidden Pottery successful then and attractive to collectors now. The work is widely varied yet easy to spot and to identify even before seeing the sgraffito signature. Its durability insures that a good deal has survived, and the millions of pieces produced over a 17-year period should encourage any collector to indulge in a bit of optimism.

Glidden Parker Jr. was born in Phillips, Maine on July 26, 1913. His mother, Avilla Hersey, and father, Glidden M. Parker, were both descendants of some of the earliest settlers to Massachusetts in the 17th century. At age 13, after attending a one-room country school, he was sent to Hebron Academy in Hebron, Maine. After his parents were divorced, his mother moved to Lewiston, Maine with her second husband, John G. Coburn, and Parker Jr. transferred to Jordan High School in Lewiston. He was far more interested in writing than he was in sculpture or ceramics, but his dreams of being a writer were never fulfilled. He wrote a mystery serial for the high school newspaper and later wrote for national college magazines. *Kenyon Review* published a short story of his in 1947, but when it was reprinted in *Best Short Stories* in 1950 it made no sense because the pages were out of order.

After graduation from Bates College, also in Lewiston, Maine, (1931-35) with a Bachelor's degree in English and a minor in Art History, Parker traveled and studied in Europe. He learned to speak and read German and studied art, history of film, literature, and philosophy at the University of Vienna in 1935 and 1936. He also studied museum collections in Edinburgh, London, Paris, Berlin, Dresden, and Budapest, as well as Vienna.

When he returned home, Parker worked on a never-published novel and attended summer school (1937-39) at the New York State College of Ceramic Art at Alfred, New York. He took classes in drawing, painting, and sculpture and was admitted to graduate school for ceramics. His misfortune in high school chemistry class (the lab blew up) did not deter Parker from exploring glaze chemistry, which he later taught at the Greenwich House Pottery in Greenwich Village, New York.

4.1 **Young Glidden Parker Jr.** (hereafter referred to as Glidden Parker). *Photo courtesy of Hinkle Memorial Library*

4.2 **Glidden Parker** *Photo courtesy of Hinkle Memorial Library*

4.3 **Glidden Parker sketching** *Photo courtesy of Hinkle Memorial Library*

In 1939 Parker married Patricia Hamill, and the same year he opened his studio pottery and design workshop. Marion Fosdick, award-winning ceramic artist, associate professor and later Dean of the College of Ceramics at Alfred, was his first partner in a venture that began by throwing a few pots per week. Fosdick had quite a large kiln for a pottery studio, so Parker used it to fire his wares about every other day for a year. His wife Pat, who had also studied ceramic art at Alfred, soon joined him. When a manufacturer's representative by the name of Eddie Rubel saw some of Parker's pottery in New York City, he immediately went to Alfred. According to former Glidden employee and designer of ceramics and glass Winslow Anderson, Rubel agreed to back Parker and build a factory, providing that he could handle all of the pottery distribution. Although Rubel did not get involved in artistic decisions, he did have a say in which items were produced. For example, if bakers and candlesticks were selling well, Parker would supply him with bakers and candlesticks. Glidden Pottery began to enjoy commercial success with national distribution that lasted from 1940 to 1957.

Apparently, Parker did not serve in the military and kept the pottery going during the war. By the time their son Christopher was born in 1942, wholesale orders for the pottery had increased, and Parker built a 50 x 125 foot one-story cement block building and installed a tunnel kiln (presumably with Rubel's backing). Even though the firing process took about 14 hours, the tunnel kiln enabled round-the-clock firing and was only shut down for ten days each year for maintenance and vacations. He also devised a way to eliminate the need for a bisque firing, thus saving time and expense. By glazing the dried but raw or unfired clay, only one firing was needed. With the continously-run tunnel kiln, quite a lot of pottery could be fired, so the only technology needed was a better method to form the pieces. When some friends from The Ohio State University recommended that Parker try the new automated pressing machine called a Ram press, he purchased a new 30-ton hydraulic press, acquired a license from the inventors, Blackburn and Steele, and he helped to pioneer this new Ram process in 1949. Not only could the new press turn out up to 300 pieces an hour, but the pottery itself was even stronger. With the Ram press, the tunnel kiln, and the single-firing method, Glidden Pottery became commercially competitive. Never compromising in design or quality, Glidden Pottery was able to keep production high and retail pricing low by taking advantage of available technology and adapting it to its needs and goals.

By 1953, with 35 employees (the number peaked at 55), the plant produced 6,000 pieces per week. They concentrated on only one of their 130 different designs at one time in order to achieve optimal efficiency. The pottery was distributed by Rubel & Co. until 1955 when Richards Morgenthau Co., with showrooms in New York and Chicago, became national distributors for Glidden. As the paper Raymor label indicates, Raymor also distributed the pottery.

Success created a need for more new designs. Parker's ties to the College of Ceramic Art at Alfred can be compared with those of Cowan to the Cleveland School of Art. Several Alfred graduates, including George Fong Chow (who later became a curator at the Metropolitan Museum of Art) and Sergio Dello Strologo, shared the creative role with Parker. Fern Mays and Kathryn Welch designed and executed decorations. Mervin Babcock and Wallace Higgins were among those who made models and then plaster molds of the designs. Recognition and awards for ceramic design included five "Good Design" shows at the Museum of Modern Art, with the first of these touring the United states and Europe; the National Ceramic Exhibition at the Syracuse Museum of Art (now the Everson Museum) each year from 1938 on; the "Gump" award of the San Francisco department store two years for outstanding ceramic design; the Albright Art Gallery of Buffalo traveling exhibition "Twentieth Century Design: U.S.A." from 1959-60; and the 1949 Detroit Institute of Arts exhibition, "For Modern Living." In the exhibition catalog Edgar Kaufmann wrote that the living art of our times is as worthy of museums' attention as the utilitarian objects representing the accomplishments of past cultures. The well-designed pieces chosen for the exhibit "embody the spirit of the world we have made, and in some degree, the world we strive to achieve." Among these "symbols of a good life" were

4.4 **Glidden Parker** *Photo courtesy of Hinkle Memorial Library*

Glidden Parker designs for a bowl, casserole, and hors d' oeuvres server.

By 1946, the year he and Pat were divorced, Parker was spending much of his time in Mexico, Puerto Rico, and the Southwest United States. Parker visited Mexican potteries and other craft industries and then returned to Alfred. This Mexican and Southwest influence is apparent in many of the designs and colors — with names like "Sage and Sand" and "Green Mesa" — although all of the pottery was designed and made at Alfred. Between 1948 and 1956, he studied native American crafts in Southwest museum collections and brought Mexican crafts to display and sell at Glidden Galleries, which he had opened in Alfred as a sales outlet for his pottery as well as a gallery to show local arts and crafts and loan exhibitions from museums. The gallery building, at 43 North Main Street in Alfred, had once been a station of the Underground Railroad.

Parker liked traveling and dealing with Southwest crafts more than running the pottery plant, and his long absences from Alfred annoyed Rubel who eventually pulled out. In addition, and despite its technological advantages, Glidden Pottery was a victim of foreign competition. In 1957 the pottery closed, leaving Glidden Galleries the only remaining operation.

4.5 **Staff at Glidden Pottery** *Photo courtesy of Hinkle Memorial Library*

4.6 **Glidden Galleries, Alfred, New York**
Photo courtesy of Hinkle Memorial Library

In 1962 the Puerto Rican government hired industrial designer Raymond Loewy to teach crafts to their people, and Loewy invited Parker to join him and teach ceramics. Parker opened a shop called Casa Cabildo, or Cabildo Crafts, in a restored 17th-century building in San Juan that originally housed the mayor's office and city jail. Thirty craftsmen and women were sponsored by the Puerto Rican Industrial Development Company (PRIDCO) to make items from materials such as wood, rattan, textiles, and ceramics. Showrooms displayed and sold some of the goods, and others were exported. In 1963 Parker married a Puerto Rican senator's daughter, Angelita Garcia Blendeo, but the marriage lasted only four years. After the Casa Cabildo project he moved to Scottsdale, Arizona and began working with glass. For the remainder of his career and life, until 1980, Parker successfully designed stained glass windows and made sculptural ceramics in Arizona. Nevertheless, he will be remembered most for his production stoneware at Alfred, New York.

4.7 Casa Cabildo, 152 Christo, San Juan, Puerto Rico Glidden Parker (right) teaching ceramics to Puerto Rican students in 1962. *Photo courtesy of Hinkle Memorial Library*

4.8 Cylindrical vase Sandy ground decorated with abstract shapes in rusts and browns with a strong Southwest influence, slipcast. H. 10 in., unmarked. *Collection of Era and Sandra Scofield*

References

Information is from the Glidden Archives, a collection of scrapbooks, periodical clippings, typed papers, and photographs, housed at the Hinkle Memorial Library at the State University of New York in Alfred, New York. An interview with Glidden Parker shortly before he died in 1980 was published by Marian F. Love in *The Santa Fean* in March of that year. An interview with Winslow Anderson in 1993 helped to confirm and add information.

4.9 Rounded vase in pale blues with mottled darker blues at the rim, H. 7 1/2 in., marked GLIDDEN 49, no ram. *Collection of Era and Sandra Scofield*

4.10 **Figural vase** Unusual four-sided vase with sgraffito and carved slip decoration of a brown female nude, H. 9 in., marked 1A. *Collection of Era and Sandra Scofield*

4.11 **New Equations Buffetware**
Photo courtesy of Hinkle Memorial Library

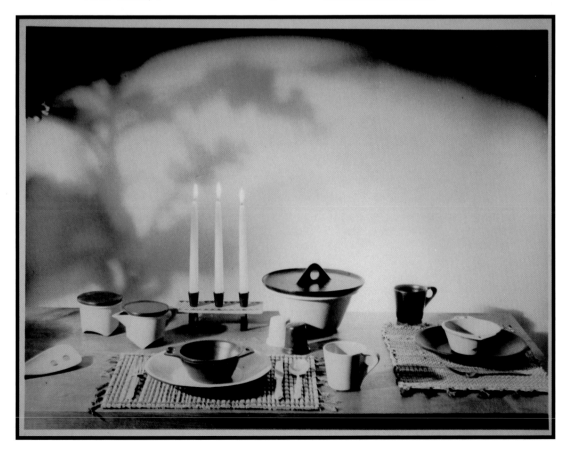

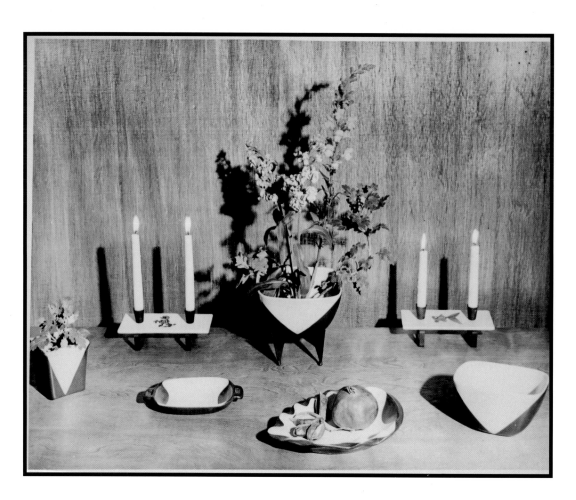

4.12 Tablesetting with geometric design
Photo courtesy of Hinkle Memorial Library

4.13 New Equations Buffetware Salad bowl or 1 1/2-quart open baker; blackstone with celadon; Good Design, June 1953. *Photo courtesy of Hinkle Memorial Library*

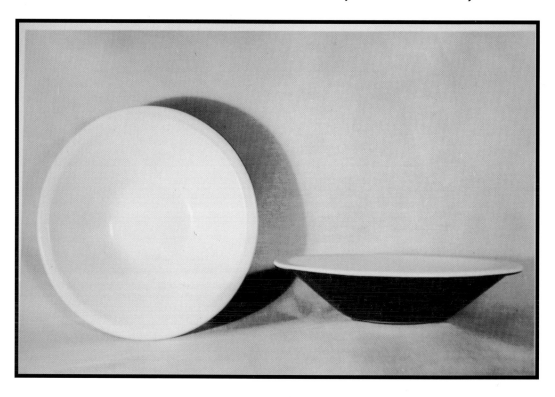

Glidden Colors/Color Patterns

Accent Green

Blackstone

Blue—rich deep blue plain or with multicolored sunburst decoration

Blue—muted greyish steel blue

Boston Spice—richly speckled brown glaze decorated with overlay of black glaze swirls and a geometric center medallion in mustard and black

Cayenne—warm brown with reddish overtones textured with dark brown flecks

Celadon

Charcoal—rust and charcoal on off-white

Charcoal and Rice—dull black finish, developed by George Fong Chow

Citrus yellow

Counterpane

Feather—sgraffito feather pattern incised freehand through white slip on tan stoneware bisque

Green—brilliant green tones with dark accents

Green Mesa—mustard yellow and mottled earth tones with brilliant green, touches of turquoise, and deep brown

Grey—either plain or with rust stripes

Gulfstream Blue—vivid turquoise with royal blue and black

High Tide—deep grey glaze with hand overlay of aqua glaze swirls and center motif in red and coral

Matrix—turquoise glaze with golden and dark brown flecks and subtle color variations

Paisley—soft medium-green glaze textured with deeper green and grey-green flecks

Pink

Purple—tones of purple and lavender-blue with deep accents

Rice

Saffron—rich yellow glaze textured with deeper green and grey-green flecks developed by Sergio Strologo in 1956 and often with linear surface decorations of herbs

Sage and Sand—off-white textured glaze with tiny flecks of metallic brown with greenish overtones

Sandstone—pale speckled sand color with soft grey, golden rust, and subtle bands of mauve

Turquoise—plain or with black stripes

White—plain or with rust stripes

Yellow—plain or with green stripes

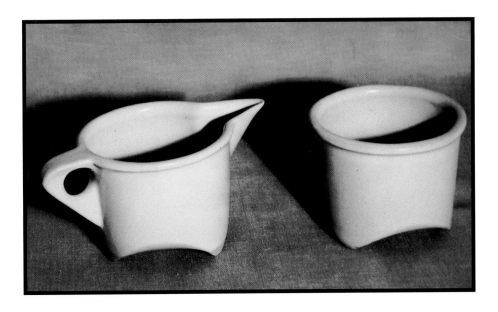

4.14 New Equations Buffetware
Celadon sugar and creamer; Good Design, June 1953. *Photo courtesy of Hinkle Memorial Library*

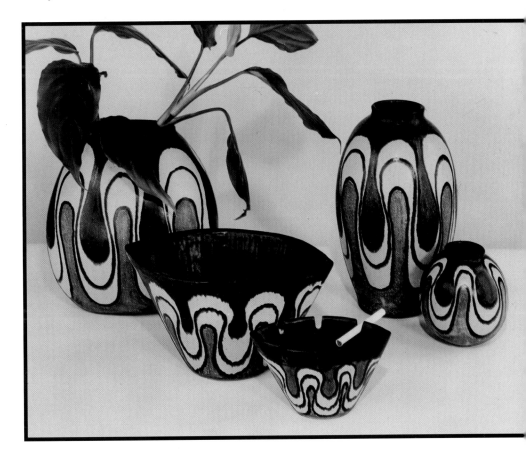

4.15 Vases and bowls All pieces made in Charcoal - rust and charcoal on off white; Purple - tones of purple and lavender-blue with deep accents; Green - brilliant green tones with rust, green, and dark accents. Top left, oval vase #940, H. 9 in. D. 9 in.; center left, deep bowl #908, H. 6 in. L. 9 in. W. 4 1/2 in. (not shown #907, H. 7 in. L 10 1/2 in. W. 5 in. and #906, H. 9 3/4 in. L. 14 3/4 in. W. 7 in.); center, slotted ashtray #909u (#909 comes without slots) H. 3 3/4 in. L. 61/2 in. W. 3 1/4 in.; top right vase #945, H. 10 1/2 in. D. 6 in.; center right, small globe #941, D. 4 in. (not shown medium globe #942, D. 5 1/2 in. and large globe #943 D. 7 in. *Photo courtesy of Hinkle Memorial Library*

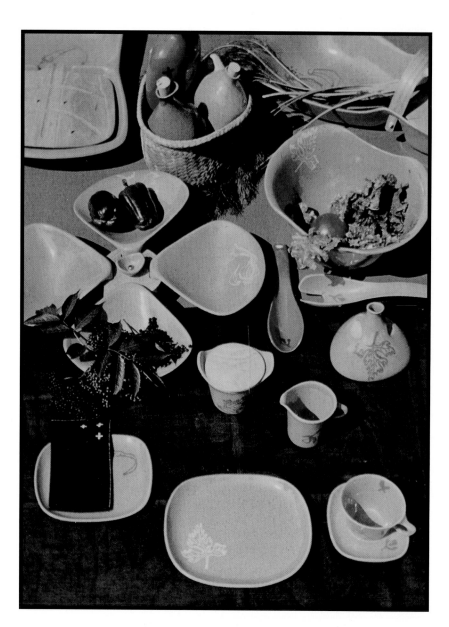

Casual Dinnerware available in Saffron only.

Buffet Plate #833; Cup #841; Saucer #842; Salad or Dessert #865; Soup or Individual Salad #826. 16-piece Starter Set consisting of 4 Buffet and Salad Plates and 4 Cups and Saucers for $16.00

Holloware (S-Saffron; P-Parsley; C-Cayene)

#801 Pepper Mill w/Oak Top (S, P, C)
#801-S Salt Shaker w/Oak Top (S, P, C)
#801-P Pepper Shaker w/Oak Top(S,P,C)
#802 Creamer, H. 4 in., D. 5 in. (S)
#803 Sugar w/Oak Cover (S)
#804 Deep Divided Serving Platter (S)
#804-B Carving Platter w/Oak Board (S)
#805 Spaghetti Server, Oak Handle (S)
#806 Casserole, 2 qts. (S)
#807 Cassorole, 3 1/2 qts. (S)
#808 Individual Beanpot (S)
#809 Beanpot, 2 qts. (S)
#810 Spice Jar w/Oak Cover (S, P, C,)
#8100 Spice Rack, Oak w/4 Jars (S,P,C)
#811 Canister w/Oak Cover, H 6 in.
 (S,P,C)
#8110 Canister Rack w/4 Jars (S, P, C)
#812 Dressing Bottle w/Cork (S)
#813 Liquor Bottle w/Cork (S)
#814 Liquor Bottle w/Cork (P)
#815 Liquor Bottle w/Cork (C)
#8130 Three Liquor Bottles in Basket (S,
 P, C)
#816 Coffee Urn w/Spigot, 20 cups (S)
#817-A Pitcher, 1 1/2 qts. (S)
#818 Teapot w/Oak Handle (S)
#8180 Tea Service: Oak Tray, Teapot,
 Sugar, Creamer (S)
#819 Serving Platter, L. 9 in., W.12 in.(S)
#820 Spoon (S, P, C)
#820-F Salad Server (S, P, C)
#821 Large Ashtray, 6 x 6 3/4 in. (S,P,C)
#822 Small Ashtray 5 in. 7 in. (in., P, C)
#823 Salad Bowl, H. 6 in., L. 12 1/4 in.
 (S)
#825 Susan, four detachable dishes, Oak
 bases (S, P, C)
#800-W Cast-iron Warmer Stand for
 Coffee Urn & Casseroles (black)

4.16 Stoneware designed by Sergio Dello Strologo Saffron: a rich yellow glaze texured with deep-hued flecks, decorated with spice and herb motifs in green, brown, and creamy white. Parsley: a soft medium green glaze textured with deeper green and grey-green flecks. Cayenne: a warm brown with reddish overtones, fleck-textured with dark brown. *Photo courtesy of Hinkle Memorial Library*

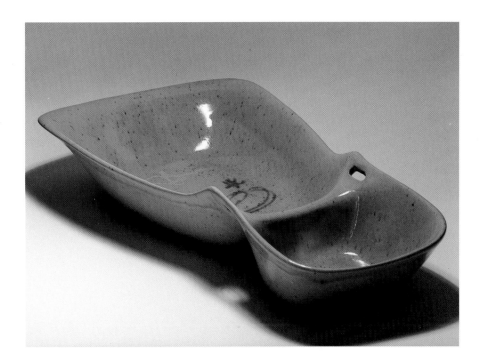

4.17 **Saffron** Large two-part bowl designed by Sergio Strologo (similar in design to a cutting bowl with wood insert on one side) signed GLIDDEN 21L w/ram. *Collection and courtesy of Hinkle Memorial Library*

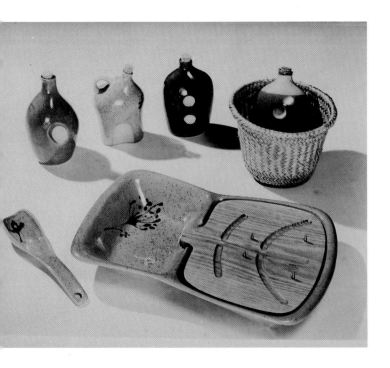

4.18 **Saffron** cutting bowl and serving spoon and liquor bottles in Parsley, Saffron, and Cayenne, designed by Sergio Strologo *Photo courtesy of Hinkle Memorial Library.*

4.19 **Red Wing sculptural vase** Abstract sculptural forms, such as this one with a hole through it by Red Wing Potteries of Red Wing, Minnesota, often resemble similar forms made at the same time by Glidden. H. 10 1/2 in., impressed signature RED WING USA B2316. *Courtesy of Studio Moderne*

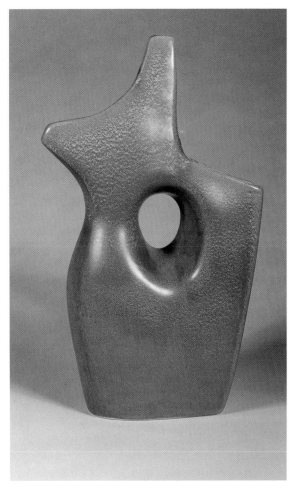

Numbering System

The following is a general sample of the shape numbers almost always found incised on the bottom of the pottery on the unglazed portion. Not all numbers listed were used, and not all numbers used are listed. Most pieces will have the number and the sgraffito Glidden signature, with or without the "ram" symbol, which is usually found on later pieces.

1-6 Safex ashtrays
17-28 either oval or square serving pieces
160s casseroles
31-270 square-shaped casual dinnerware and some accessories such as vases
270s ashtrays
431-467 oval casual dinnerware often using the same number as the corresponding square pieces, prefixed with the number *4*, ie., a square plate *#31* in the same sized oval shape would be *#431*
608-622 pitchers and bowls
630-640 shakers and bottles
800s dinnerware
900s vases and bowls
1127 tumblers
1430, 1440 creamer and sugar
4000-4046 vases, flower pots, ashtrays, and designer items
8000s companion pieces to *800s*

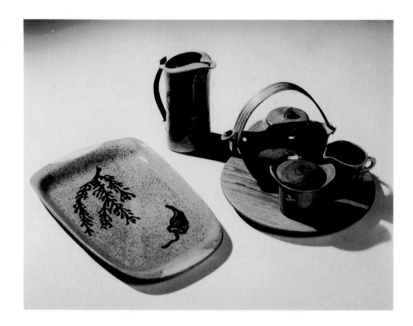

4.20 **Sergio Strologo designs in Saffron**
Serving tray, water pitcher, teapot, creamer, and sugar in Saffron. *Photo courtesy of Hinkle Memorial Library*

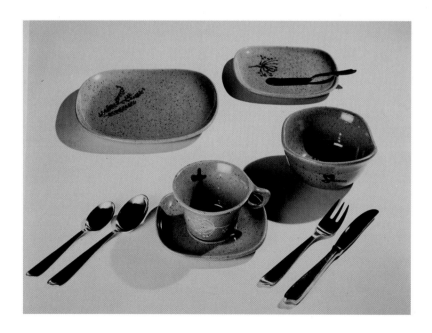

4.21 **Sergio Strologo designs in Saffron**
Top left, buffet plate #833, 8 1/2 x 9 1/2 in.; top right, salad/dessert plate #865, 7 x 7 3/4 in.; bottom right, soup/salad #826; bottom left, cup #841 and saucer #842. *Photo courtesy of Hinkle Memorial Library*

4.22 **Salad plate #465** Saffron plate, 7 1/2 in., signed GLIDDEN 465 w/ram. *Collection of Era and Sandra Scofield*

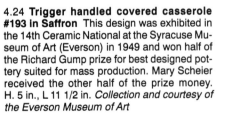

4.23 **Serving bowl or baker** #260-A, small rectangular bowl with rounded corners in saffron exterior and turquoise interior, L. 7 in., signed GLIDDEN 260-A (no ram).

4.24 **Trigger handled covered casserole #193 in Saffron** This design was exhibited in the 14th Ceramic National at the Syracuse Museum of Art (Everson) in 1949 and won half of the Richard Gump prize for best designed pottery suited for mass production. Mary Scheier received the other half of the prize money. H. 5 in., L 11 1/2 in. *Collection and courtesy of the Everson Museum of Art*

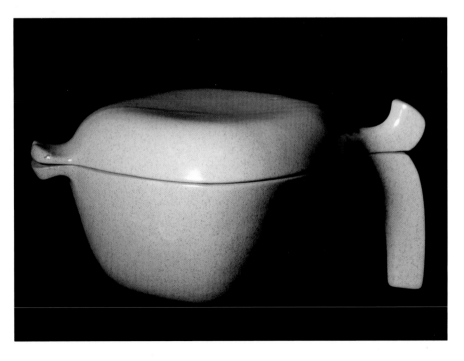

4.25 #193 opened with turquoise interior

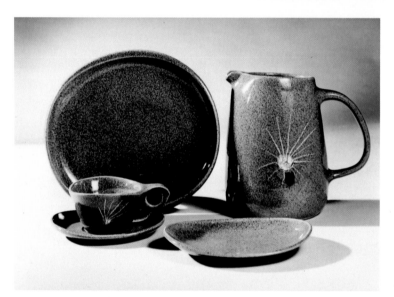

4.26 **New Blue ovenproof stoneware**
Top left, luncheon plate #433, 10 1/2 in.; top right, 1-qt. pitcher #615; bottom left, 6 1/2-oz. cup #441-A and saucer #442; bottom right, salad plate #464, 7 1/2 in. *Photo courtesy of Hinkle Memorial Library*

4.27 **Ovenproof dinnerware** Left, #167-8 individual 1/2-pint casserole; center, large baker 9 x 11 x 2 in.; right, square fruit #271, 4 1/2 in. *Photo courtesy of Hinkle Memorial Library*

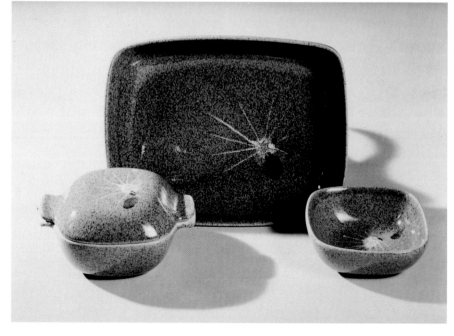

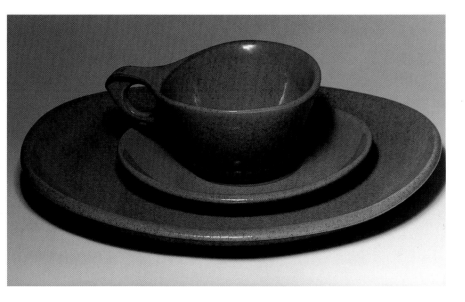

4.28 Cup, saucer, and dinner plate
Turquoise-blue cup #441A, L. 5 3/8 in.; saucer #442, D. 6 1//4 in.; plate #443, D. 10 in., each signed GLIDDEN with # and ram. *Collection of Era and Sandra Scofield*

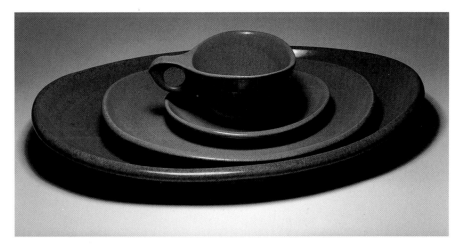

4.29 Cup, saucer, dinner, and serving plate
Large #428 serving plate added to group, D. 14 1/2 in., signed GLIDDEN 428 with ram.

4.30 #417 oval bowl Deep turquoise blue bowl. L. 9 1/2 in., H. 4 1/2 in., signed GLIDDEN 417 (no ram).

4.31 #17 square bowl Square version of #417 oval bowl in warm brown Cayenne glaze with light blue interior. W. 8 in., H. 4 1/2 in., signed GLIDDEN 17 (no ram).

4.32 Small baker Turquoise-blue #24 baker, L. 9 in., signed GLIDDEN 24 (no ram).

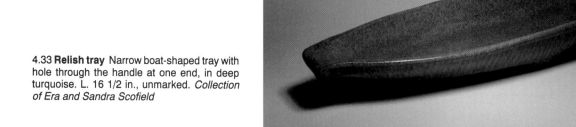

4.33 Relish tray Narrow boat-shaped tray with hole through the handle at one end, in deep turquoise. L. 16 1/2 in., unmarked. *Collection of Era and Sandra Scofield*

4.34 Three-lobed bowl between creamer and sugar *Photo courtesy of Ralph and Terry Kovel*

4.35 **#47 Four-lobed tray** Tray in the shape of a flattened quatrefoil in a mottled muted turquoise glaze, L. 13 in., signed GLIDDEN 47 (no ram).

4.36 **Round vases on tray** #62 globular vases on #47 tray in mottled muted turquoise. vase H. and D. 4 in., signed GLIDDEN 62 (no ram).

4.37 **Striped cube vase** #89 cube shaped vase in muted turquoise bisque covered with thick white wavy frosting-like stripes, 4 1/2 in. sq., signed GLIDDEN 89 (no ram).

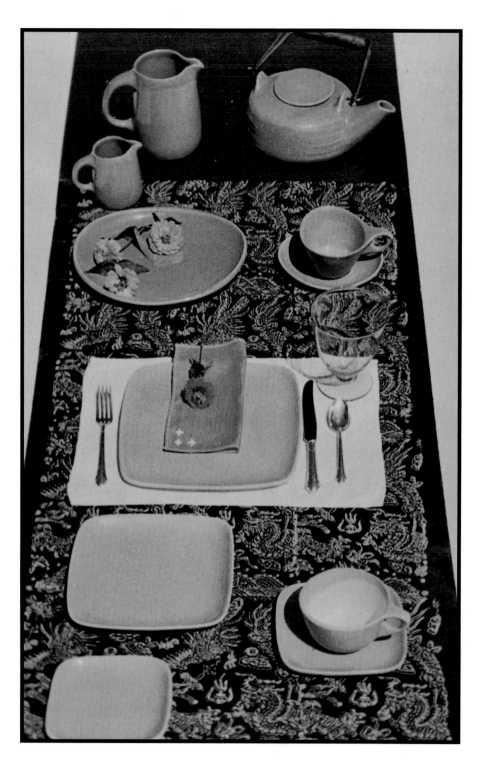

4.38 **Matrix** Aqua-green glaze with golden and dark brown flecks and subtle color variations. Casual dinnerware in oval and square; 16-piece starter set in either shape comes with Luncheon Plate, Bread & Butter, Cup & Saucer.

#31 square Dinner Plate, #431 oval
#33 square Luncheon Plate, #433 oval
#35 square Bread & Butter, #435 oval
#65 square Salad Plate, #465 oval
#141 square Cup, #441-A oval
#142 square Saucer, #442 oval
#270 square Soup, #467 oval

Holloware (either square or oval)
#17 Deep Veg. or Salad Bowl, 8 in. sq.
#22 Large Baker, 9 x 11 x 2 in.
#24 Small Baker, 7 x 9 x 2 in.
#28 Large Platter 11 x 15 in.
#30 Small Platter 9 x 12 in.
#161-2 Jumbo Covered Casserole, 4 qts.
#163-4 Large Covered Casserole, 2 qts.
#165-6 Medium Covered Casserole,
 1 1/2 qts.
#167-8 Individual Covered Casserole,
 1/2 pt.
#271 Fruit, 4 1/4 in. sq.
#608 Chop Plate with lug handles, 17 in.
#610 Egg Cup, H. 2 in., D. 3 in.
#612 Creamer, 1/3 pt. matches teapots
#613 Sugar w/cover matches teapots
#614 Small Milk Pitcher, 1 1/3 pts.
#615 Quart Pitcher
#616 Pitcher, 2-qts.
#617 Pitcher, 3-qts.
#618 Teapot, 6-cup w/infuser-strainer, copper
& wood handle
#619 Teapot, 8-cup as above
#620 Large Serving Bowl, lug handles,
 12 1/2 in.
#621 Medium Serving Bowl, lug handles,
 10 in.
#622 Small Serving Bowl, lug handles,
 7 1/2 in.
#1430 Creamer, H. 3 1/2 in.
#1440 Sugar w/cover, H. 4 in.

The same items and corresponding numbers also apply to the patterns Boston Spice, Feather, High Tide, and Sage & Sand. *Photo courtesy of Hinkle Memorial Library*

4.39 **Individual Covered Casseroles designed by Glidden Parker** 1/2-pint casseroles #167 in Matrix, L. 5 1/2 in., signed GLIDDEN 167 w/ram plus paper label: MADE IN THE TRADITION OF GOOD TASTE RAYMOR DESIGNS BY GLIDDEN PARKER AND FONG CHOW FOR GLIDDEN POTTERY.

4.40 **Sage and Sand** Off-white textured glaze with tiny flecks of metallic brown with greenish overtones. All Casual Dinnerware and Holloware numbers and items are the same as for Boston Spice, Feather, High Tide, and Matrix. *Photo courtesy of Hinkle Memorial Library*

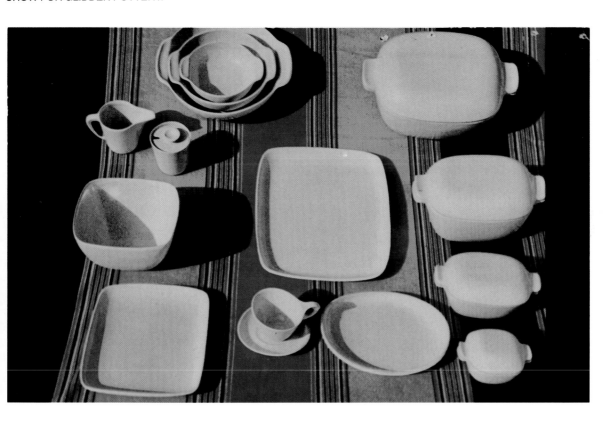

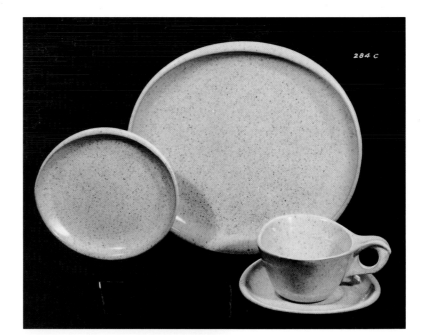

4.41 **Sage and Sand place setting** *Photo courtesy of Hinkle Memorial Library*

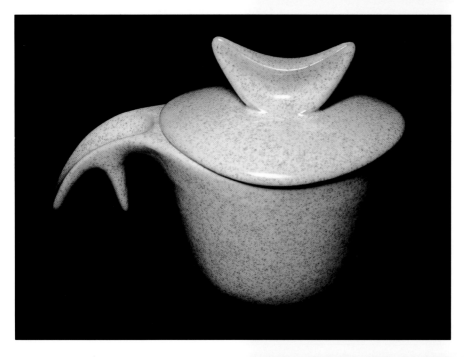

4.42 **Sugar in Sage and Sand with trigger handle** #454 with unusual handle, L. 7 in., H. 5 1/4 in., signed GLIDDEN 454 (no ram). *Collection of Era and Sandra Scofield*

4.43 **Creamer in Sage and Sand** Trigger handled creamer #453, L. 8 1/2 in., H. 4 in., signed GLIDDEN 453 (no ram). *Collection of Era and Sandra Scofield*

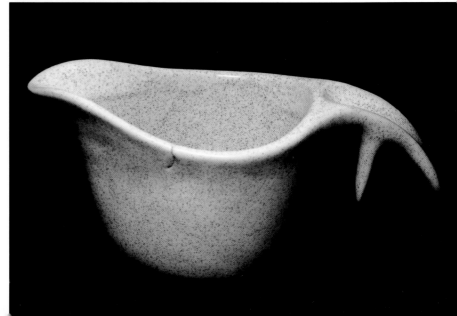

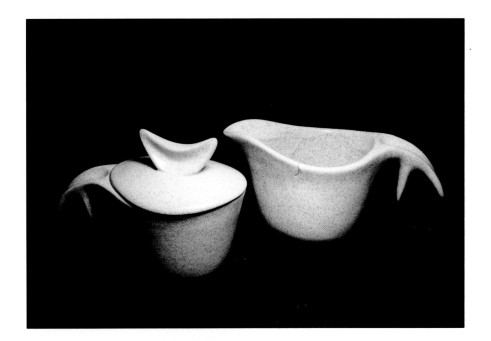

4.44 Sage and Sand creamer and sugar
Collection of Era and Sandra Scofield

4.45 Punch bowl and cup Large bowl #496 with winged handles in Sage and Sand together with one punch cup #495 in teal blue, bowl H. 6 in., L. 16 1/2 in., cup H. 2 3/8 in., L. 4 3/4 in., both signed GLIDDEN and # (no ram). *Collection of Era and Sandra Scofield*

4.46 Sage and Sand plate #465, D. 7 1/2 in., signed GLIDDEN 465 w/ram. *Collection of Era and Sandra Scofield*

4.47 Fong Chow and Glidden Parker designs
Gulfstream Blue: turquoise with royal blue and black bands.
Green Mesa: mustard yellow and mottled earth tones inlaid with brilliant green, touches of turquoise, and deep brown.
Sandstone (not pictured): pale speckled sand color inlaid with soft grey, golden rust, and subtle bands of mauve.

#4000 Wall Vase, half cylinder, 15 x 4 1/2 in.
#4001 Wall Vase, smaller, 10 1/2 x 3 1/2 in.
#4002 Vase, H. 15 1/2 in., D. 6 in.
#4002-P Vase w/hand cut perforations
#4003 Cylindrical Vase, H. 17 1/2 in., D. 3 in.
#4003-P Cylindrical Vase w/perforations
#4004 Cylindrical Vase, H. 9 1/2 in., D. 2 1/2 in.
#4004-P Cylindrical Vase w/perforations
#4005 Cache Pot, H. 4 3/4 in., D. 6 in.
#4006 Large Square Slotted Ashtray, 10 in.
#4007 Medium Square Slotted Ashtray, 7 1/2 in.
#4008 Bird, Ashtray, & Ivy Planter, 3 3/4 x 5 1/2 in.
#4009 Small Vase, H. 7 1/2 in., D. 4 1/2 in.
#4010 Wall Vase, circular 10 in.

#4011 Small Round Bowl, D. 7 in. H. 2 in.
#4012 Large Round Bowl, D. 14 1/2 in., H. 3 in.
#4013 Medium Round Bowl, D. 8 1/2 in., H. 2 in.
#4014 Hanging Shallow Planter, H. 9 in., W. 8 in.
#4015 Large Server & Flower Bowl 14 1/2 x 4 1/2 in.
#4016 Large Globe Vase, H. 10 in., D. 11 in.
#4017 Large Cylindrical Vase H. 15 1/2 in., D. 4 1/2 in.
#4017-P Large Cylindrical Vase w/perforations
#4019 Small Cylindrical Vase, H. 5 1/4 in., D. 2 1/4 in.
#4019-P Small Cylindrical Vase with perforations
#4020 Small Apple Vase, H. 5 in., D. 4 in.
#4021 Big Apple Vase, perf. 15 1/2 x 10 1/2 in.
#4023 Wall Mask, circular, 10 in.
#4024 Round Slotted Ashtray, D. 8 1/2 in.
#4025 Small Square Slotted Ashtray, 5 1/2 in.
#4026 Cache Pot, D. 4 in.
#4027 Cache Pot, D. 7 1/2 in.
#4028 Cache Pot, D. 10 1/2 in.

#4029 Self-watering Flower Pot with drainage, saucer, & fiberglass water wick, 4 in.
#4030 Self-watering Flower Pot, 6 in.
#4031 Self-watering Flower Pot, 7 1/2 in.
#4032 Self-watering Flower Pot, 10 1/4 in.
#4033 Miniature Boat, H. 2 in., L. 6 in.
#4033-U Slotted Boat Ashtray, L. 6 in.
#4034 Boat, H. 3 1/2 in., L. 10 in.
#4034-U Slotted Boat Ashtray, L. 10 in.
#4035 Boat, H. 4 1/4 in., L. 14 in.
#4035-U Slotted Boat Ashtray, L. 14 in.
#4036 Boat, H. 5 1/4 in., L. 17 in.
#4036-U Slotted Boat Ashtray, L. 17 in.
#4041 Pedestal Bowl, perforated, H. 10 in, L. 9 1/2 in.
#4041-P Pedestal Bowl w/elaborate piercing
#4042 Large Pedestal Vase, perforated, H. 17 1/2 in., D. 15 in.
#4042-P Large Pedestal Vase w/elaborate piercing
#4043 Pouch Vase, H. 17 1/2 in., L. 14 1/2 in.
#4044 Oval Cigarette Jar, 3 in.
#4045 Oval Cigarette Box, 8 in.
#4046 Candelabrum Vase, H. 10 in., L. 8 in.
Photo courtesy of Hinkle Memorial Library

4.48 Candelabrum vase with round ashtray
Gulfstream Blue #4046 candelabrum, signed
Glidden with ram in ink, together with #4013
ashtray (also described as #4024) signed
GLIDDEN plus # w/ram. *Collection of Mitchell
Attenson, courtesy Attenson's Antiques*

4.49 Square ashtray #272 similar in color to
Gulfstream Blue, W. 10 1/4 in., signed
GLIDDEN 272 w/ram. *Collection of Era and
Sandra Scofield*

4.50 **Round Covered Casserole** Sandstone color pattern - pale speckled sand color inlaid with soft grey, golden rust, and subtle bands of mauve, D. 9 in., unmarked. *Collection of Era and Sandra Scofield*

4.51 **Sandstone vase** #4009, H. 7 1/2 in., D. 4 1/2 in., signed GLIDDEN 4009. *Collection of Era and Sandra Scofield*

4.52 **Sandstone bowl** #4011, D. 7 in., signed GLIDDEN 4011 U.S.A. w/ram. *Collection of Era and Sandra Scofield*

4.53 **Sandstone boat ashtray** #4034 with notches, L. 10 in., signed GLIDDEN 4034 (no ram). *Collection of Era and Sandra Scofield*

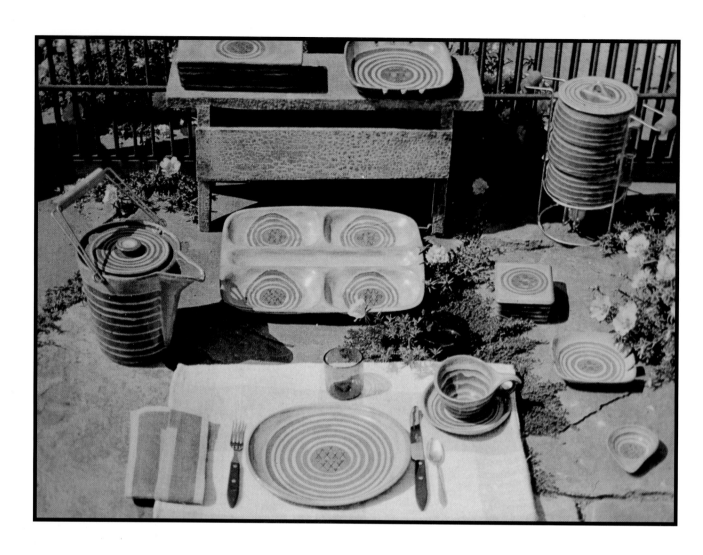

4.54 **High Tide** Deep grey glaze with hand overlay of aqua glaze swirls and center motif in rust and coral. The available items and corresponding numbers are the same as for the color patterns Boston Spice, Feather, Matrix and Sage & Sand. *Photo courtesy of Hinkle Memorial Library*

4.55 **High Tide bowls** Top left, #620 large serving bowl with lug handles, D. 12 in.; bottom left, #621 medium bowl, D. 10 in.; top right, #622 small bowl, D. 7 1/2 in.; bottom right, #467 soup cup with single lug handle in Blue. *Photo courtesy of Hinkle Memorial Library*

4.56 **Serving pieces** Top left, #17 deep salad or vegetable bowl in High Tide, H. 4 1/2 in., 8 in. sq.; top right, #22 large baker or open vegetable in Blue with sunburst decoration, 12 x 9 3/4 in.; center, #38 large platter in Blue with sunburst, 15 x 11 1/2 in. *Photo courtesy of Hinkle Memorial Library*

4.57 **Oval salad plate** Plate in blue variant of High Tide, #465, D. 7 1/2 in., signed GLIDDEN 465 w/ram. *Collection of Era and Sandra Scofield*

4.58 **Salad plate in another High Tide variation** *Collection of Era and Sandra Scofield*

4.59 **Boston Spice** Richly speckled brown glaze decorated with a hand overlay of black glaze swirls and a geometric center medallion in mustard and black. Pieces and corresponding numbers are the same as for color patterns *Feather, High Tide, Matrix,* and *Sage & Sand.* *Photo courtesy of Hinkle Memorial Library*

4.60 **Boston Spice cigarette accessories** Top left, #272u jumbo square ashtray, 10 in.; top center, #225 cigarette cup, H. 4 in.; top right, #274u small ashtray, 5 1/2 in.; bottom center, #273u medium ashtray, 7 3/4 in. *Photo courtesy of Hinkle Memorial Library*

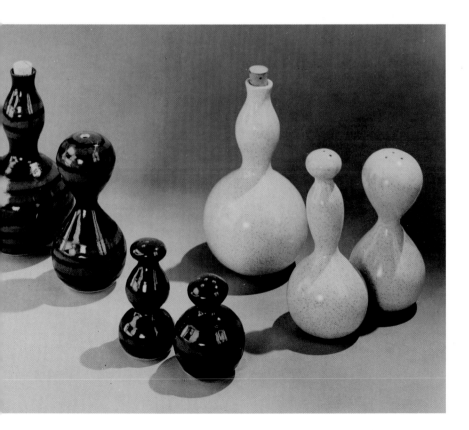

4.61 **Shakers and bottles** Top left, #632 oil/vinegar bottle in Boston Spice, H.8 in.; similar Sage & Sand bottle on right; top left center, #633 sugar dispenser in Boston Spice, H. 6 1/4 in.; bottom left, #631 pepper shaker in Boston Spice, H. 4 in.; bottom right, #630 salt shaker in Boston Spice, H. 3 1/2 in.; center left, #641 barbecue pepper shaker in Sage & Sand, H. 7 in.; far left, #640 barbecue salt shaker in Sage & Sand, H. 6 in. *Photo courtesy of Hinkle Memorial Library*

4.62 Boston Spice salad plate #465
Collection of Era and Sandra Scofield

4.63 Boston Spice chop plate #608, D. 17 in.
with lug handles, signed GLIDDEN 608 w/ram.
Collection of Hinkle Memorial Library

4.64 Rectangular box #223 container, possibly for cigarettes since many items in the 200s refer to ashtrays, L. 8 5/8 in., signed GLIDDEN 223 w/ram. *Collection of Hinkle Memorial Library*

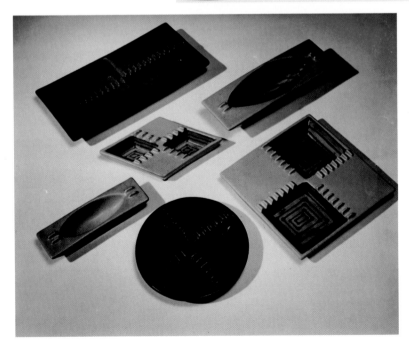

4.65 Safex ashtrays All ashtrays shown in this photo are made of high-fired stoneware and include the patented self-extinguishing "Safex" feature and come in the following colors:
-plain turquoise
-decorated turquoise with black stripes in well
-plain yellow
-decorated yellow with green stripes in well
-plain grey
-decorated grey with rust stripes in well
-plain white
-decorated white with rust stripes in well
Top left, #6 plain rectangular 12 1/2 x 6 1/2 in.; top right, #5D decorated large long 3 1/2 x 10 1/2 in.; center, #2D decorated diamond shape 5 1/2 x 8 1/2 in.; bottom left, #1 plain small long 2 1/4 x 7 1/4 in.; bottom center, #3D decorated round 7 in.; bottom right, #4D decorated large square 8 1/2 in. *Photo courtesy of Hinkle Memorial Library*

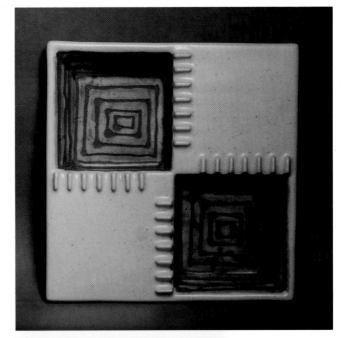

4.66 Safex ashtray #4D large square in white with grey and rust stripes in well (which does not quite fit the company description of either white or grey decorated) 8 1/2 in. sq., unsigned. *Collection of Hinkle Memorial Library*

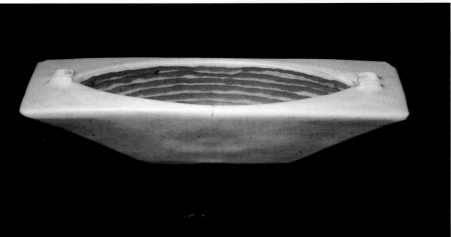

4.67 Safex ashtray #5D white. L. 10 1/2 in. unmarked. *Collection of Era and Sandra Scofield*

4.68 #273 Ashtray Square black ashtray with narrow stripes in burnt orange and white, 7 1/2 in. sq., signed GLIDDEN 273 w/ram. *Collection of Era and Sandra Scofield*

4.69 Feather with Gulfstream Blue vase
Feather is a sgraffito pattern through white slip on tan stoneware bisque. The motifs are incised freehand with a stylus. All items and corresponding numbers are the same as for Boston Spice, High Tide, Matrix, and Sage & Sand. *Photo courtesy of Hinkle Memorial Library*

4.70 Covered casseroles in Feather pattern
Left, #165 1 1/2-pt. casserole was exhibited in the 12th Annual Ceramic National at the Syracuse Museum of Art in 1947 and won 1/4 of the Richard Gump purchase prize for the best designed pottery suitable for mass production. The other designs sharing the prize were by Edwin and Mary Scheier, Christine Miller, and Minnie Negoro. Center, #161 4-qt. casserole, L. 14 5/8 in.; right #163 2-qt casserole, L. 11 1/4 in. *Collection and courtesy of the Everson Museum of Art, gift of Evaleen C. Harrison*

4.71 **Feather setting** The photo is from Gorham, dated 1-7-50 and shows Gorham's Lily of the Valley pattern with Glidden's Feather. *Photo courtesy of Hinkle Memorial Library*

4.72 **#465 salad plate in Feather** *Collection of Era and Sandra Scofield*

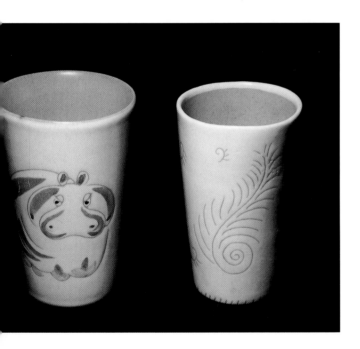

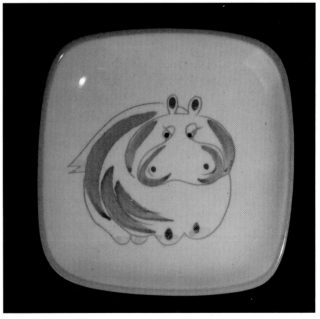

4.73 **#1127 Tumblers** Hippo motif from Circus series and Feather tumblers. H. 5 1/2 in., signed GLIDDEN 1127 (no ram). *Collection of Era and Sandra Scofield*

4.74 **Hippo canape dish #35** Glidden produced several different series of hand decorated figural designs in both sgraffito and flat paint. Of the most popular early series are the animal and circus designs, with various animals and performers sketched with a stylus and accented with color, especially gold, grey, and earth tones on an off-white ground. The 5 1/2 in. sq. canape dishes were sold in sets and signed GLIDDEN 35 with or without the ram. The examples with the ram are thicker and heavier and the painting is bolder.

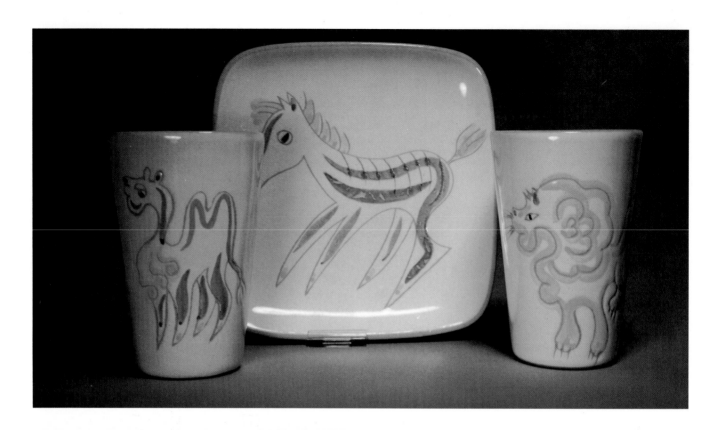

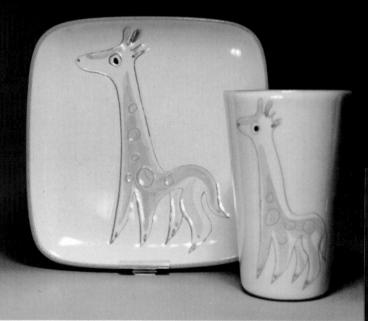

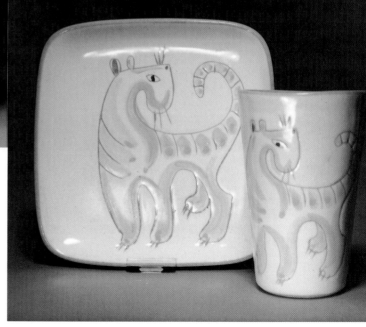

4.75 **Tumblers and plate** Left, camel tumbler #1127. H. 6 in.; center, horse plate #33, 8 in. sq.; right, lion tumbler #1127, H. 6 in., signed GLIDDEN with # (no ram).

4.76 **Giraffe plate and tumbler** Plate #33, 8 in. sq.; tumbler #1127, H. 6 in., each signed GLIDDEN and # (no ram).

4.77 **Tiger plate and tumbler** Tiger plate #33, 8 in. sq.; tiger tumbler #1127, H. 6 in., each signed GLIDDEN and # (no ram).

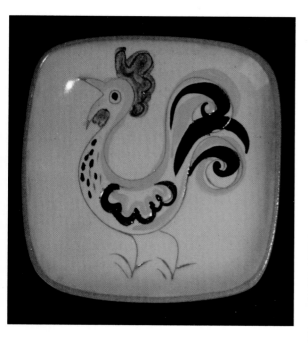

4.78 Rooster canape dish #35

4.79 Double covered casserole #169
Rooster motif, H. 5 in. L. 14 1/2 in., signed
GLIDDEN 169. *Collection of Era and Sandra
Scofield*

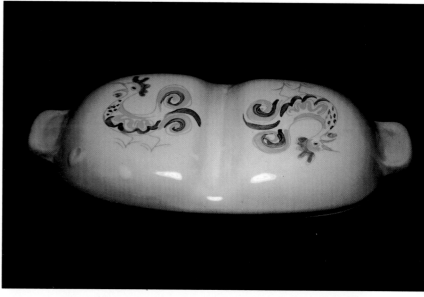

4.80 Rooster casserole opened

4.81 Hors d'oeuvres server #250 Rooster
motif is on each of the four sections. An un-
decorated version was exhibited in the 1949
"For Modern Living" exhibit of the Detroit Insti-
tute of Arts. 11 1/2 x 14 3/4 in., signed GLIDDEN
250 (no ram).

4.82 **Lion canape dish #35** 5 1/2 in. sq.

4.83 **Tiger canape dish #35**

4-84 **Zebra canape dish #35**

4.85 **Goat canape dish #35**

4.86 **Camel canape dish #35**

4.87 **Giraffe canape dish #35**

4.88 **Deer canape dish #35**

4.89 **Muscleman canape dish #35**

4.90 **Clown canape dish #35**

4.91 **Trapeze artist canape dish #35**

4.92 **Animal trainer canape dish #35**

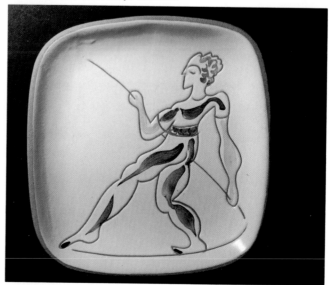

4.93 **Tight rope walker canape dish #35**

4.94 Three leaf canape dish #35

4.95 Four-leaf plate #33 Leaf in deep teal green and gold, 8 in. sq. *Collection of Era and Sandra Scofield*

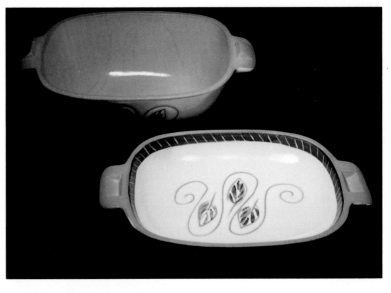

4.96 Three-leaf covered casserole #165
1 1/2-pint casserole, L. 8 1/2 in., signed GLIDDEN 165 (no ram). *Collection of Era and Sandra Scofield*

4.97 Open casserole showing leaf design inside

4.98 Three-fish casserole #163 Yellow fish on white 2-qt. casserole, signed GLIDDEN 163 (no ram). *Collection of Era and Sandra Scofield*

4.99 **Performing tiger canape dish #35**
Flat painted decoration instead of sgraffito.
Collection of Era and Sandra Scofield

4.100 **Zebra canape dish #35** *Collection of Era and Sandra Scofield*

4.101 **Cat canape dish #35**

4.102 **Christmas reindeer canape dish #35**
Collection of Era and Sandra Scofield

4.103 **Fruit plate #32** Rectangular plate decorated with hanging fruit, L. 9 in., signed GLIDDEN 32 (no ram). *Collection of Era and Sandra Scofield*

4.104 **Rooster casserole #167** Individual serving 1/2-pint size with painted rooster, signed GLIDDEN 167 (no ram). *Collection of Era and Sandra Scofield*

4.105 **Poodle casserole #167 with canape dish #35**

4.106 **Covered casserole #365** Round casserole with wood knob, decorated with butterflies and leaves, H. 7 1/2 in., signed GLIDDEN 365 (no ram). *Collection of Era and Sandra Scofield*

4.107 **Bowls #184** Three bowls with single lug handle creating a teardrop shape, decorated with butterflies, signed GLIDDEN 184 (no ram). *Collection of Era and Sandra Scofield*

4.108 **Square plate #33** Sage & Sand decorated with blue and turquoise butterflies, 8 in. sq., signed GLIDDEN 33 (no ram). *Collection of Era and Sandra Scofield*

4.109 **Sheep canape dish #35** Light grey with speckled brown border and a high gloss finish, signed GLIDDEN 35 (no ram). *Courtesy of Studio Moderne*

4.110 **Seal canape dish #35** *Courtesy of Studio Moderne*

4.111 **Reindeer canape dish #35** *Courtesy of Studio Moderne*

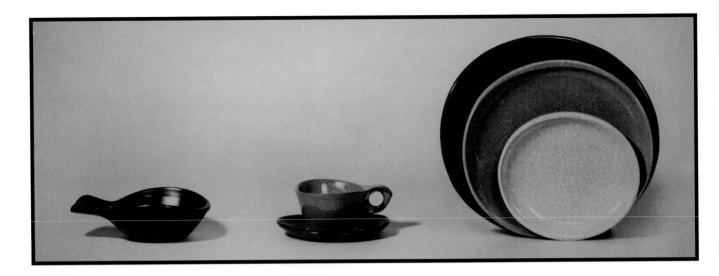

4.113 **Table setting** *Photo courtesy of Hinkle Memorial Library*

4.112 **#6 vase** Beige vase with brown speckled texture and a high gloss finish, H. 6 1/4 in., signed GLIDDEN 6 (no ram). *Courtesy of Studio Moderne*

4.114 **Salad plate #465 with blue printed design** *Collection of Era and Sandra Scofield*

4.115 **Salad plate #465 with painted abstract design** *Collection of Era and Sandra Scofield*

4.116 **Salad plate #465 in pink** *Collection of Era and Sandra Scofield*

4.117 **Salad plate #465 with printed abstract pattern in white** *Collection of Era and Sandra Scofield*

4.118 Salad plate #465 in deep teal
Collection of Era and Sandra Scofield

4.119 Salad plate #465 in mottled teal
Collection of Era and Sandra Scofield

4.120 Salad plate #465 in dull finish
Collection of Era and Sandra Scofield

4.121 **Ferris wheel** Three teal green and three gold rectangular bowls resting on a black metal wheel, each L. 6 in., signed 1005-F and probably by Glidden.

4.122 **Ferris wheel**

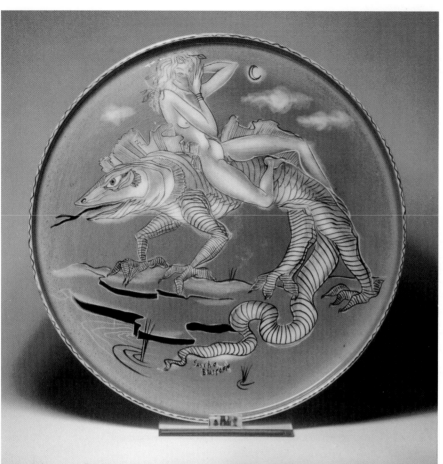

5.1 Night Rider by Sascha Brastoff
Earthenware canape tray from the extraordinary 1948 Nightmare series picturing a nude woman riding on the back of a giant lizzard in black and white on brown in a high gloss finish, D. 11 1/4 in., painted by and signed SASCHA BRASTOFF. *Collection and courtesy of the Everson Museum of Art*

5.2 Serenade by Sascha Brastoff White dancing figures against a midnight blue background in high gloss from the nightmare series of canape trays. *Serenade* won a purchase prize award in the 13th Ceramic National in 1948. D. 11 1/4 in., painted by and signed SASCHA BRASTOFF. *Collection and courtesy of the Everson Museum of Art*

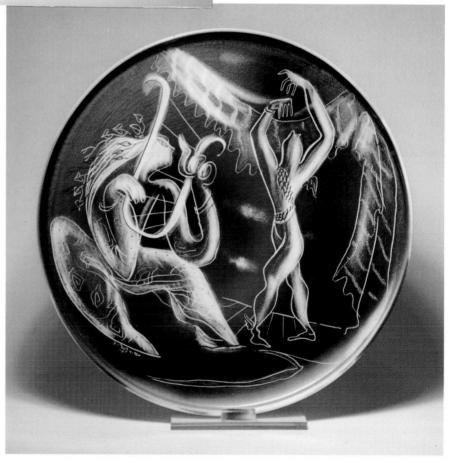

Chapter Five
Sascha Brastoff and other California Potteries

Sascha Brastoff was colorful, flamboyant, and imaginative, and his pottery designs reflect this. Words like theatrical, exotic, and even bizarre come to mind when encountering his prancing horses or Siamese dancers. Although the pottery shapes are usually modern and typically Fifties, it is the decoration with its subtle color schemes and gold accents that catches the eye and identifies his wares. Rather than emphasizing tableware and dinnerware (place settings) as other American pottery manufacturers of the period did, Brastoff preferred oversized vases, smoking accessories, figurines, lamps, and other items destined to decorate kidney-shaped cocktail tables and Danish Modern shelves. His was production pottery because it was factory-made in pre-determined designs, but Brastoff's creations were also art pottery with hand-painted decoration assuring that no two pieces were exactly alike. Advertisements and Brastoff himself declared that each piece was an original. In a 1958 interview with *The Cleveland Plain Dealer*, he said, "It is more difficult to turn out an ashtray for five dollars than a display piece for $3,000...but why shouldn't everybody live with beautiful things?" Like the pottery, it was said that Sascha Brastoff was an original.

Born in Cleveland, Ohio in 1918, Samuel (Sammy) Brastoff was one of eight children (five were from his father's previous marriage). Before emigrating to the United States, his father Louis was a clothing cutter in a Russian factory; his mother Rebecca was from Hungary. Sammy decorated his first pottery as a toddler, but these early dinnerware designs were always washed away in order to serve dinner. As he grew, his interest in painting turned more toward sculpture. He also studied ballet and, with a little coaxing from a Russian ballet teacher, took the name "Sascha." His mother disapproved and continued to call him Sammy. Later, Sascha's talent as a dancer and entertainer would be his

5.3 Night Monster by Sascha Brastoff
White multi-legged winged monster on a blue-grey ground from the 1948 nightmare series, D. 11 1/4 in., painted by and signed SASCHA BRASTOFF. *Collection and courtesy of the Everson Museum of Art*

5.4 Sex Monster by Sascha Brastoff
Earthenware canape tray with grotesque female monster in white against a grey ground in high gloss finish, D. 11 1/4 in., painted by and signed SASCHA BRASTOFF. *Collection and courtesy of the Everson Museum of Art*

5.5 Abstract Fruit by Sascha Brastoff
Earthenware canape tray decorated with white abstract fruit on a brown ground in high gloss finish, D 11 1/4 in., painted by and signed SASCHA BRASTOFF. *Collection and courtesy of the Everson Museum of Art*

ticket out of an Army mechanical job and into Special Services where he earned the nickname "the G. I. Carmen Miranda."

After graduating from Glenville High School in Cleveland in 1935, he went to New York and found a job with Macy's Department Store doing window display. In his spare time, Sascha worked in ceramics. When he returned home to Cleveland, his sister Evelyn saved pennies from her household budget to pay for carfare so that Sascha could attend the Cleveland School of Art.

Clay sculpture was one of his early successes, and one piece was awarded a prize for whimsy in the 1939 Ceramic National at the Syracuse Museum of Art (Everson) and another was in the 1948 exhibit. In 1941 the Clay Club Gallery at 4 West 8th Street in New York presented his terra cotta sculptures called "Whimsies" in a one-man show from May 3 to June 7. In the printed program, Sahl Swarz applauded Brastoff for both his fantastic imagination and the technical skill. "Only one who is a sculptor

at heart could model forms so fundamentally well-proportioned and graceful in composition..." Swarz also wrote, "Sascha Brastoff was born in Bangkok, Siam; Petrograd, Russia; or in Cleveland, Ohio depending on a mood or occasion...he lives in a world akin to that of Alice in Wonderland, where time is endless." Fish-mouthed figures and plump nudes were modeled in tinted clay, so that rather than by applying a glaze, Sascha achieved an unusual color effect with a natural matte finish.

One of the most well-received pieces in the show, *Europa and the Bull*, demonstrated both a strong Cleveland School and an Austrian influence. In the 1920s and 1930s, clay sculpture was an important and popular art form with students and faculty at the Cleveland School of Art. Those who had studied in Austria brought a sophisticated yet whimsical style to this institution that was in the process of forming an artistic identity. Cowan Pottery collaborated with most of these ceramic artists, several of whom also used the Europa theme. Other

titles from Brastoff's group of 37 whimsies listed in the exhibit program include *Faun Baby*, *Europa Etcetera*, *Neptune's Folly*, *Snake Charmer*, *Afrique*, *Lady Godiva*, and *Leda* — which also suggest images similar to those of the Austrian-influenced Cleveland School.

His memorable appearance as Carmen Miranda in the Army's "Winged Victory" show in 1944 was the last time Brastoff saw his parents for many years. Although he would return to Cleveland to promote or show his work (Higbee's Department Store often featured his pottery), California was his new home. His first job in California was with 20th Century Fox designing costumes; and he continued to work in ceramics in his spare time making dog and cat dishes for movie stars. Then, in 1948, with financial backing from Winthrop Rockefeller, he opened his first ceramics plant on Sepulveda Blvd. in West Los Angeles making handpainted earthenware. Any pieces Brastoff painted were signed "Sascha Brastoff," and those done under his

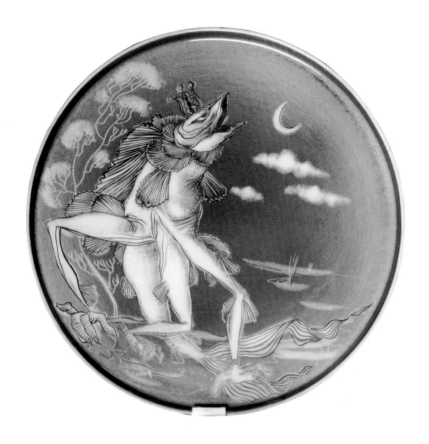

5.6 **Fish Monster by Sascha Brastoff**
Earthenware canape tray depicting a multi-legged fish monster with crescent moon and clouds in black and white against a blue-grey ground, D. 11 1/4 in., painted by and signed SASCHA BRASTOFF. *Collection and courtesy of the Everson Museum of Art*

supervision by one of several decorators trained to paint in his style were signed "Sascha B." According to Jack Chipman in *The Encyclopedia of California Pottery*, Tom Hamilton of American Ceramic Products offered Brastoff a limited partnership at his plant in Hawthorne, and so in April of 1952, Sascha Brastoff of California opened. Sadly, the plant burned down several months later. With Rockefeller's continued backing, a new plant was built at 11520 West Olympic Blvd. in Los Angeles. The larger, half-million dollar facility covered a city block and employed about eighty people. Among the guests at the factory dedication in 1953 were Zsa Zsa Gabor, Edward G. Robinson, and Mitzi Gaynor. At that time, Sasha Brastoff's rooster backstamp in gold or platinum came into use. The following year they introduced the first dinnerware lines.

Winslow Anderson sometimes met Brastoff at ceramic and glass trade shows, such as in Pittsburgh, where he said Brastoff's booth gave new meaning to the word "chaos." "Talk about care for madness...,"

5.7 **Fish Monster detail**

5.8 Sascha Brastoff vase Chalky white vase tapering to a narrow neck with flared lips and decorated in metallic pewter and gold leaves and flowers, H. 8 in., signed SASCHA B. with rooster backstamp.

Anderson added. Brastoff loved the wonderfully modern glass that Anderson designed for Blenko in Milton, West Virginia, and so they would trade Brastoff's big (expensive) gilded talc roosters for Anderson's big colored glass bottles. The cheap talc body fired at a low temperature made Brastoff's wares very soft. According to Anderson, "If you yelled too loudly, they would break." Yet, the decoration was appealing and well executed, and the company continued successfully.

Exhausted from the pace, Brastoff retired from the company in 1963, leaving Gerald Schwartz to carry on as plant manager for another decade. Sculpture then occupied Brastoff's time, and in 1966 he had fifty pieces of metal sculpture in a one-man show at the Dalzell Hatfield Galleries in Los Angeles. The show was also seen at the Ross Widen Gallery in Cleveland in 1967. A significant departure from clay whimsies, the theme and title was "Moon-Age Sculpture." The result of five years of experimentation with various metals and techniques, many of the works were in silver-white magnesium. This was a new material for a work of art, and Brastoff gained a reputation as an innovator. He experimented with many materials and, in addition to sculpture and ceramics during his long artistic career, made jewelry of gold and gems, enameled on copper in the same decorative style as the pottery, painted, worked with glass, and eventually experimented with holograms.

In February of 1993, Sascha Brastoff died in Los Angeles leaving a legacy of mid-century design that ranged from semi-serious clay sculpture to high camp gilded production pottery. His work can be seen in museum collections such as the Everson Museum of Art, Los Angeles County Museum of Art, Metropolitan Museum of Art, Cranbrook Academy, Guggenheim Museum of Art, Houston Museum of Art, and the Sculpture Center in New York. Of particular interest to collectors today, Sascha Brastoff pottery (and enamels) frequently turns up at flea markets, antiques shows, and antiques shops.

Whether a lamp or an ashtray, Sascha Brastoff's pottery can be readily recognized. His themes include prancing horses, roosters and exotic birds, dancers and other figures in exotic costumes, houses and roof-

tops, fruit, fish, animals such as walruses, and abstract geometric patterns especially horizontal stripes. His color schemes tend toward greys, muted earthtones, deep teal, brown, navy blue, black, and white, with metallic gold generously applied as accents. Most of his finishes are extreme —either flat matte or high gloss.

5.10 Sascha Brastoff mushroom vase Mushroom-shaped vase with molded or slip-decorated design and SASCHA B. signature, covered in a metallic pewter finish, H. 5 in. with rooster backstamp.

5.9 Sascha Brastoff vase Tall slender cylindrical vase with narrow neck decorated in horizontal bands in muted tones of green, blue, and brown with metallic gold on a matte white ground. Whether high gloss or matte finish, the most typical Brastoff color schemes use muted and deep colors with bright gold accents. H. 17 in., signed SASCHA B. (meaning that one of Brastoff's decorators painted this under his supervision) with rooster backstamp.

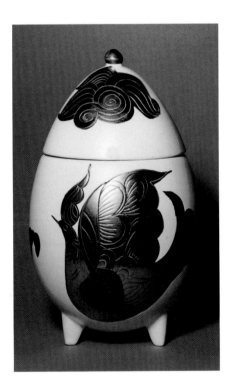

5.11 Sascha Brastoff covered egg Chalky white vase in the form of a covered egg mounted on three legs and decorated with a metallic pewter and gold stylized bird with an Eastern European flavor, H. 7 1/2 in., signed SASCHA B. with rooster backstamp.

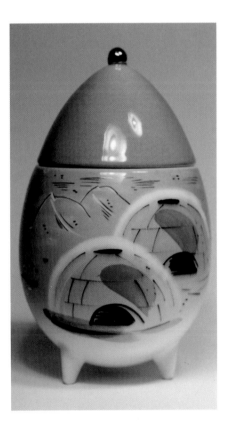

5.12 Sascha Brastoff covered egg Pale olive green covered vase in the shape of an egg on three feet, painted with igloos, H. 7 1/2 in., signed SASCHA B. with rooster backstamp.

Brastoff and other California Potteries 145

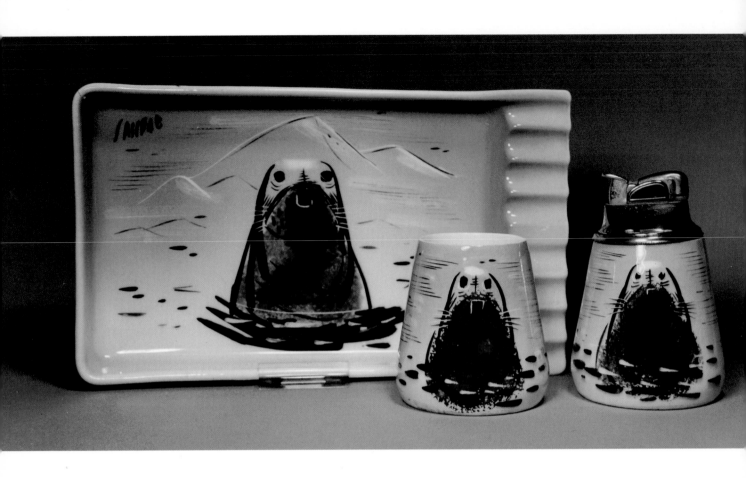

5.13 Brastoff smoking set Rectangular ash-tray, L. 8 1/2 in; cigarette holder, H. 2 5/8 in., and lighter, each in pale olive green decorated with a brown walrus and signed SASCHA B. on front, no rooster.

5.14 Sascha Brastoff slipper dish Nut or relish dish shaped like a slipper and decorated with pagoda rooftops surrounded by trees in earth tones and teal blue in a high gloss finish, L. 13 1/2 in, signed SASCHA B. with rooster backstamp. *Courtesy of Attenson's Antiques*

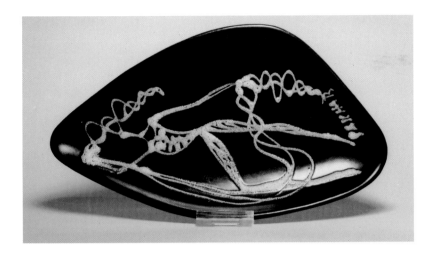

5.15 Sascha Brastoff freeform plate
Black plate in typical Fifties shape with abstract figure sketched in white, L. 9 1/4 in., signed SASCHA B., no rooster. *Collection of Mitchell Attenson*

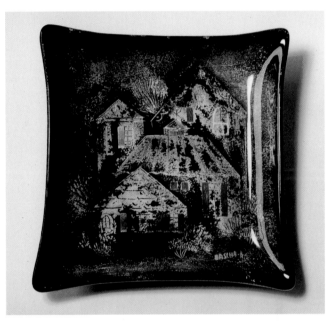

5.16 Sascha Brastoff ashtray Square ashtray with extended corners in high gloss black and green background, decorated in a sponged-on technique with houses in brown, black, and pink with gold windows, 8 in., signed SASCHA B. with rooster backstamp.

5.17 Detail of house

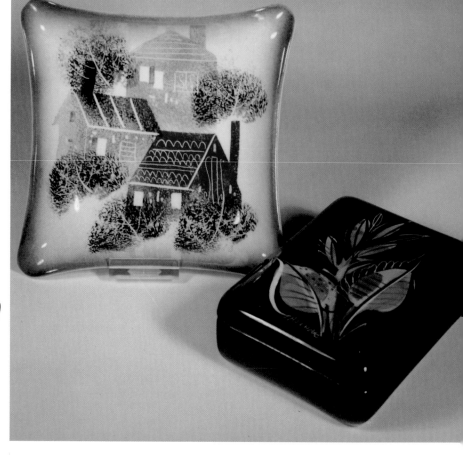

5.18 Sascha Brastoff ashtray with box
Square ashtray with stretched corners, the white ground edged in grey and decorated with pink, gold, and brown houses, W. 6 3/8 in., signed SASCHA B. with rooster backstamp; together with a dark green covered box decorated with colored leaves, L. 5 in., signed SASCHA B. no rooster. *Courtesy of Studio Moderne*

5.19 Sascha Brastoff ashtray Square ashtray with pulled corners in deep teal green painted with leaves,W. 6 in., signed SASCHA B. on front, no rooster.

5.20 Leaf detail

5.21 Sascha Brastoff freeform plate
Biomorphic Fifties shape with sides turned up, the deep teal ground decorated with a prancing horse in earthtones and turquoise accented in gold, L. 9 in., signed SASCHA B. with rooster backstamp.

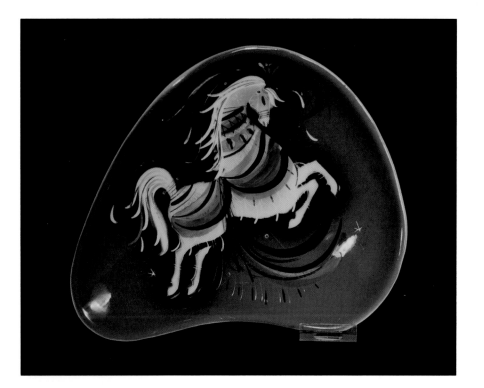

5.22 Horse detail

5.23 Sascha Brastoff freeform ashtray
Biomorphic shape with another of Sascha's prancing horses, in greys and muted earthtones in a matte finish and accented in metallic gold, L. 8 1/2 in., signed SASCHA B. with rooster backstamp.

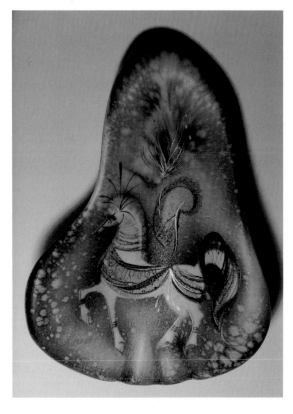

Brastoff and other California Potteries 149

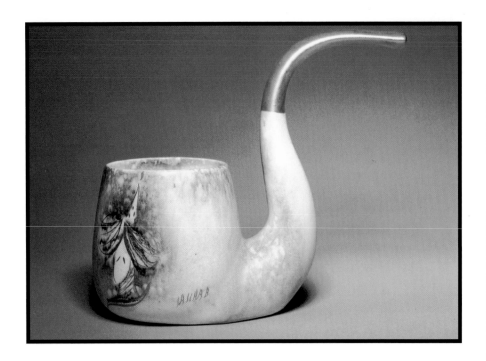

5.24 **Sascha Brastoff pipe** Cigarette container in the form of a pipe in popular gray matte finish decorated with stylized faces in greys, muted earthtones, and metallic gold, H. 5 1/4 in., L. 6 1/4 in., signed SASCHA B. with rooster backstamp.

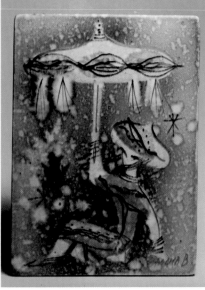

5.25 **Sascha Brastoff covered box** Seated figure under a parasol dressed in pink on a grey and white background with gold accents and a matte finish, L. 5 1/2 in., signed SASCHA B. no rooster. *Courtesy of Attenson's Antiques*

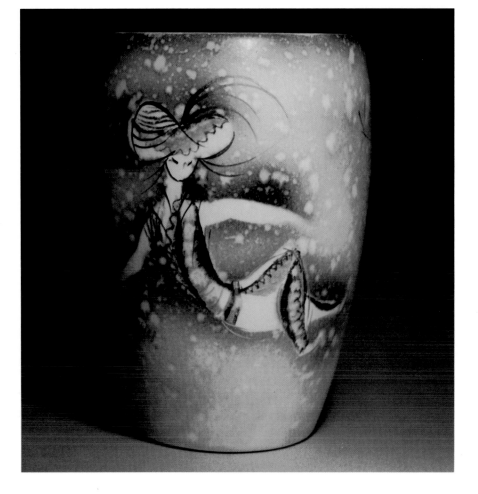

5.26 **Sascha Brastoff vase** Tapered cylindrical vase in mottled greys decorated with a seated figure in exotic costume, in a matte finish, H. 5 1/2 in., signed SASCHA B. with rooster backstamp.

5.27 Sascha Brastoff tray Large square serving tray in matte finish with greys and earth tones, two figures dancing between a fire and a tree and another on horseback, 14 1/2 in. sq., signed SASCHA B. with rooster backstamp.

5.28 Tray detail

5.29 Sascha Brastoff ashtray Square ashtray with pulled corners decorated with an exotic dancer in ochre, black, and white against a mottled grey background, D. 8 in., signed SASCHA B. with rooster backstamp.

5.31 **Sascha Brastoff footed bowl** Round bowl in black luster glaze with glassy orange and rust abstract shapes, D. 5 3/4 in. H. 4 in., signed SASCHA B. no rooster.

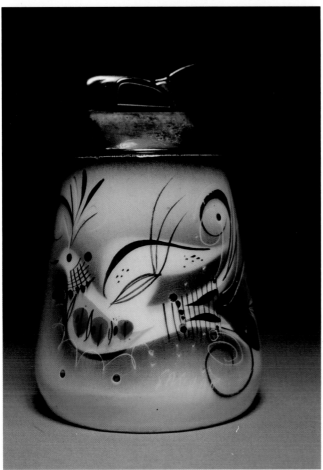

5.32 **Sascha Brastoff round ashtray**
Covered bun-shaped ashtray open at one end, with black lustre glaze and glassy abstract shapes in orange and rust. D. 5 3/4 in., signed SASCHA B. no rooster.

5.30 **Sascha Brastoff cigarette lighter**
Lighter mounted in a pottery container with exotic bird in black, white, and earth tones on a grey ground with gold accents and high gloss finish, H. 2 3/4 in., signed SASCHA B. with rooster backstamp.

Other California pottery companies during the same time also produced modern wares of interest. Vernonware (1930-58) was made by the Vernon Kilns in Vernon, California. The Poxon China Co. was purchased in 1930, renamed Vernon Kilns (also Vernon Potteries) in 1931; they made original dinnerware designs by 1934. The 1950s were the best years, but they closed in 1958 and Metlox Potteries of Manhattan Beach, California bought the name. Among the most successful designs is a series of hand painted plaids originally designed by Gale Turnbull. The six popular patterns of the 1940s and 1950s were named Tam O'Shanter, Organdie, Homespun, Gingham, Calico, and Tweed. Metlox Potteries also began to produce dinnerware from about 1947, often under the name Poppytrail.

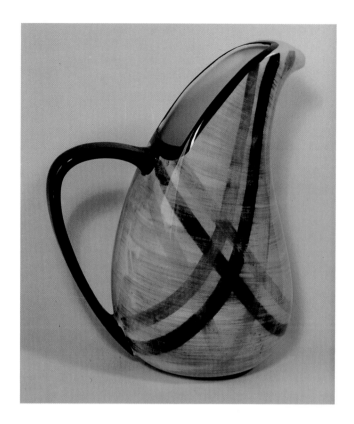

5.33 Vernonware water pitcher This water pitcher, shaped much like Russel Wright's American Modern pitcher, is in the Tam O'Shanter pattern in rust, forest green, and chartreuse plaid with the edges in forest green, H. 11 1/4 in., marked UNDERGLAZE HAND PAINTED TAM O'SHANTER VERNONWARE CALIFORNIA U.S.A.

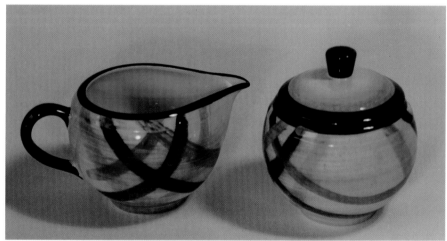

5.34 Vernonware creamer and sugar Also in the Tam O'Shanter pattern of rust, forest green, and chartreuse, creamer L. 5 1/2 in., suger H. 4 1/2 in., marked AUTHENTIC VERNONWARE MADE IN U.S.A.

5.35 Vernonware creamer and sugar Somewhat different shape of creamer, with a circular top and separate spout, and sugar bowl is slightly wider; this pattern is called Homespun, in rust, deep yellow, and medium green, with edges in rust, marked.

5.36 **Vernonware** Cup and saucer, lug handle soup bowl, D. 7 3/8 in., and small bowl, D. 5 5/8 in., in Tam O'Shanter pattern, marked.

5.37 **Vernonware butter dish** Covered butter dish in Homespun pattern, L. 7 1/2 in., marked.

5.38 **Vernonware salt and pepper** Identical shakers with holes at the top forming an S or a P, also in the Homespun pattern.

5.39 **Vernonware plate** Dinnerware sets include dinner, salad, and bread and butter plates (pictured in Tam O'Shanter pattern, D. 6 3/8 in., marked.)

5.40 **Vernonware plate** Salad plate in the Homespun pattern, D. 7 1/2 in., marked.

5.41 **Vernonware plate** Dinner plate in the Organdie pattern of deep yellow and dark brown with edges in the brown, D. 9 3/4 in., marked.

Brastoff and other California Potteries 155

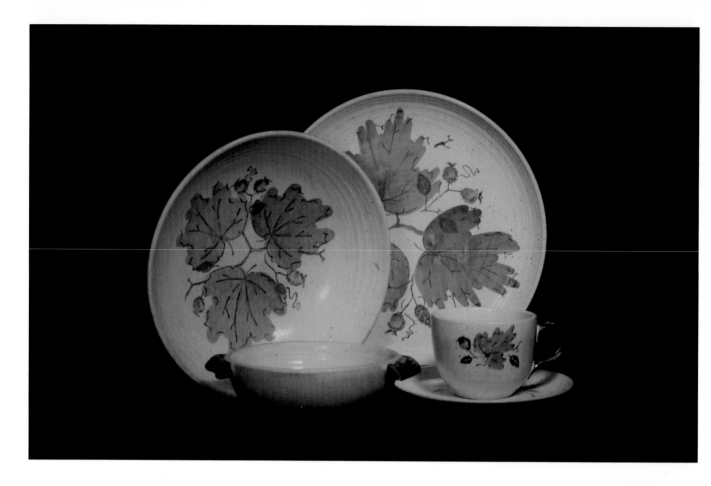

5.42 Metlox Poppytrail Woodland Gold
Woodland Gold pattern in off-white with spattered earth tones, decorated with Fall leaves and seed pods in earth tones; the cup and bowl handles shaped and painted like tree bark, plate D. 10 1/2 in., bowl D. 9 in., small bowl D. 7 in., marked POPPYTRAIL BY METLOX MADE IN CALIFORNIA, the plate with WOODLAND GOLD.

5.43 Metlox Poppytrail rooster mug
Courtesy of Second Hand Rose Antiques

5.44 Poppytrail California Ivy White cup with brown tree bark handle and white bowl, decorated in trailing dark and light green ivy design with a glossy finish, marked CALIFORNIA IVY HANDPAINTED POPPYTRAIL with map of California. *Courtesy of Second Hand Rose Antiques*

The Gladding McBean company, founded in 1875, patented a talc body to replace the usual clay in 1928. Its dinnerware division began about 1934 and used the trade name "Franciscan." Gladding McBean purchased the Catalina Clay Products line from the Santa Catalina Island Company and added the trade name "Catalina" to their line.

5.45 Franciscan covered containers Small covered containers in modern shapes glazed in deep forest green, papaya, and yellow, average H. 3 in., marked FRANCISCAN MADE IN CALIFORNIA

5.46 Franciscan Starburst plate Oval plate in white, decorated with typically Fifties graphic stars, D. 8 in., marked FRANCISCAN MADE IN CALIFORNIA U.S.A. COLOR SEAL OVEN SAFE. *Courtesy of Ralph and Terry Kovel*

5.47 Catalina center bowl Late 1930s white bowl with molded Art Deco style scroll base and glossy turquoise interior resembling pieces by Cowan Pottery, D. 13 in., marked CATALINA POTTERY MADE IN U.S.A.

5.48 **William Manker vases** Left, clear turquoise; right, shaded from pink at the top to deep mauve, H. 7 1/2 in. marked WILLIAM MANKER CALIFORNIA U.S.A. *Collection of Mitchell Attenson, courtesy of Attenson's Antiques*

William Manker worked in Claremont, California from about 1933 to 1954 making simple yet elegant modern forms glazed in soft colors. He said, "I've always maintained that if the shape is beautiful, there's no occasion for using decoration on it, and if is isn't, then all the decoration in the world isn't going to make it more beautiful." (Chipman 1983)

Another California potter working in the modern style was Howard Pierce, born and schooled in Chicago, who established a studio in La Verne, California in 1941. After the war, he and his wife produced comtemporary figurines at Claremont, and business was especially good during the 1950s.

5.49 **Weil chinoiserie vase** Light grey four-sided vase with dark brown base and tree limbs decorated with applied relief leaf clusters painted green in a distinctly Chinese style, H. 9 in., paper label with picture of a donkey and WEIL WARE MADE IN CALIFORNIA and marked at the base HAND DECORATED WEIL WARE MADE IN CALIFORNIA with donkey.

5.50 Howard Pierce birds Long-necked water birds in off-white with dark brown bills and bottoms, H. 14 in., marked HOWARD PIERCE. *Courtesy of Ralph and Terry Kovel*

5.51 Pheasants Although not signed, the chalk body and gilding in a turquoise glaze is typically Californian. Roosters and other flamboyant birds were especially popular themes in California, as well as in other areas. H. 15 3/4 in.

5.52 Coffeepot Asymmetrical forms have become trademarks of mid-century design. This coffeepot with molded stylized fluting to resemble drapery folds, and a prominent freeform finial, has a talc body glazed in turquoise and generously gilded, made by California Originals, which began in 1947 in Manhattan Beach. H. 10 3/4 in., paper label CALIFORNIA ORIGINALS MANHATTAN BEACH CALIF.

5.53 Asymmetrical plate Freeform plate glazed in deep teal green mottled with black, incised to reveal the white body, with an abstract linear figure of an archer, L. 8 1/2 in., signed PETERSON CALIFORNIA.

Brastoff and other California Potteries 159

5.54 **Brock egg plate** Forest green serving plate with depressions for 12 hard-boiled eggs, a white (the talc body) center decorated with a crowing rooster, D. 13 in., marked CALIFORNIA BROCK WARE

5.56 **Rooster detail**

5.55 **Brock lazy Susan** Five pottery sections decorated with green and brick red roosters and a round covered centerpiece, all edged in brown and placed on a round revolving wooden tray, D. of pottery 15 5/8 in., marked BROCK OF CALIFORNIA.

5.57 **Morning rooster by Walter Duff** Although
not made in California, this series of rooster
designs resembles others made in California
and typical of the period, D. 6 1/4 in., marked
MR. & MRS. J. COCK-TAIL DESIGNED AND
COPYRIGHTED BY WALTER R. DUFF
ISSUED BY FONDEVILLE & CO. NEW YORK.

5.58 **Afternoon rooster by Walter Duff**

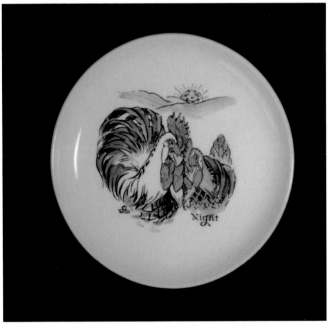

5.59 **Evening rooster by Walter Duff**

5.60 **Night rooster by Walter Duff**

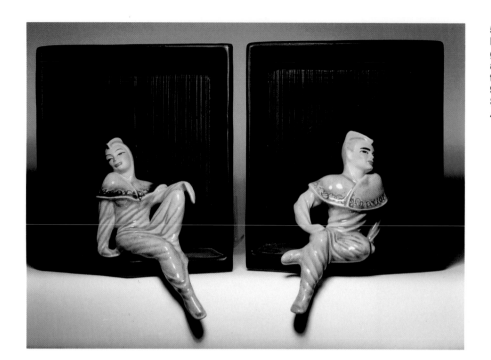

5.61 **Michelle and Maurice** Seated figures, Michelle on the right and Maurice on the left, in gold costumes, each placed in a black box like a theater stage, in the style of California pottery but from Wisconsin, box H. 8 in., figure L. 9 in., marked CERAMIC ART STUDIO MADISON WISCONSIN. *Courtesy of Attenson's Antiques*

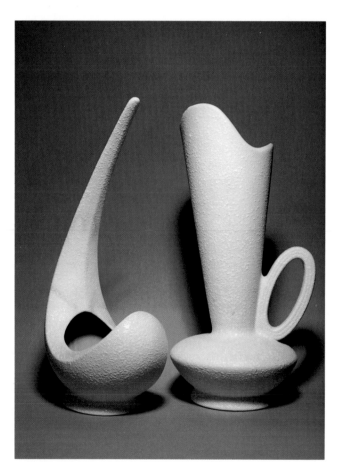

5.62 **Sculptural vase and pitcher** Fifties abstract forms textured in a white stucco-like finish, the vase with one end rounded and the other stretched like a tail, the pitcher designed more with sculpture in mind than function, H. 14 in., marked ORIGINAL U.S.A. *Courtesy of Attenson's Antiques*

5.63 **Footed vase** White textured, four-sided vase with orange glazed interior on an orange pyramidal foot, H. 12 3/4 in., marked ORIGINAL U.S.A.

Similar styles came, too, from others, not from California. The Red Wing Pottery of Red Wing, Minnesota produced a number of modern dinnerware patterns in the 1950s and early 1960s that at first glance easily could be mistaken for California wares. Their Pompeii is one of six patterns of the 1962 Cylinder series which focused on simple geometric shapes. Another of the modern designs offered by Red Wing was Merrileaf, circa 1960.

5.64 **Red Wing Pompeii dinner plate** Circa 1962, D. 10 1/4 in., unmarked. *Courtesy of Ralph and Terry Kovel*

5.65 **Red Wing Merrileaf dinner plate** D. 10 in., marked TRUE CHINA RED WING U.S.A. HAND PAINTED 121. *Courtesy of Ralph and Terry Kovel*

Part Two:
From England and Europe

Introduction

Dozens of English and European pottery companies with long established reputations and traditions either added or focused on particular modern lines, especially during what is loosely called the Art Deco period of the 1920s and 1930s and even into the 1940s. The French pottery Longwy boasts more than a 200-year history, yet its cloisonné enamel decorated wares, particularly the Art Deco designs, are the most sought after. In England, on the conservative side, old favorite Royal Doulton Co. indulged in some richly glazed and painted earthenware with a distinctly modern look, as well as some very modern dinnerware. Other English companies, such as Crown Works in Burslem, introduced new shapes like Susie Cooper's Kestral. Some used traditional shapes and covered them with lavish lustre and enamel decoration, as did Wiltshaw and Robinson in their Carlton Ware. This was similar to a much admired venture into exotic painting by Wedgwood, an otherwise traditional company, with its Fairyland and Dragon lustres. At the most extreme end of this spectrum would be

the unmistakably Art Deco pottery by Clarice Cliff, who introduced new angular shapes and smothered them with bold Bizarre and Fantasque patterns and colors. Some of the Czechoslovakian wares of the period also enjoyed the same playful spirit of decoration with vibrant contrasting color, sometimes referred to as peasant designs. Some of the Czech shapes followed English trends, notably the popular lines of animal shaped mugs and jugs which can be compared with Doulton's Tobys or Burleigh Ware animal-handled pitchers.

The trend toward colorful painted decoration as well as unusual shapes continued into the next decades. By the 1950s, the Art Deco designs had been replaced by either a different angular geometry or a softly curved biomorphism that characterized a more confident modernism. Oddly, many of these innovative and well-crafted pieces were made anonymously. Some have no identifying mark at all, while others have only the country of origin painted or molded at the bottom. Italy, Czechoslovakia,

Germany, (and Japan) produced some interesting and often good quality pottery in the 1950s and into the 1960s. Fifties asymmetrical forms were embellished with deep incising and thick slip or enamel that added to their sculptural quality.

The examples shown here represent the range of European pottery from the tentatively to the boldly modern. Each relies on surface decoration, from the cloisonné enamel of French Longwy to the applied silver of Swedish Gustavsberg, to the exaggerated crackle of Hungarian Zsolnay. Many of these items are being collected and admired today, not for the company name or mark, which is sometimes absent, but for the style and quality of each design. The variety of style and design (and quality) over this forty year period is wide. Perhaps the samples shown here will help to attract some well-deserved attention from researchers, because much research is needed, and from inquisitive collectors, the real moving force in the decorative arts.

6.1 **Carlton Ware** Cream pitcher in Rouge Royale with enameled and gilded flying duck, H. 6 in., marked CARLTON WARE MADE IN ENGLAND TRADE MARK; slightly bulbous tapered cylindrical vase with two handles, also in Rouge royale, H. 6 1/4 in., marked CARLTON WARE MADE IN ENGLAND ROUGE ROYALE; and small pitcher with spider web, H. 3 in., marked CARLTON WARE MADE IN ENGLAND HANDPAINTED ROUGE ROYALE with paper labels for Carlton and Birks.

Carlton Ware
and Other Innovators

Wiltshaw and Robinson, a Staffordshire manufacturer of earthenware and porcelain, began operating the Carlton Works in 1890. In the mid-1920s they made novelty tableware, often in the shapes of leaves and vegetables, like majolica. They also developed several colors of lustre, giving them names like "Rouge Royale" and "Bleu Royale," and by 1924 they were using twelve of these colors. These lustres were often lavishly gilded and enameled in Chinese style or Art Deco designs. In the 1930s, coffee sets with gilded interiors and enameled exteriors were often of very high quality. In 1932 Wiltshaw and Robinson merged with Birks, Rawlins & Co. and continued to make vases, coffee sets, and other artware richly decorated in lustre and enamel relief. They were renamed Carlton Ware Limited in 1957 and changed ownership again in 1967 and in 1987.

6.2 Detail of duck.

References
Bartlett 32-33, Cameron 357

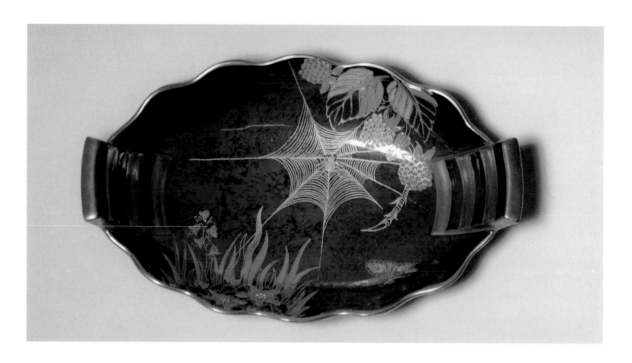

6.3 **Carlton Ware** Shallow bowl with scalloped edge in Rouge Royale lustre, decorated with enameled leaves and spider web, L. 7 in., marked CARLTON WARE MADE IN ENGLAND TRADEMARK ROUGE ROYALE.

6.4 Detail of web.

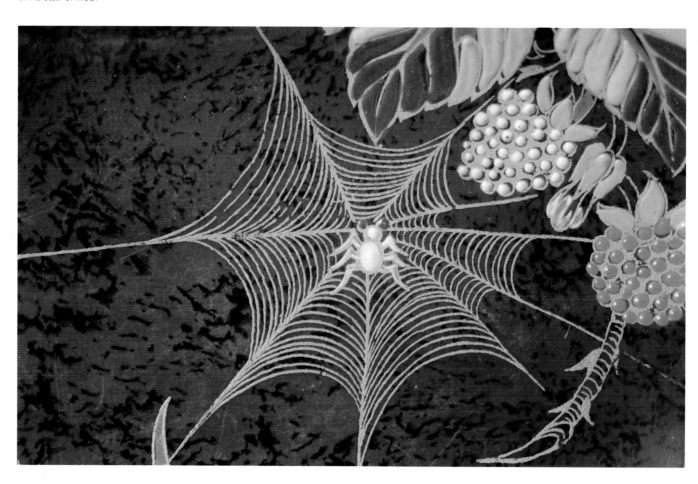

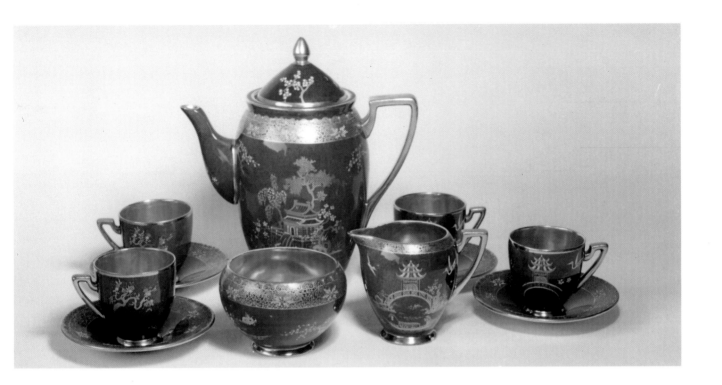

6.5 **Carlton Ware** Coffee set in Bleu Royale with gilded interior and elaborate Chinese style and gilded decorations. Coffee pot H. 8 in., marked W&R STOKE ON TRENT CARLTON MADE IN ENGLAND with different numbers on each piece.

6.6 Detail of coffee pot.

6.7 Detail of gilded saucer edge.

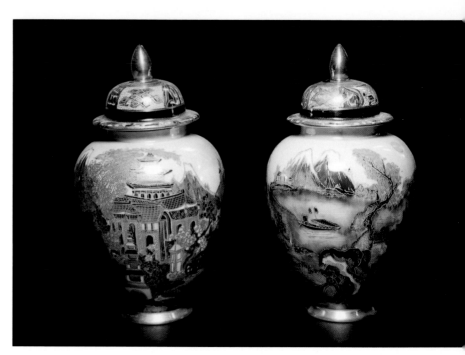

6.8 Pair of Carlton Ware ginger jars elaborately decorated in Chinese style, H. 7 1/4 in., marked CARLTON WARE MADE IN ENGLAND TRADEMARK BLEU ROYALE. *Courtesy of Ralph and Terry Kovel*

6.9 Detail of building.

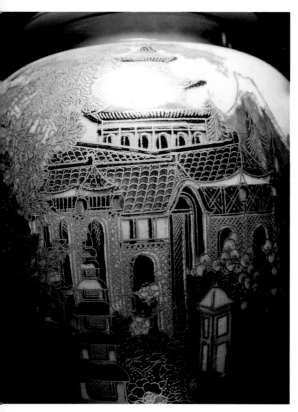

6.10 **Carlton Ware** Molded relief decoration of flowers and leaves on a light green leaf-shaped bowl. L. 8 1/4 in., marked CARLTON WARE MADE IN ENGLAND TRADEMARK REGISTERED AUSTRALIAN DESIGN.

168 POTTERY: Modern Wares

Other English gilded and enameled lustres can be easily mistaken for Carlton Ware, including Wilton Ware from Stoke on Trent and even certain of Wedgwood's lustres.

6.11 **Wilton Ware** Turquoise lustre beaker vase, decorated with deer, H. 8 1/2 in., marked A G H J STOKE ON TRENT WILTON WARE MADE IN ENGLAND.

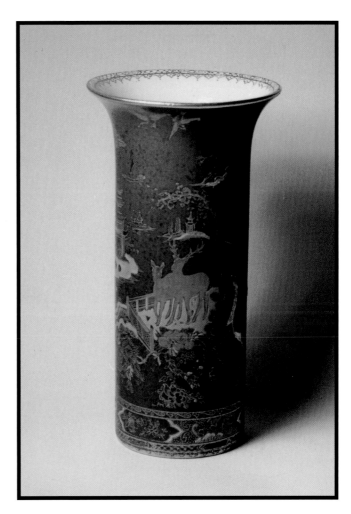

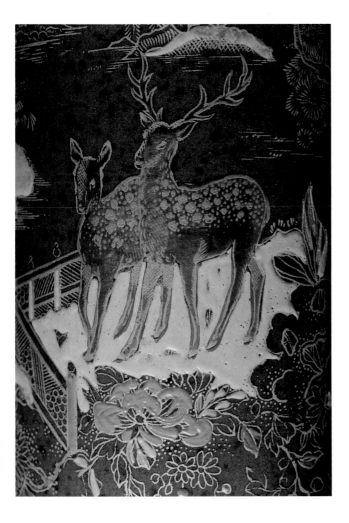

6.12 Detail of deer.

WEDGWOOD

FAIRYLAND LUSTRE

Although often considered to be more Art Nouveau than Art Deco, admired and sought-after Dragon and Fairyland lustres by Wedgwood have a style of their own. Susannah Margaretta Makeig-Jones (Daisy) joined Wedgwood in 1909 as an apprentice decorator and later became a designer. She developed a lustre decoration with motifs of dragons, birds, butterflies, fairies, and other exotic nature subjects in 1915. She used bright underglaze colors and gilding in sumptuously detailed scenes until she retired in 1931.

Reference
Cameron 211

6.14 Detail

6.13 **Wedgwood** Fairyland Lustre round bowl with Poplar Trees decoration on the exterior, and Elves and Bell Branch on the interior, D. 9 in., marked with amphora and WEDGWOOD MADE IN ENGLAND Z4968. *Collection of Robert and Linda Kendall*

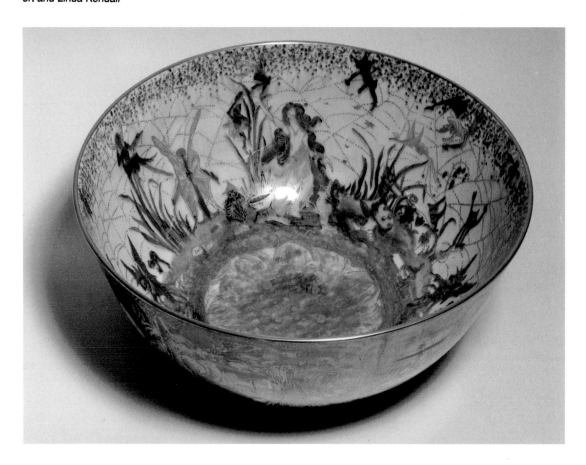

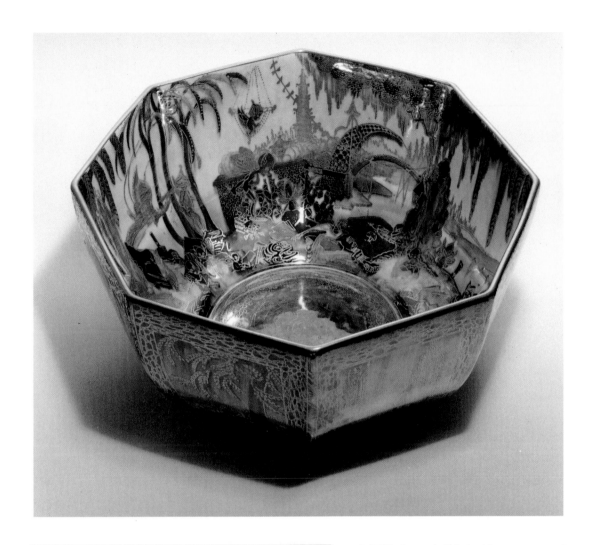

6.15 **Wedgwood** Fairyland Lustre octagonal bowl decorated with Castle on a Road on the exterior, and Fairy in a Cage on the interior, D. 8 1/2 in., marked with amphora and WEDGWOOD ENGLAND Z5125. *Collection of Robert and Linda Kendall*

6.16 Detail

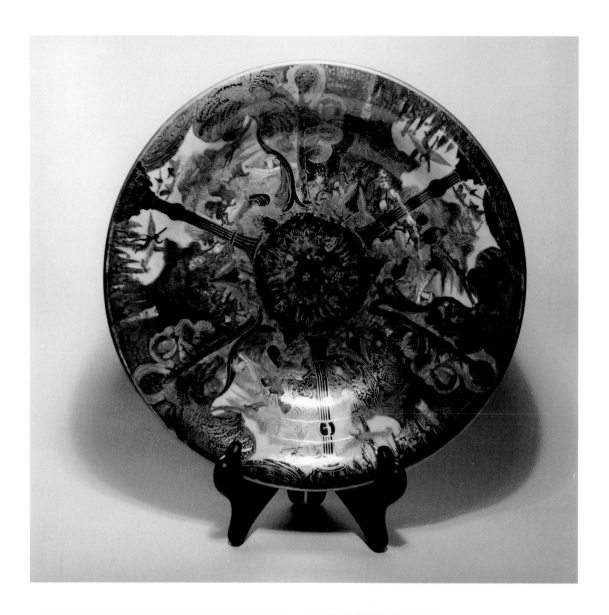

6.17 **Wedgwood** Fairyland Lustre shallow bowl decorated with Garden of Paradise variation I, D. 11 in., marked with amphora and WEDGWOOD ENGLAND. *Collection of Robert and Linda Kendall*

6.18 Detail

6.19 **Wedgwood** Fairyland Lustre vase with Candlemas pattern, H. 8 1/2 in., marked with amphora and WEDGWOOD ENGLAND Z5157. *Collection of Robert and Linda Kendall*

6.20 **Wedgwood** Ordinary lustre trumpet-shaped vase decorated with Flying Humming-birds pattern, H. 11 1/4 in., marked with amphora and WEDGWOOD ENGLAND. *Collection of Robert and Linda Kendall*

WILLIAM ADAMS AND SONS

The Adams family were Staffordshire potters descended from a late 14th century potter in Burslem. William Adams and Sons was founded in 1657 in Burslem. Three cousins, all named William Adams, worked in Staffordshire in the 19th century and made traditional wares. From the early 1920s to the 1950s they made a line of hand-painted earthenware on an ivory ground with flowers and fruits in bold colors. Decoration on this Art Deco line, called Titian Ware, resembled (and was sometimes nearly identical to) Czechoslovakian peasant designs of the period.

References
Cameron 9, Spours 28-29

6.21 **Adams Titian Ware** Plate with wide yellow rim and boldly colored fruit and flowers very close to Czech pottery designs from the 1920s (pictured in Forsythe, 28-32), marked ROYAL IVORY ADAMS ENGLAND TITIAN WARE.

BURGESS AND LEIGH

Burgess and Leigh were Staffordshire makers of earthenware from 1867. Their 1930s line called Burleigh Ware is among the most interesting of the British Art Deco wares. Charlotte Rhead, pottery designer and daughter of Frederick Rhead, worked for Burgess and Leigh from 1926 until 1931 designing tableware and ornamental items in bright clear colors. Among the most unusual and appealing designs was a series of embossed and handpainted earthenware animal character jugs produced in the early 1930s. Probably inspired by stoneware hound handles, they used molded animal handles such as parrots clenching jug rims with their beak, dragons with colorful scaly tails, squirrels with their paws over the rims, and diving kingfishers.

Reference
Spours 101 & 103

6.22 **Burleigh Ware** Art Deco animal character jug in yellow with molded handle in the form of a green stork with a grey fox sticking out its tongue at the bird, H. 10 in., marked BURLEIGH WARE B&L LTD. MADE IN ENGLAND.

DOULTON

Doulton (at both Burslem and Lambeth) is one of the most familiar names in English ceramics. Doulton and Co. was established in 1854 following Doulton and Watts. Known for their stoneware and earthenware art pottery in the late 19th century and for Royal Doulton bone china from the early 20th century to the present, the majority of styles and themes have been traditional. They did, however, occasionally make modern lines, such as their Art Deco Casino dinnerware and a series of earthenware artware with rich drippy glazes and handpainted motifs of fruits and flowers with a distinctly Art Deco flavor. The Lambeth factory closed in 1956.

Reference
Cameron 111-115

6.23 **Doulton Lambeth** Pair of red earthenware vases with thick blue glaze and painted fruit and leaves extending down from the rim, H. 8 in., ink mark ROYAL DOULTON LAMBETH with impressed circular Royal Doulton seal with lion and artist initials.

SUSIE COOPER

Susie Cooper is known for her affordable tableware made of earthenware, especially from the 1930s. Her decoration, whether hand-painted or transfer-printed, is integral to the composition and shape of the item, rather than being superimposed. Born in Burslem, Staffordshire, England in 1902, Cooper enjoyed art as a young girl and later attended art school in Burslem, but did not study ceramics. She was hired by the decorating firm A. E. Gray & Co. Ltd. and worked there from about 1920 until 1929. Her work can often be recognized by a monogram, S. V. C. (for Susan Vera Cooper) or S. C., on special production pieces next to the printed backstamp.

Cooper started Susie Cooper Pottery in 1929 and moved to Crown Works, Burslem in 1931 where she collaborated with Wood & Sons. In addition to the many new decorations, shapes (such as the popular Kestral) were also introduced. The many different marks that were used can help to identify the type of ware, date, and sometimes indicate the pattern name, the most common mark being the running deer. They became part of the Wedgwood Group in 1966. Susie Cooper Potteries at Burslem closed in 1980.

Reference

Eatwell 8, 9, 23, 73, 94

6.24 Earthenware plate in copper lustre with white stenciled pattern of grape vines, designed by Susie Cooper for Gray Pottery, D. 8 in., marked GRAY POTTERY with clipper ship. *Courtesy of Ralph and Terry Kovel*

6.25 **Susie Cooper** Earthenware plate designed in 1942 with scalloped interior and edge, in deep turquoise with sgraffito plant design in white, D. 9 in., marked A SUSIE COOPER PRODUCTION CROWN WORKS BURSLEM with running deer. *Courtesy of Ralph and Terry Kovel*

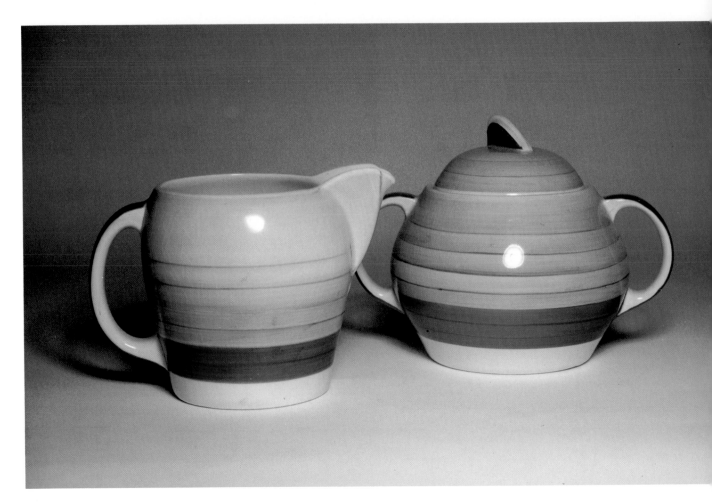

6.26 **Susie Cooper** Earthenware creamer and sugar in Kestral shape with shaded washbanding in deep brick red, pastel brick red, and grays; creamer H. 3 1/2 in., sugar H. 4 1/2 in., W. 5 1/2 in., with running deer mark, circa 1930s. *Courtesy of Attenson's Antiques.*

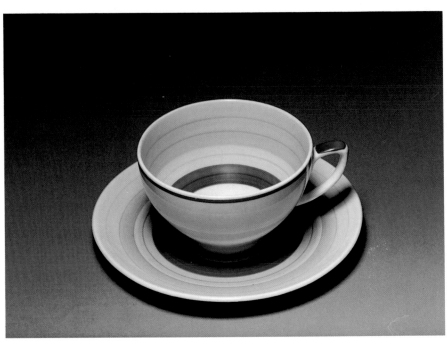

6.27 Cup and saucer with same shaded washbanding.

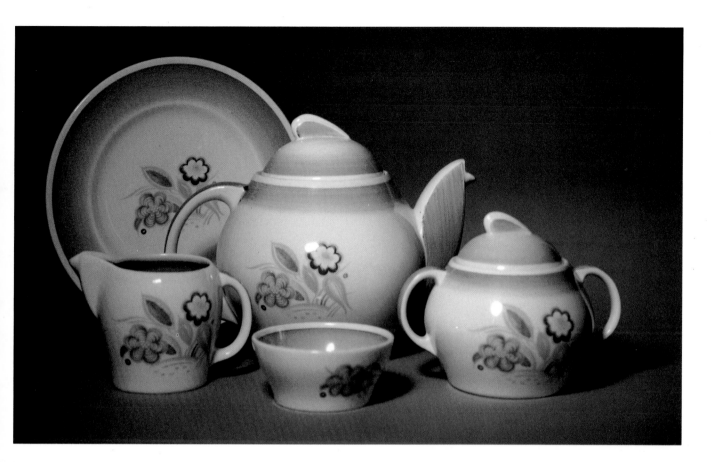

6.28 **Susie Cooper** Partial tea service consisting of teapot, creamer, sugar, small bowl and one plate in popular Kestral shape, circa 1935, decorated in transfer printed Nosegay pattern of pastel colored flowers and a shaded washband of turquoise. teapot H. 6 3/4 in., plate D. 8 in., all marked SUSIE COOPER PRODUCTION CROWN WORKS BURSLEM with running deer.

6.29 Detail of Nosegay pattern

6.30 **Susie Cooper** Fluted dinner plate, cup and saucer made of earthenware and decorated in Woodlands pattern of transfer printed ash leaves on the plate and beech leaves on the cup and saucer, circa 1939, plate D. 10 in., with running deer mark, cup marked SUSIE COOPER ENGLAND WOODLANDS, saucer marked A SUSIE COOPER PRODUCTION CROWN WORKS ENGLAND.

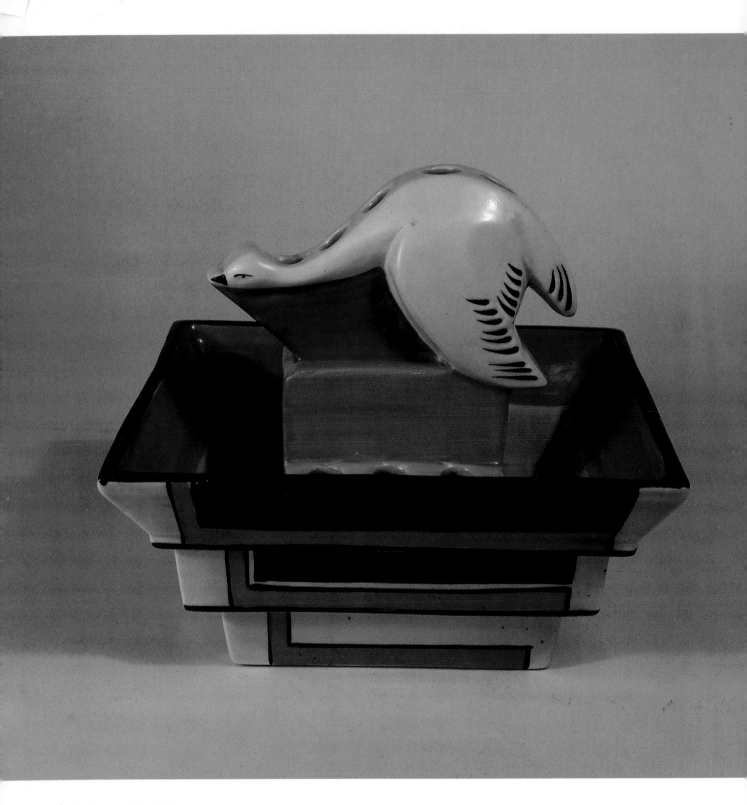

6.31 **Clarice Cliff** White flying swan, shape
#423, introduced in 1930, on a flower block with
red top, orange middle, and yellow bottom, de-
signed to fit into the square tiered flower bowl,
shape #367, introduced in 1929, decorated in
orange, blue and white geometric pattern.
Photo courtesy of Ralph and Terry Kovel

CLARICE CLIFF

Another well-known woman designer of Art Deco English pottery is Clarice Cliff. Born in 1898 in Tunstall, Staffordshire and one of eight children, Cliff had an uneventful childhood with little exposure to art. As a young girl, she apprenticed at an earthenware manufacturing company and learned to paint decorations on pottery. After a few years, she left to apprentice at a lithography company and began to attend art school evening classes. Her part-time art education would continue for many years. From 1916 to 1920, Cliff worked for A. J. Wilkinson Pottery doing lithography on the pottery and eventually got the chance to work along with Wilkinson's top designers. By 1924 she was producing pieces with her name on them. When Wilkinson purchased the Newport Pottery in 1925, her employer Colley Shorter gave Cliff her own studio in the new facility. Thousands of odds and ends were left at Newport when the company changed hands, and Cliff asked to decorate them. The experiment was so successful that she was given a staff of decorators to paint bold geometric patterns on new blanks. In 1928 the name "Bizarre" was selected for the first of many colorful lines produced through the 1930s. Bizarre (original Bizarre 1928-1930) and Fantasque (1929-1934), the two most popular of the Cliff series, have become classics of Art Deco pottery.

The Sunkissed series, designed by Eric Elliott in 1954, is perhaps the most successful of Cliff's later work, and retains some of the spirit of the early bold stylized designs. The pattern uses black transfer printed outline of fruits and vegetables with handpainted colors.

References

Watson 1989 & 1992

6.32 **Sunkissed** Salad plate decorated with celery stalk in green, D. 8 1/2 in., marked GENUINE HANDPAINTED SUNKISSED ROYAL STAFFORDSHIRE DINNERWARE BY CLARICE CLIFF MADE IN ENGLAND.

6.33 **Sunkissed peaches by Clarice Cliff.**

6.34 **Sunkissed banana**

6.35 **Sunkissed oranges**.

6.36 **Sunkissed pears**.

Other English potteries also introduced modern wares in the 1950s, notably the emblematic Homemaker design. Produced by Ridgway Potteries, originally a 19th century Staffordshire producer of pottery and porcelain, the line was retailed by Woolworth's stores through the 1960s. Designed by Enid Seeney in 1955, the black transfer-printed pattern includes a 1952 design of a reclining armchair by Robin Day for Hille, a boomerang table, and other Fifties modern symbols.

6.37 **Homemaker** Serving platter, L. 14 in., marked HOMEMAKER RIDGWAY POTTERIES LTD, MADE IN STAFFORDSHIRE ENGLAND. *Courtesy of Ralph and Terry Kovel*

7.1 Cylindrical vase mounted on blue animal feet, decorated with asymmetrical green and blue plant and flying bird on an ivory ground, with an Art Nouveau flavor, circa 1890s, H. 7 in., marked LONGWY D 314. *Courtesy of Ralph and Terry Kovel*

7.2 Vase with white and turquoise floral decoration on a deep cranberry ground, H. 6 1/2 in., with impressed numbers. *Courtesy of Ralph and Terry Kovel*

Longwy is both the name of a small French city by the borders of Luxembourg and Belgium and a pottery factory with a nearly two-hundred-year history. The pottery began in 1798 when the clay was formed at a Carmelite convent and sent to be fired at Senelle. These early wares included statues, decorative reliefs, and pieces with popular slogans and national symbols associated with the French Revolution. Under Napoleon's rule, the eagle replaced the early patriotic symbols. Longwy Pottery was commissioned to create a service for the Houses of the Legion of Honor, which was decorated with bees, eagles, and crowns.

After 1815, J. A. de Nothomb and M. Christine Boch improved the quality of the clay mixture. In 1835 the Baron Henri-Joseph d'Huart took over the company and introduced new firing techniques. His sons, Hyppolite and Henri Ferdinand, who had both received training in engineering in Paris, became active in the company. After becoming acquainted with Oriental ceramics, they introduced the cloisonné technique of enamel decoration in the early 1870s. From that time on Longwy has focused on and excelled at making this beautifully decorated enameled pottery.

Unlike the Chinese and Japanese "true" cloisonné, in which metal wires separate the colored enamels which are applied to a metal base, no metal is used in ceramic cloisonné. Rather, the thick enamel color is outlined in dark, blackish, resist lines. Where cloisonné on metal goes through a grinding and polishing process and is smooth to the touch, ceramic cloisonné has an uneven surface of hills and valleys with the black resist lines being the lowest valleys. The development of these resist lines, explained in an article by Alan Roberts, began with studio potters around 1860. By brushing on a non-porous resist material or by applying thin coils of clay slip around the colored enamel, the outline was achieved. But in or-der to create multi-colored designs with very small cloisons (each separate color shape, whether bounded by wire in true cloisonné or by resist lines of ceramic cloisonné is called a cloison), a better method had to be developed. It was in the early 1870s in France that a paper transfer technique enabled factory production of ceramic cloisonné. Although not the only company to use the new method — the Belgian factory Boch Frères Keramos is another well known example— Longwy was a leader then and the only significant producer of ceramic cloisonné today. (Roberts 43-46)

Appropriately, many of the early designs borrowed Chinese and Japanese color schemes and motifs. Inspiration was derived not only from Oriental cloisonné but from other Japanese and Oriental design. European producers and consumers of art in the late nineteenth century were intrigued by the exotic patterns and materials from both the Near and Far East. Islamic and Japanese designs and objects could be found together in any fashionably eclectic interior. Longwy incorporated early Islamic Iznik pottery motifs and adopted a traditional turquoise glaze color that has remained a company staple to this day.

Italian ceramicist Amadeo de Carranza (Amédée de Caranza) was artistic director at Longwy when the new cloisonné technique was introduced. He established the factory branch called Emaux de Longwy, but he left shortly to work at the Vieillard factory at Bordeaux, another producer of the new ware. The Expositions of 1878 and 1889 contributed to the success of the enameled pottery, and while more factories were built to meet the demand, Longwy remained a leader.

In 1901 the Huart brothers made Longwy a collectively-owned society. Unlike other French decorative arts producers of the time, Longwy hardly acknowledged the Art Nouveau style. However, by 1912 their traditional de-signs were reevaluated and a more modern look began to emerge. After being bombed by the Germans in 1914, they ceased production until 1919. By this time, the craze for ceramic cloisonné had worn thin, leaving Longwy as one of the few producers. Some of their most sought-after pieces, made in the new Art Deco style, were created in the 1920s and 1930s. François Lindley was artistic director from 1893 to 1925, and toward the end of this period many modern designs were introduced. From 1921 to 1936, designers René Buthaud and Colette Guéda collaborated with Longwy. Then, Maurice Paul Chevallier (who became art director in 1925), Ray Chevallier, and several other modern designers carried on the Art Deco tradition at Longwy. Added prestige and recognition were earned by the affiliations with Paris department store Le Bon Marché and with the Atelier Primavera group at the request of Au Printemps. The Primavera group of Au Printemps was the most important of the Art Deco workshops.

In 1950, Hélène Gabet and Jean Rabet were hired as artists at Faïenceries de Longwy. Born in 1914, Gabet won a bronze medal at the expositiion at Rochefort sur Mer at age 21. From 1937 to 1940 she studied at l'Ecole Nationale Supérieure des Beaux Arts. She was one of only two women to win a scholarship to l'Ecole Nationale Supérieure des Arts décoratifs de Paris, where she earned a diploma in 1941. At Longwy, she created a number of limited edition pieces, such as those for the Chevaliers du Tastevin (wine tasters' organization) and the Commandeurs des Cordons bleus (famous Cordon bleu cooking school). She left Longwy in 1960. (Dreyfus 1990, 81-82) Jean Rabet was born in 1927 in Brumath. He was interested in design at an early age, but to please his parents earned a baccalaureat degree in 1946. He began to study industrial design but acquired a passion for Art Deco. He

married Marie à Briey in July of 1950 and joined the Faïenceries de Longwy in September of the same year. He enjoyed working with the thick enamel designs resembling cloisonné and had great success with unique and limited edition pieces. One of these celebrated editions was La Confrérie des Chevaliers du Tastevin in 1951. Rabet left Longwy in 1952 to become art and publicity director at Arts Français at Luynes. (Dreyfus 1990, 92-93)

While new decorations have been continually introduced to Longwy's extensive line, the Eastern influence (China, Japan, Egypt, Iraq, Turkey) has been the most prominent. Longwy Municipal Museum curator and Longwy pottery historian Dominique Dreyfus estimates that some 6000 decorations have been used over the years.

Both pottery forms and decorations have been numbered, but understanding of the system has been complicated by the many gaps, jumps, and exceptions. The forms were not numbered at all until 1872, with the introduction of cloisonné enamel. In order to account for the pre-1872 production, Longwy began its numbering system in 1872 with 1,000. Today this number is near 5,000. To complicate this further, some forms have not been used for enamels, and other forms have been used for all types of decoration. Certain forms have not been given numbers, but are designated by their function, such as bucket, pail, or box. In addition, numbers have not been distributed in any logical order. For example, an important piece may be followed by an insignificant one. Furthermore, the numerical order does not help to date a piece, because some forms have been made for more than a century. Decorations have also been numbered, but about 1920 Longwy began to use a new numbering system for the decoration, beginning again with number one. Fairly accurate dating is possible however by using the stamped or impressed mark, and the book on marks and signatures by Dreyfus (see Bibliography) is an excellent reference for this. In addition to one of the many different company marks and the inked and/or impressed numbers denoting the form and/or decoration, some pieces will also carry an artist's or designer's signature.

7.3 Plate with Islamic style arabesque border in green and red with central bird perched on a branch on an ivory ground, late 19th century, D. 7 1/4 in., impressed LONGWY in oval with ink numbers.

Some of the important artists and designers are:

Alexandre Bida (1823-1895)
Marie Adrienne Breda (1899-1987)
Eugène Carrière (1849-1906)
Maurice Paul Chevallier (1892-1987)
Raymond Chevallier (1900-1959)
Georges Clairin (1843-1919)
Aristide Croisy (1840-1899)
Fabien Fabiano (1893-1962)
Hélène Gabet (b. 1914)
Emile Kilbert
Martinus Kruytenbrouwer (1821-1897)
Achille Lemot (1845-1909)
Manon Lescaut
François Lindley (1861-1950)
Jean Luce (1895-1964)
Paul-Emile Morlon
Ernest Quost (1844-?)
Jean Rabet (b. 1927)
Charles Rudhart.

The following photos of enameled pottery represent a small sample of the rich design repertoire of Emaux de Longwy. Although the Art Deco items were among the most artistically successful, the most sought-after by collectors, and appropriate for the scope of this book, both earlier and later examples have been included. The earlier color schemes and patterns not only led up to Art Deco, they were also produced during those decades. Some later pieces, particularly the limited edition commemoratives from the early 1950s, are shown because they exemplify the persistence and interpretation of the earlier "modern" style.

Among the appealing features of Longwy pottery are the continuity and compatability of styles within a portfolio of thousands of designs. Without looking at the particular mark, it is difficult or impossible to date many of the pieces. But more than compensating the inability to catalog these wares is the pleasure derived from experiencing the quality of this colorfully enameled pottery, quality that has been surprisingly consistent for more than a century.

7.4 Plate with vivid turquoise rim filled with opulent multi-colored enamel floral design, the ivory center with a sprig of flowers, early 20th century, D. 7 1/2 in., marked with elaborate stamp with ten crosses of Lorraine and traditional emblem of Huart family and ECORE DE LA MAIN EMAUX DE LONGWY FRANCE. *Courtesy of Attenson's Antiques*

7.6 Detail of plate center

7.5 Detail of plate rim

7.7 Turquoise tile with yellow and white bird, flowers, and a navy blue textile, mounted in ornate metal two-handled tray, tile, W. 7 1/2 in. *Courtesy of Ralph and Terry Kovel*

7.8 Richly decorated tile in turquoise and navy blue with central plant motif, mounted in a heavy ornate two-handled metal tray, tile W. 8 in. *Courtesy of Ralph and Terry Kovel*

7.9 Covered hexagonal box with round lid in bright turquoise decorated with pink and white flowers, H. 2 3/4 in., D. 5 1/2 in., marked PEINT MAIN MADE IN FRANCE LONGWY with numbers. *Courtesy of Ralph and Terry Kovel*

7.10 Chinese style turquoise dragon on an ivory ground, D. 9 in, with impressed mark resembling a fish. *Courtesy of Ralph and Terry Kovel*

7.11 Octagonal plate with overall decoration of pastel blossoms on a turquoise ground, D, 7 3/8 in., marked DECORE A LA MAIN EMAUX DE LONGWY FRANCE. *Courtesy of Ralph and Terry Kovel*

7.12 Small octagonal plate with overall decoration of colorful stylized flowers against a turquoise ground, D. 4 1/8 in., marked MADE IN FRANCE LONGWY RF 1926 D 5685.

7.13 Detail of small plate

7.14 Detail of flower

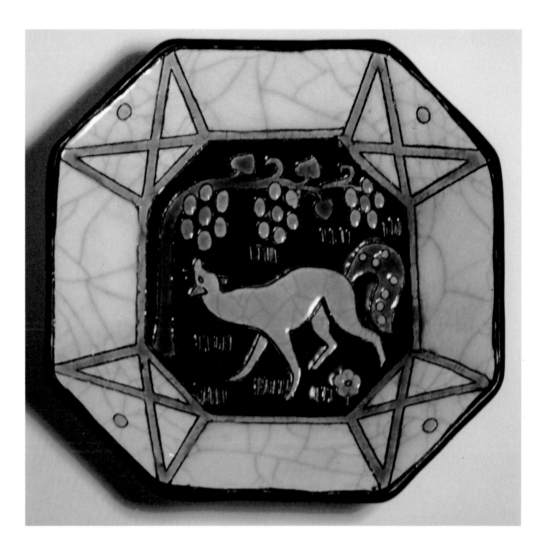

7.15 Longwy Primavera Art Deco plate
Small eight-sided plate depicting a tan fox against a black ground, D. 4 3/4 in., marked ATELIER PRIMAVERA LONGWY FRANCE.

7.16 Detail of fox

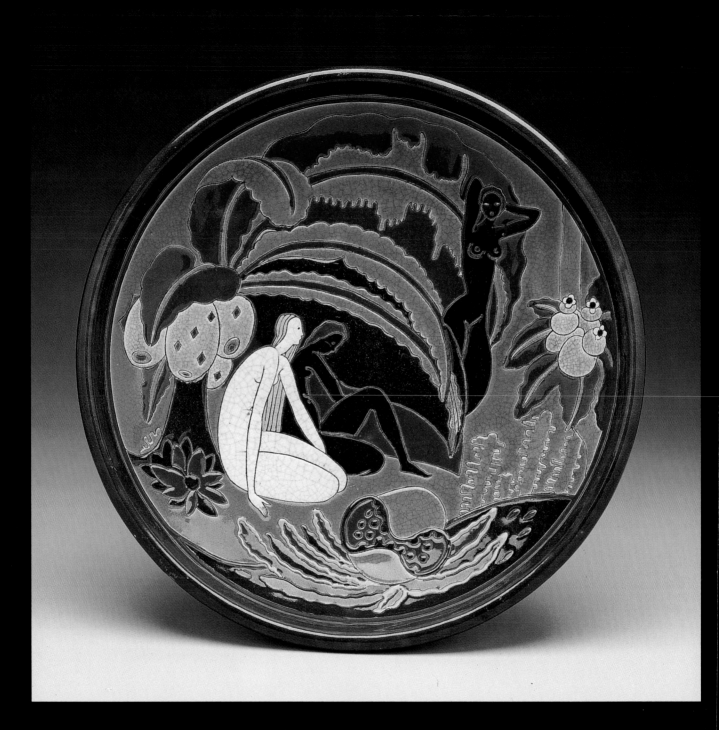

7.17 Longwy Primavera Art Deco Charger
Shallow circular charger decorated with a stylized nude female with white skin and long yellow hair in a tropical beach setting of eggplant and bright blues, D. 14 1/2 in., marked PRIMAVERA LONGWY FRANCE. *Photo courtesy of Christie's New York*

7.18 Circular Art Deco box with turquoise and yellow decoration on ivory ground, D. 3 5/8 in., marked BOITE NO. 3, 4025 LONGWY FRANCE. This mark was in use from 1919 to 1939. Maurice Paul Chevallier, who became art director in 1925, encouraged a much freer and more modern style.

7.19 Box lid

7.20 Small Art Deco twelve-sided shallow bowl decorated in alternating purple and ivory tapered stripes and a central stylized flower, circa 1920s, D. 4 1/4 in., marked LONGWY FRANCE with shield and numbers impressed and in ink.

7.21 Limited edition charger designed by Hélène Gabet This charger, designed in the early 1950s, is number 24 of a limited edition, decorated with coat of arms, blue ribbon and other symbols of the esteemed Cordon bleu cooking school, and the inscription COMMANDERIE DES CORDONS BLEUS in enamel as part of the design, D. 14 3/4 in., marked PIERRE CRETIN - DIJON PIÉCE A TIRAGE LIMITE 24 EMAUX DE LONGWY FRANCE ATELIER D'ART MADE IN FRANCE REHAUSSÉ (initials) CRÉATION H GABET.

7.22 Back of charger

7.23 Detail of border

7.24 Detail of border

7.26 Back of charger

7.25 **Longwy limited edition charger decorated by Jean Rabet** This charger is decorated with colorful symbols of the Confrérie: wine taster, coat of arms and ribbons, knight's armor, and grapes. D. 14 3/4 in., marked DÉCOR DE J.RABET EMAUX DE LONGWY FRANCE ATELIER D'ART MADE IN FRANCE CONFRÉRIE DES CHEVALIERS DU TASTEVIN.

7.27 Detail of charger

Other French factories made ceramic cloisonné and sometimes decorated it in colors and designs similar to those used by Longwy. Leon Parvillée, a French architect involved with the restoration of Islamic architecture, also made pottery with cloisonné decoration in Islamic style in the 1870s and 1880s.

7.28 Parvillée charger This charger, from the 1870s, decorated in Islamic blues and earthtones, could be mistaken for Longwy at first glance, D. 16 1/4 in., marked PARVILLÉE 263

7.29 Detail of Parvillée charger

7.30 Detail of Parvillée charger

7.31 Bowl with stylized cloisonné enamel decoration in yellows and browns that could be interpreted as either an Art Nouveau or an Art Deco transitional design, H. 3 3/4 in., D. 5 1/4 in., signed L. DAGE FRANCE.

7.32 Detail from a Spanish piece showing a technique that resembles "openwork cloisonné" on metal in which the background is not filled in with enamel; here it is left bisque.

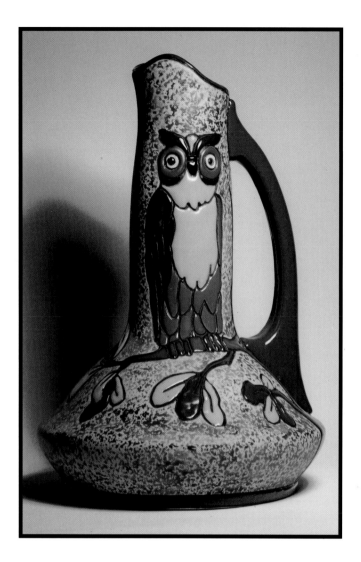

8.1 This later Amphora carafe has a mottled brown matte ground with teal and yellow enamel owl, H. 10 3/4 in., oval mark AMPHORA MADE IN CZECHOSLOVAKIA. *Courtesy of Attenson's Antiques*

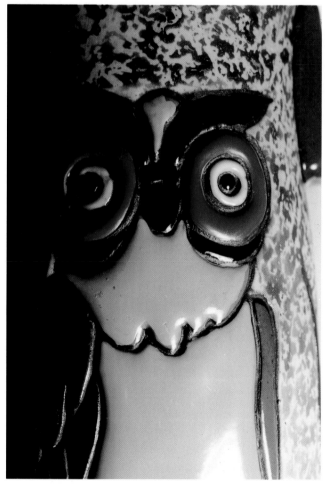

8.2 Detail of owl

Chapter Eight
Europe

CZECHOSLOVAKIA

The trade name "Amphora" is associated with both the Bohemian porcelain company in Turn Teplitz that made the sought-after Art Nouveau gilded portrait vases, and the thickly enameled Art Deco style pottery made after 1918 in Czechoslovakia.

8.3 Hexagonal vase decorated with thick enamel birds in contrasting pastel and dark colors, on a mottled faux stone ground, H. 7 1/2 in., oval mark AMPHORA MADE IN CZECHOSLOVAKIA. *Courtesy of Attenson's Antiques*

8.4 Two-handled vase with matte turquoise finish, decorated with thick enamel figure of an ancient classical warrior and Art Deco geometric patterns, H. 9 1/2 in., oval mark AMPHORA MADE IN CZECHOSLOVAKIA.

8.5 Reverse of warrior vase with geometric designs.

Other favorites with collectors are the fantastic and flamboyant Czech animal jugs with bold black, red, and white designs. Regardless of the motif, Czech pottery can be recognized by its bright colors and stylized patterns.

8.6 Left, ram with hoof raised; right, with long mustache and smiling, ave. H. and W. 8 1/2 in., molded mark CZECHOSLOVAKIA and ink stamp E R PHILA HANDPAINTED CZECHOSLOVAKIA. *Courtesy of Ralph and Terry Kovel*

8.7 Bird character mugs; left, toucan, H. 9 in., W. 8 3/4 in., stamped in red HAND PAINTED URBACH MADE IN CZECHOSLOVAKIA; right, duck, H. 7 1/4 in., W. 9 1/2 in., with molded mark CZECHOSLOVAKIA and black ink stamp E R PHILA HANDPAINTED CZECHOSLOVAKIA. *Courtsey of Ralph and Terry Kovel*

8.8 Dog mug, H. 6 1/4 in., W. 9 in., molded mark
CZECHOSLOVAKIA and black ink stamp E R
PHILA HANDPAINTED CZECHOSLOVAKIA.
Courtesy of Ralph and Terry Kovel

8.9 Detail of toucan

8.10 Rounded vase in pastel yellow with stylized fish scale or feather pattern with black outlines, H. 6 1/2 in., marked CZECHOSLOVAKIA.

8.11 Wide planter with yellow molded relief decoration and a band of multicolored pastel flowers, H. 5 in., W. 9 1/4 in., molded mark CZECHOSLOVAKIA EICHWALD 3987-5.

8.12 Detail of flower band.

8.13 Yellow flower pot with stripes of molded relief multicolored flowers, H. 4 1/2 in., molded mark EICHWALD 7003/9 MADE IN CZECHO-SLOVAKIA.

8.14 Small pitcher and hexagonal vase decorated in predominently orange, yellow, black, and white bold peasant designs resembling those by Clarice Cliff; pitcher H. 3 1/2 in., impressed MADE IN CZECHOSLOVAKIA; vase H. 6 1/4 in., stamped CZECHOSLOVAKIA HANDPAINTED. *Courtesy of Ralph and Terry Kovel*

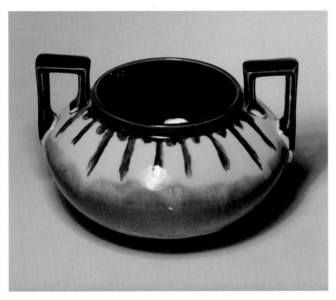

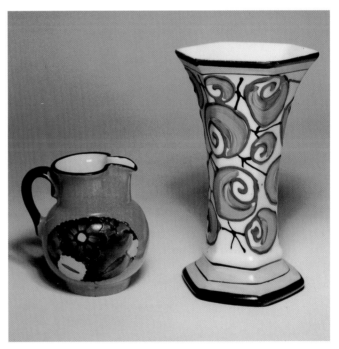

8.15 Squat round vase with dark blue glaze dripping onto yellow, above green, with brown rectangular handles, H. 4 3/4 in., W. 7 1/2 in., marked TRADE MARK CORONET with crown CZECHOSLOVAKIA REGISTERED.

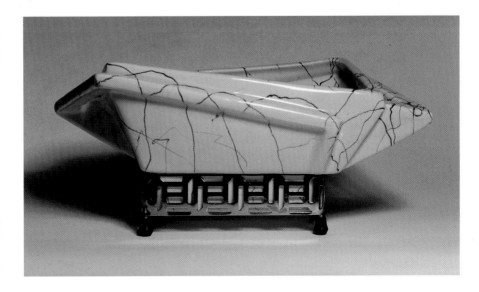

8.16 Planter in typically Fifties asymmetrical form in pink with handpainted black lines, mounted in a metal base, H. 4 in., L. 10 in., marked HANDMADE IN CZECHOSLOVAKIA. *Courtesy of Attenson's Antiques*

HUNGARY
ZSOLNAY

Ignaz Zsolnay founded the Zsolnay factory in 1862 at Pécs, Hungary and produced creamware. His brother Vilmos took over in 1865 and began making decorative earthenware. The firm is perhaps best known for its iridescent glazes and lavish Art Nouveau designs from around the turn of the century. They also produced interesting lines in the 1940s and 1950s using simple modern forms with exaggerated crackle glazes developed by the important Hungarian (though born in Czechoslovakia) ceramic artist of the period, Géza Gorka. Glaze techniques, especially crackled, are considered to be his most notable contribution for which he received numerous prizes at Milan Triennales, World's Fairs and other international exhibitions. Gorka cooperated with Zsolnay until 1948 developing thick crackle glazes and those described as shrunk and burst, which he adapted from his studio work to the advanced methods of heating the kilns at the Zsolnay factory. (Pataky-Brestyånszky 22-24)

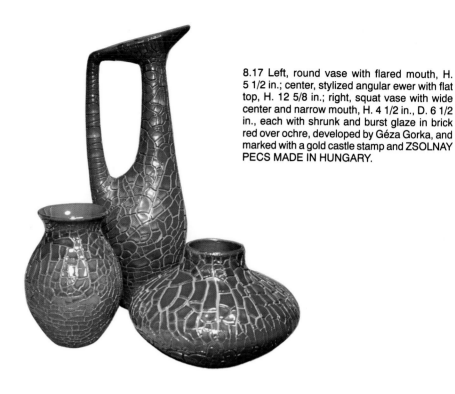

8.17 Left, round vase with flared mouth, H. 5 1/2 in.; center, stylized angular ewer with flat top, H. 12 5/8 in.; right, squat vase with wide center and narrow mouth, H. 4 1/2 in., D. 6 1/2 in., each with shrunk and burst glaze in brick red over ochre, developed by Géza Gorka, and marked with a gold castle stamp and ZSOLNAY PECS MADE IN HUNGARY.

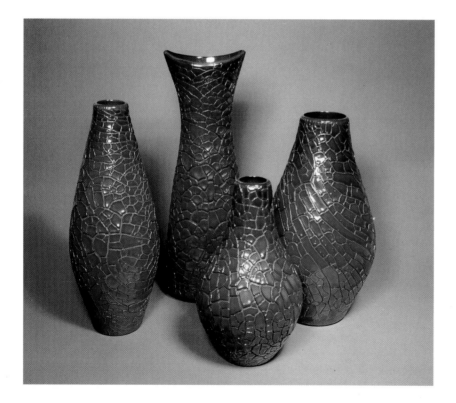

8.18 Three bulbous vases, each with tapering neck and narrow mouth, and one waisted vase with boat-shaped mouth, each in shrunk and burst glaze in brick red over ochre with glossy ochre interiors, left H. 9 1/2 in., top center H. 11 in., bottom center H. 7 in., right H. 9 in., each with gold castle stamp and ZSOLNAY PECS MADE IN HUNGARY.

8.19 Detail of crackle

8.20 Abstract bowl in the form of a duck (or abstract duck in the form of a bowl) with glossy red glaze, 5 1/2 x 5 1/2 in., with gold castle stamp and ZSOLNAY PECS MADE IN HUNGARY.

HOLLAND

GOUDA

The town of Gouda in the province of Zuid (meaning south), as well as other towns in the Netherlands and Belgium, had several workshops — Arnhem, Distel/Goudewaagen, Eskaf, Ivorn, Koninklyke, Plazuid, Regina, Schoonhoven, Zenith, Zuid Holland — that made what is commonly referred to as Gouda pottery. Although often considered Art Nouveau designs, the bold, highly contrasting, black and colored patterns also have a more modern Art Deco feelng.

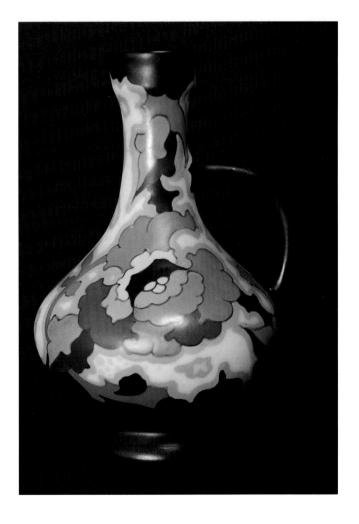

8.21 Vase with handle, H. 7 3/4 in. marked REGINA 229 W.B. LYDIA GOUDA HOLLAND. The initials WB on Regina pieces refer to the two owners, van der Want and Barras. (*Dutch Potter*, Nov. 1989)

8.22 Gouda footed bowl, D. 8 in., marked REGINA 320 MELBA W.B. GOUDA HOLLAND

SWEDEN

GUSTAVSBERG

The Gustavsberg factory, near Stockholm, Sweden, made faïence and creamware in the 18th century. By the early 19th century, they made porcelain after English styles. In 1917 Wilhelm Kåge (1889-1960) became art director. He is best known for a unique line of stoneware with a greenish turquoise matte glaze that resembles verdigris bronze, in which the decoration is applied in sterling silver. This unusual Art Deco line, called Argenta, was popular in the 1930s and later. Stig Lindberg succeeded Kåge when the company was reorganized under the Swedish Cooperative Union and Wholesale Society in 1937. Although the company made other excellent modern wares, the Argenta series is a favorite among collectors.

8.23 Shallow bowl with shaped rim in turquoise with a silver plant, by Wilhelm Kåge, circa 1930s, D. 6 in., marked with gold anchor GUSTAVSBERG and ARGENTA MADE IN SWEDEN 1129 with paper label GUSTAVSBERG SWEDEN

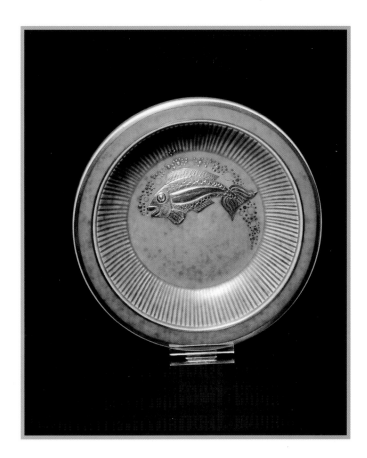

8.24 Turquoise green bowl in the Argenta series with applied silver fish with bubbles, designed by Wilhelm Kåge, circa 1930s, D. 6 1/8 in., marked with gold circular stamp with anchor GUSTAVSBERG and ARGENTA MADE IN SWEDEN A59 and paper label GUSTAVSBERG SWEDEN

8.25 Detail of silver fish

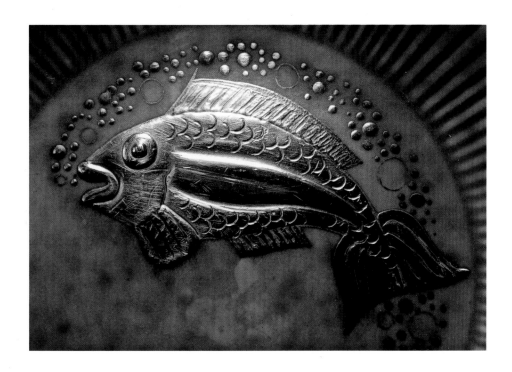

8.27 Rectangular dishes or ashtrays, each with silver ship; left, turquoise with antique ship, marked in gold GUSTAVSBERG MADE IN SWEDEN and in black WASA 1628 and two paper labels, one WASA NÅMDEN; right, white with silver ocean liner, marked in gold GUSTAVSBERG and silver ESPECIALLY DESIGNED FOR SWEDISH AMERICAN LINES. *Courtesy of Ralph and Terry Kovel*

8.28 Detail of ship

8.26 Cylindrical vase with silver fish, H. 7 in., marked ARGENTA MADE IN SWEDEN with paper label; and cone shaped candle holder with flared top and decorated with silver plant, H. 7 1/8 in., marked GUSTAVSBERG ARGENTA MADE IN SWEDEN 1244. *Courtesy of Ralph and Terry Kovel*

8.29 Turquoise vase with applied silver vertical stripes, H. 4 in., with impressed circular anchor mark and ARGENTA 1937 applied in silver, plus gold stamp MADE IN SWEDEN; with taller slender cylindrical vase, H. 6 in., with gold circular anchor stamp and ARGENTA 1029 MADE IN SWEDEN.

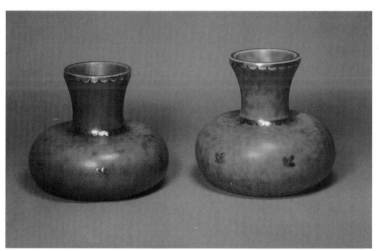

8.30 Pair of squat round vases with narrow necks and applied silver decoration, H. 3 1/4 in., each with gold anchor stamp, one impressed ARGENTA 1095 MADE IN SWEDEN plus paper label.

8.31 Scalloped saucer or ashtray with applied silver decoration, D. 4 1/4 in., circular anchor stamp and ARGENTA 939 MADE IN SWEDEN; matching vase or cigarette holder, H. 2 5/8 in., same mark plus 1113; cup or ramekin with cloverleaf design, H. 2 1/4 in., with same mark and A26, matching saucer, D. 3 1/8 in., same mark and 957; cup with dot design, paper label and stamp with A 26, saucer A25.

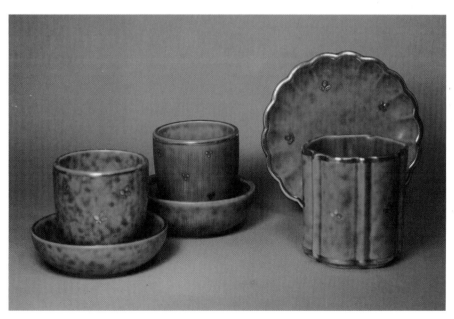

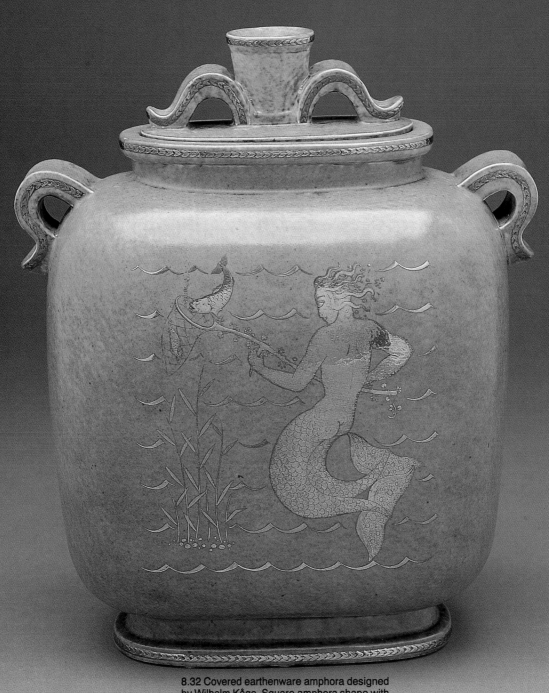

8.32 Covered earthenware amphora designed
by Wilhelm Kåge. Square amphora shape with
two thick handles and cover with knob finial,
the sea-green ground decorated with inlaid sil-
ver merman netting fish, and the reverse with
fish among seaweed, H. 12 1/2 in., signed
GUSTAVSBERG KAGE 1040. *Courtesy of
Christie's, New York*

ITALY

Many factories produced modern pottery designs but did not mark the wares or only used the country name to identify them. Names such as the distributor Raymor may be found on some Italian pieces. One name that stands out is that of Piero Fornasetti (1913-1988), self-taught painter, engraver, draftsman, craftsman and designer noted for his printed *trompe l'oeil* and other designs on ceramics, wood, and other materials.

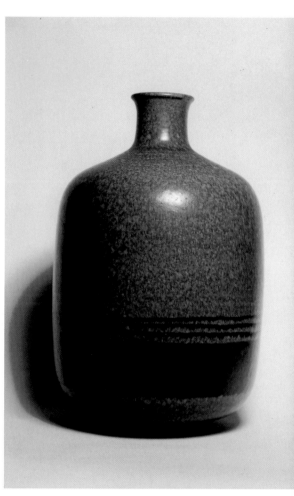

8.33 Bottle vase in mottled mustard and olive colors with dark brown banding near the base and a narrow neck and opening, H. 10 in., marked RAYMOR ITALY. *Courtesy of Attenson's Antiques*

8.34 Turquoise bowl in the form of a chicken with blue, green, and white striped neck feathers and white face, marked ITALY.

8.35 Tall bluish purple vase decorated with
bands of thick enamel color inside a white grid,
H. 18 in., marked 1128 ITALY. *Courtesy of
Attenson's Antiques*

8.36 Detail of grid

8.37 Tall stoppered bottle with orange glossy glaze surrounding a panel of black slip with white sgraffito lines around thickly enameled colorful flying geese, the stopper and back of the bottle textured to simulate cork, H. 15 in., signed in front panel CASES.

8.38 Detail of stopper

8.39 Detail of geese

8.40 Freeform shaped bowl in midnight blue with white sgraffito stylized bottles, D. 9 1/4 in., marked RAYMOR ITALY.

8.42 Party plate with cup, from a series decorated with musical instruments, fruit, and decorative containers, L. 10 1/2 in., impressed mark on cup and plate ITALY.

8.41 Slightly bulbous cylindrical vase with clamshell opening, decorated in horizontal bands of olive green, yellow, and white with black linear fence pattern, H. 6 3/4 in., marked ITALY JI.

8.43 Two cups with different versions of the same handpainted decoration, probably painted by different decorators.

8.44 Plate painted with fruit and table setting.

8.46 Plate with stringed instrument and apple.

8.45 Plate with saxophone and carafe, L.
10 1/2 in., impressed mark ITALY.

8.47 Plate with decorative containers.

8.48 Series of small plates or coasters of the Musicalia series, each decorated with a different musical instrument in black and white against a gold metallic background, designed by Piero Fornasetti, D. 4 in., marked FORNASETTI MILANO MUSICALIA MADE IN ITALY EXCLUSIVELY FOR BONWIT TELLER.

8.49 Detail of instrument

8.50 Tall cylindrical vase with bulbous lower portion and waisted neck, decorated with staggered black, grey, and yellow stripes on a white ground, H. 18 in., marked ITALY with paper RAYMOR label.

GERMANY

German potters also made wares in the modern styles with markings "Germany" for pre-1940 production and "West Germany" after 1945.

8.53 Twisted and stretched biomorphic shaped vase and bowl in white decorated with multi-colored circles; vase H. 10 in., marked 1786; bowl L. 12 1/2 in., marked MADE IN WEST GERMANY.

8.51 Rounded triangular shaped shallow bowl in cream color with black sketchy grid design with random squares of color, D. 8 1/2 in., molded mark GERMANY 431.

8.52 Detail of grid

8.54 Cylindrical vase with slightly widened
shoulder and narrower neck, with an angular
abstract design in burgundy, yellow, and white
with a glossy finish, on a buff colored matte
ground, H. 12 in., molded mark GERMANY 569/
30.

8.55 Pitcher and cups or drinking glasses in bright glossy orange with hand painted green and red fruit; pitcher H. 8 in., cups 3 7/8 in., with impressed beehive mark and numbers.

Marks, Labels, and Signatures

Most of the production pottery is marked by the factories with stamps and labels to identify their products. The information provided in these markings ranges from general to very specific, from only company or country name to words or codes denoting shape, pattern, designer, decorator, plant location, the date a company was founded, or the date a piece was made.

The most commonly used form of marking is an applied ink stamp. It can be in black, such as Fiesta; in a color, as with Susie Cooper; or in gold, as used by Gustavsberg. The marks can also be handwritten and range from the elaborate Gouda mark to the simple "Made in Italy." Printed marks usually are found on the bases, but an artist's signature or facsimile, such as "Sascha Brastoff," can be included in the decoration.

Since wet clay takes an incised or sgraffito mark easily, many are written onto or into the base, as with Glidden. The marks can also be mechanically impressed, such as the Russel Wright stamp. Molded marks can either be concave or in relief, as with Eichwald. Some factories, such as Gustavsberg, sometimes use a special form of marking, as with their applied sterling silver technique. Or several marking methods can be used in combination, perhaps with an added paper label.

It is difficult to know today whether a piece once had a paper label, but since most of this pottery also carries a more permanent mark, the loss of an original paper label is not as distressing as it is with glass items, where it may have been the only means of identification.

The purpose of labels and marks is to provide information, and astute collectors can glean a good deal of information from them. By analyzing the intrinsic qualities and comparing the marked items with the unidentified items, one can attribute unmarked pieces. Needless to say, it is better to rely on a close study of these qualities on any piece, even a marked one. Certain designs are more desirable, quality can vary, "seconds" may have been sold as "firsts," rarity may be an issue, and there is no denying that forgeries exist. Reliance on marks alone is unwise. After studying the attributes of a piece of pottery, however, the mark can be enlightening. The following sample of labels and marks from pieces illustrated in this book may be helpful to the seasoned collector as well as the beginner.

Adams Titian Ware

Sascha Brastoff rooster backstamp

Sascha Brastoff

Burgess & Leigh Burleigh Ware.

Brock Ware

Wiltshire and Robinson Carlton Ware

Burgess & Leigh Burleigh Ware

Carlton Ware, plus numbers

Marks, Labels and Signatures 219

Carlton Ware Rouge Royale mark, with paper
labels for Carlton Ware and for Birks

Susie Cooper, Crown Work, Burslem, with deer

Carlton Ware Bleu Royale

Susie Cooper, without deer

Ceramic Arts Studio, Madison, Wisconson

Gray Pottery (Susie Cooper design)

Cowan R.G. circular mark

Phila, Czechoslovakia

Amphora, Czechoslovakia

Urbach, Czechoslovakia

Eichwald, Czechoslovakia

L. Dage, France

Doulton, Lambeth.

Fondeville, New York

Genuine Fiesta

Fiesta Casual

Fornasetti, Milan

Glidden, in blue ink with stylized ram (uncommon mark)

Glidden/Raymor paper label

Glidden, sgraffito with ram and shape number (most common mark)

Gouda, Holland
Regina is the factory name with its symbol, WB stands for the owners' initials, and Lydia is the pattern name.

Gustavsberg Argenta gold stamp

Gustavsberg WASA stamp and paper labels

Gustavsberg gold stamp plus paper label

Iroquois Informal

Gustavsberg impressed, silver, and gold marks

Longwy stamp used between 1875 and 1890. Variations can include coded information for the date and/or decoration.

Longwy Art Deco mark used from 1919 to 1939

Longwy Primavera Art Deco mark used from 1921 to 1936

Longwy mark introduced in 1954

Example of Longwy number code for shape and decoration

Longwy elaborate stamp with the ten crosses of Lorraine along with the traditional emblem for the Huart family, in use from the early 20th century until about 1948, and may have been temporarily revived since then.

Longwy mark with Huart family coat of arms, used from 1920 until 1977 in both green (shown) and brown versions; a dark blue version was introduced after 1977, and the words "depuis 1798" were added to the mark in 1986.

Longwy with Huart coat of arms and crown,
early 20th century

Metlox Poppytrail Woodland Gold

William Manker

Parvillée

Metlox Poppytrail

Raymor, Italy

Raymor paper label

Red Wing incised mark

Red Wing ink stamp

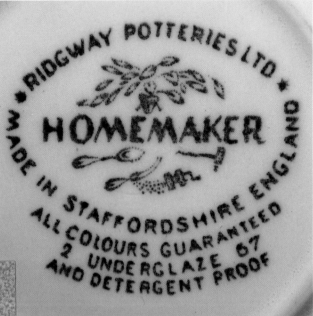

Ridgway Homemaker

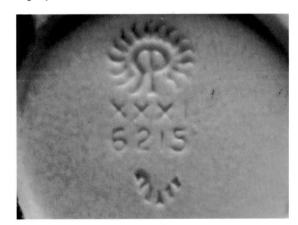

Rookwood impressed mark with Roman numeral date

Vernonware Homespun

Vernonware Organdie

Weller ink stamp

Wedgwood Fairyland

Weller impressed mark

Weil Ware paper label

West Germany

Russell Wright impresssed on American
Modern

Russel Wright ink stamp for Knowles

Russel Wright Iroquois Casual

Zsolnay, Hungary gold stamp with castle

Bibliography

General

Bass Musuem of Art. *Mid-Century Design: Decorative Arts 1940-1960*. Miami Beach: Bass Museum, 1985.

Bougie, Stanley J. and David A. Newkirk. *Red Wing Dinnerware*. Privately printed, 1980.

Cameron, Elisabeth. *Encyclopedia of Pottery and Porcelain 1800-1960*. New York: Facts on File, 1986.

Cincinnati Art Galleries. *Keramics 1993*. Cincinnati: Art Galleries, 1993.

Clark, Garth and Margie Hughto. *A Century of Ceramics in the United States 1878-1978*. New York: Dutton, 1979.

Duncan, Alastair. *Art Deco*. New York: Thames & Hudson, 1988.

Eidelberg, Martin, ed. *Design 1935-1964 What Modern Was*. New York: Abrams, 1991.

Jackson, Lesley. *The New Look: Design in the Fifties*. New York: Thames & Hudson, 1991.

Kovel, Ralph & Terry. *Depression Glass and American Dinnerware*. New York: Crown, 1991.

_____. *Kovels' Collector's Guide to American Art Pottery*. New York: Crown, 1974.

_____. *Kovels' American Art Pottery*. New York: Crown, 1993

Lehner, Lois. *Lehner's Encyclopedia of U. S. Marks on Pottery, Porcelain & Clay*. Paducah, KY: Collector Books, 1988.

McDonald, Ann Gilbert. "Ohio Art Deco Pottery: Cowan, Roseville, and Weller." *Antique Trader Weekly*, Jan. 6, 1988.

Monsen, Randall. "Futura Pottery by Roseville." *Journal of the American Art Pottery Association*, Vol. 3, No. 5, Dec. 1988.

Perry, Barbara, ed. *American Ceramics: Collection from the Everson Museum of Art*. New York: Rizzoli, 1989.

Cowan

Allison, Grace. "Cowan — Ohio Pottery of the Roaring Twenties." *American Clay Exchange*, Feb. 1984.

_____. "Cowan Turned Pottery Into Fine Art." *Antique Week Tri-State Trader*, Vol. 18, No. 6, May 6, 1985.

Barbero, Kathleen Hill. "Portfolio: Cowan Pottery." *Ceramics Monthly*, Vol. 33, No. 8, Oct. 1985.

Bassett, Mark. "Cowan Pottery — Cleveland's Art Deco." *Collectors News and the Antique Reporter*, Vol. 34, No. 3, July 1993.

Beal, Eileen. "Mr. Cowan's Pottery." *Antiques and Collecting*, Oct. 1989.

Bordner, Robert. "Suburban Art Pottery Plant Planned Here." *Cleveland Press*, Oct. 14, 1929.

Boros, Ethel. "Playing the Antique Market". *The Cleveland Plain Dealer*, Nov. 12, 1967.

_____. "Cowan Comes Home". *The Cleveland Plain Dealer*, Saturday Magazine, Jan. 28, 1978.

Borsick, Helen. "Pottery Lights up a Brilliant Ohio Epoch." *The Cleveland Plain Dealer*, Aug. 24, 1969.

Brodbeck, John. "Cowan Pottery." *Spinning Wheel*, March, 1973.

Bulletin of the Society of Arts and Crafts. "Cowan Pottery." *Bulletin*, Boston and New York, Vol. II, No. 5, Oct. 1927.

Calkins, Donald. "Cowan Pottery." *Antique Trader Weekly*, Nov. 30, 1977.

_____. "Cowan Pottery." *Journal of the American Art Pottery Association*, Vol. 6, No. 6. Nov-Dec. 1991.

Clark, Edna. *Ohio Art and Artists*. Richmond: Garrett and Massie, 1932, reprinted Detroit: Gale Research, 1975.

Cleveland City Directories 1914-1931.

Cleveland Institute of Art. *Scrapbook* vol. 6, 1916-1921; vol. 10, 1927-1932.

Cleveland Museum of Art. "Guy Cowan" folder in the library with various newspaper clippings, dated and undated.

Cleveland Museum of Art Registrar's File. Labels from "Cleveland Art Comes of Age."

The Clevelander. "Beauty Pays a Profit."

Columbia Broadcasting System. "America in Transition." typescript for Oct. 21, 1941 broadcast.

Cowan, R. Guy. "What Is Art?" *Bulletin of the American Ceramic Society*, Vol. 5, Nov. 1926.

_____. "A Potter's View of American Ceramics." *Art News*, Vol. 35, Oct. 24, 1936.

_____. "The Fine Art of Ceramics as Exemplified in the 1936 Exhibition of Ceramic Art at the Syracuse Museum." *Design* Nov. 1936.

_____. "Calls for Cooperation in Industry." *Retailing and Home Furnishings*, Jan. 5, 1948.

Cowan Potters Inc. *Photo Book Featuring the Process of Making Cowan Pottery* Rocky River, Ohio, 1930.

"The Cowan Potters, Inc. Dealer's Manual and Retail Price List." July 1, 1930.

Cowan Pottery Journal. Cowan Pottery Museum, Rocky River, Ohio. Vol. 1, No.1, Fall 1993.

Cowan Pottery Museum, Rocky River Public Library, 1600 Hampton Road, Rocky River, Ohio 44116.

Cowan Pottery Sales Catalogs 1925, 1926 1928, 1929, 1930, 1931.

Cowan Pottery Studio Inc. *Cowan Pottery*, Rocky River, Ohio, 1926.

Davis, Elrick B. "Ceramic Sculpture is City's Unique Industry." *Cleveland Press*, July 26, 1929.

Fansler, Richard. "He Collects Rocky River Ceramics." *Cleveland Press*, May 3, 1971.

Hawley, Henry. "Cowan Pottery and the Cleveland Museum of Art." *Bulletin of the Cleveland Museum of Art*, Vol. 76, No. 7, Sept. 1989.

Kelly, Grace. "Cowan Would Keep Pottery Alive." *The Cleveland Plain Dealer*, July 13, 1930.

Mickey, Karl B. "City Leads in Art Pottery through Artist's Genius." *Cleveland Press*, July 25, 1925.

Perry, Barbara and Ross Anderson. *Diversions of Keramos: American Clay Sculpture 1925-1950*, Syracuse: Everson Museum of Art, 1983.

Piña, Leslie. "Cowan Pottery and the Arts and Crafts Movement." unpublished typescript, 1984.

Pinzone, Sharon. "Rocky River's Lost Colony of Artists." *Avenues*, Dec. 1989.

Randle, Bill. "Cowan Pottery Pieces Now Heirlooms, Collector Items." *Sun Press*, Nov. 29, 1973.

_____. "Cowan Pottery: Beauty, Utility Prevails." *Sun Press*, Nov. 29, 1973.

Robbins, Carle. "Cowan of Cleveland, Follower of an Ancient Craft." *Bystander of Cleveland*, Sept. 7, 1929.

Rocky River Public Library. *Cowan Pottery Museum*. Rocky River, Ohio, 1978.

Saloff, Tim and Jamie. "Cowan Artists." *Journal of the American Art Pottery Association*, Vol. 8, No. 4, July-Aug. 1993.

_____. *Collector's Encyclopedia of Cowan Pottery*. Paducah KY: Collector Books, 1993.

Scherma, George W. unpublished typescript, 1978, in Rocky River Public Library.

Silver, Adele Z. "Cleveland Art Comes of Age: 1919-1940." Cleveland Museum of Art, Press Release, June 26, 1989.

Turnquist, Tom. "Cowan Pottery." *Antique Trader Weekly*, 1982.

Western Reserve Historical Society. Collection of letters, articles, and clippings.

Fiesta

Huxford, Bob and Sharon. *Collector's Encyclopedia of Fiesta*. Paducah KY: Collector Books, 1992.

Lamoureux, Dorothy. "An Issue of Style." *Journal of the American Art Pottery Association*, Vol. 1, No. 1, Jan.-Mar. 1992.

Riederer, Lahoma et. al. "A Collector's Guide to Fiesta Dinnerware." privately printed. Jan 1974.

_____. "Fiesta II: A Collector's Guide to Fiesta, Harlequin, and Riviera." privately printed, 1976.

Ross, Marie. "Fiesta Finds Favor." *The Daze*, Dec. 1973.

Welch, Jack."The Homer Laughlin China Company." reprinted from *Goldenseal: West Virginia Traditional Life*, Vol. 2, No. 1, 1985.

Russel Wright

George Arents Research Library, Russel Wright Archives. Syracuse University, Syracuse, New York.

Hennessey, William. *Russel Wright: American Designer*. Cambridge: MIT, 1983.

Horn, Richard. "Russel Wright: A Pioneer in Modern American Design." *New York Times*, Aug. 23, 1979.

Kerr, Ann. *Collector's Encyclopedia of Russel Wright*. Paducah KY: Collector Books, 1993.

vonEckhardt, Wolf. "Reflections in the Wright Look." *Time Magazine*, July 25, 1983.

Glidden

Bernstein, Melvin H. *Art and Design at Alfred: A Chronicle of a Ceramics College*. Philadelphia: The Art Alliance Press, 1986.

Hinkle Memorial Library, Alfred, New York. "Glidden Archives" in the Historical Collection.

Brastoff and California Potteries

Chipman, Jack. *Collector's Encyclopedia of California Pottery*. Paducah KY: Collector Books, 1992.

_____. "William Manker Ceramics: Objects of Timeless Beauty." *Antique Trader*, Sept. 28, 1983.

Cleveland Museum of Art. Artist files, "Sascha Brastoff" folder of clippings from *The Cleveland Plain Dealer, Cleveland Press, New Yorker Magazine*, etc.

Cox, Susan. "Sascha Brastoff, Innovator for All Times." *American Clay Exchange*, Nov. 1983

Nelson, Maxine Feek. *Versatile Vernon Kilns: An Illustrated Value Guide Book II*. Paducah KY: Collector Books, 1983.

Steinberg, Sheila and Kate Dooner. *Fabulous Fifties: Designs for Modern Living*. Atglen PA: Schiffer, 1992.

England and Europe

Bartlett, John. *English Decorative Ceramics*. London: Kevin Frances, 1989.

Bergesen, Victoria. *Bergesen's British Ceramics Price Guide*. London: Barrie & Jenkins, 1992.

Clark, Garth. "Art Deco Ceramics: England." *Ceramics Monthly*, Sept. 1979.

Dreyfus, Dominique. *Emaux de Longwy*. Paris: Charles Massin.

_____. *Longwy: Les Marques, Les Signatures*. Longwy, 1990.

The Dutch Potter, Vol. 1 No. 1, Nov. 1989.

Eatwell, Ann. *Susie Cooper Productions*. London: Victoria & Albert Museum, 1987.

Ernould-Gandouet. *La céramique en France au XIX siècle*. Paris: Gründ, 1969.

des Fontaines, Una. *Wedgwood Fairyland Lustre*. New York: Born-Hawes, 1975.

Forsythe, Ruth. *Made in Czechoslovakia Book 2*. Marietta, OH: Antique Publications, 1993.

Griffin, Leonard, et al. *Clarice Cliff: the Bizarre Affair*. New York: Abrams, 1988.

Pataky-Brestyánszky, Ilona. *Modern Hungarian Ceramics*. Budapest: Corvina, 1961.

Roberts, Alan. "Ceramic Cloisonné The European Tradition." *Antiques & Collecting*, April 1990.

Schwartzman, Paulette. *A Collector's Guide to European and American Art Pottery*. Paducah: Collector Books, 1978.

Spours, Judy. *Art Deco Tableware: British Domestic Ceramics 1925-1939*. New York: Rizzoli, 1988.

Tardy. *Les Poteries et les faïences Françaises*. Wiltshire, England: Hilmarton Manor, 1949, 1979.

Trimble, Alberta. *Modern Porcelain*. New York: Bonanza, 1962.

Watson, Howard and Pat. *Collecting Clarice Cliff*. London: Kevin Francis, 1989.

_____.*The Colorful World of Clarice Cliff*. London: Kevin Francis, 1992.

Price Guide

The only sure thing about prices is that they will change; by the time this guide is printed, some of the prices will already have done so. Regional variations — whether in different parts of a state or of the world — should be expected, and samples taken from diverse areas make up price guides. So one can expect to find about as many different estimates for similar objects as there are guides to list them. The purpose of this or any other guide is not to attach a specific dollar amount to an object; rather, it is to provide the buyer and seller, collector and dealer, with a general value range gathered from a variety of sources: auctions, antique shows, flea markets, and shops (house and garage sales, though perhaps the most fun, obviously cannot be included).

For example, collectible dinnerware lines like Fiesta include both common and uncommon items. Whether a plentiful item is listed in the $5-$10 range in one guide or the $10-$15 range in another is of little consequence. The point is that a buyer can avoid paying $100 for the item by consulting either guide. Conversely, if an item is in the $100-$200 range, a seller will know that it would be unwise to to let it go for $5.

When a popular collectible has been in the marketplace for some time, there will be some consensus regarding its value. However, more recent market entries, such as Glidden, will have a wider and more volatile range until its market becomes established. An unusual or important item, such as a Longwy limited edition, will command a high price based on willingness to pay, more than on some number on a list. An estimated value of $2,500-$5,000 in a price guide does not assure that a similar object will be priced as such, or that one will even be available. The number is a guideline, an indicator that the piece is special and that others in its class have exchanged hands in that range.

Since there can be no guarantee that any of the estimates in this or any other guide will match actual purchase prices, the publisher cannot be responsible for any outcomes. My advice to the collector is: buy the best you can afford in as perfect condition as possible; buy only what you like and what you think you will like to look at, to learn more about, and to live with. To the dealer: buy what you and your clients like, and at the least cost possible; then price low what you want to sell, and price high what you want to keep. Those who follow this advice will surely perpetuate some of the more baffling ranges and variations found in price guides.

To use this guide, the left hand number is for the page, followed by the photo number. Letters indicate the position of the object in the photograph: T=top, L=left, TL=top left, TC=top center, TR=top right, C=center, CL=center left, CR=center right, R=right, B=bottom, BL=bottom left, BC=bottom center, and BR=bottom right. The right hand numbers are the prices in U. S. dollars.

page	no.	position	$	page	no.	position	$
13	1.7	L	300-600	22	1.27		400-600
		R	500-700		1.28		2,000-3,000
14	1.8		300-600		1.29		400-600
15	1.9		300-600	23	1.31		1,000-2,000
	1.10		500-800		1.32		1,000-2,000
16	1.11		500-800 each		1.33		1,000-2,000
	1.13		800-1,200	24	1.34		100-300 each
17	1.14		25,000-50,000		1.35		600-800 each
	1.16		5,000-15,000	25	1.36		1,000-1,500
18	1.17		600-800 each		1.37		500-800
	1.18		400-600	26	1.38	bowl	100-200
19	1.19		1,500-2,500			bird	300-600
	1.20		500-800	27	1.41		800-1,000
20	1.21		400-700	28	1.42	L	1,000-2,000
	1.22		1,000-1,500			R	1,000-2,000
	1.23		400-600 each		1.43	L	800-1,000
21	1.24		500-700 each			R	500-700
	1.26		500-800		1.44		300-500 each

Page	Fig.	Pos.	Price		Page	Fig.	Pos.	Price
29	1.45		40-60		63	2.15	T	20-30
	1.46		2,000-3,000				B	15-25
	1.47		1,000-2,000			2.16		20-30 each
30	1.48		200-300 each		64	2.17		20-25 each
	1.49		200-300 each			2.18		15-25 each
31	1.51		300-500 each			2.19		15-25 each
32	1.53		1,000-2,000		65	2.20		5-10 each
	1.54		3,000-4,000			2.21		20-25 each
33	1.55		2,000-3,000 each			2.22	L	10-15
34	1.57		200-400				R	15-25
	1.58		500-700				tray	10-20
	1.59		600-800		66	2.23		30-40 each
35	1.60		100-200			2.24	T	15-25
36	1.63		150-250				C	10-15
	1.64		100-200				B	20-40
37	1.66		100-150 each			2.25	T	15-20
	1.67		100-150 each				B	75-125
	1.68	bowl	100-150		67	2.26	L	75-125
		frog	150-250				R	150-200
		others	25-60 each			2.27		15-25
38	1.69		200-300			2.28		15-25 each
	1.70		100-300 each		68	2.29	L	30-40
40	1.77		200-300				R	10-15
41	1.78		200-300			2.30	T	15-35 each
	1.79		200-300				B	15-25
42	1.80		100-200 each			2.31		15-25 each
	1.83		100-150		69	2.32	L	30-40
43	1.84	L	20-30				C	10-15
		R	30-60				R	20-30
	1.86		40-60 each			2.33	T	20-25
44	1.88	L	30-50				B	15-20
		R	60-100			2.34		25-35
	1.89	L	25-50 each		70	2.35		15-25 each
		R	75-125			2.36		20-35
	1.90	L & R	25-75 each			2.37	L	10-20
		C	75-125				R	20-30
45	1.91		400-600		71	2.38	L	20-30
	1.92		25-75 each				CL	5-10
46	1.93		25-35 each				CR	15-20
	1.95		1,500-2,500				R	15-25
47	1.96		200-300 each			2.39	L	25-35
	1.98		50-100 each				R	20-30
48	1.99		400-600			2.40		15-25 each
49	1.100		600-900		72	2.41		5-15 each
	1.101		600-900			2.42		10-20
	1.102		600-900		73	2.43	T	20-40
50	1.103		800-1,000				B	15-20
	1.104		800-1,000			2.44	L	30-40
	1.105		600-900				C	30-40
51	1.106		600-900				R	20-30
52	1.108		50-75 each		74	2.45		50-150
	1.109		50-75		78	3.1		8-15 each
53	1.110		50-100 each			3.2		8-15 each
	1.111		100-200		79	3.3		5-15 each
61	2.10		15-25 each		80	3.4		10-20
	2.11	L	3-6 each			3.5		10-20 each
		TC	5-15 each		81	3.6		10-20
		BR	20-30 each			3.7	L	10-20
	2.12	L	20-25 each				R	20-40
		R	15-20 each		82	3.8		50-100
62	2.13	T	15-25			3.9		50-100
		B	3-6 each		83	3.10	L	50-100
	2.14	T	75-100				R	50-100
		B	15-25			3.11	T	125-175

Page	Fig.	Pos.	Price
		B	20-30
	3.12		10-15 each
84	3.13	L	10-20
		R	10-15
	3.14	L	10-15
		R	10-20
	3.15	L	10-15
		C	50-100
		R	10-20
85	3.16	BL	10-15
		T	50-100
		BR	10-20
	3.17		50-100
	3.18		20-40
86	3.19		30-60
87	3.20		75-100
	3.21		75-100
	3.22		15-20 each
88	3.23		40-60
	3.24		20-40
	3.25	T	15-20
		others	4-15 each
89	3.26	TL	5-15
		BL	15-20
		TR	4-8
		BR	8-15
	3.27		25-50
	3.28	L	20-30
		R	10-15 pair
90	3.29	TL	50-100
		BL	10-15
		C	10-15
		TR	100-150
		BR	20-40
	3.30		50-100
91	3.31	C	100-150
		L & R	10-15 set
	3.32		40-60
92	3.33		75-100
	3.35	TL	6-12
		BL	8-12 each
		R	50-100
93	3.36	T	8-12 each
		B	8-12
	3.37	L	15-20
		R	15-20
	3.38		50-75
94	3.39		50-75
	3.40		8-12
	3.41	T	20-30
		BL	20-30
		BR	15-25
95	3.42	L	50-100
		C	50-100
		R	15-25
	3.43		10-20
96	3.44		15-25
	3.45		5-10
	3.46		5-10
100	4.8		150-250
101	4.9		100-200
	4.10		200-300
105	4.17		75-125
	4.19		50-80
107	4.22		10-15
	4.23		20-40
	4.24		50-150
109	4.28		10-25 each
	4.29		10-25 each
	4.30		30-60
110	4.31		30-60
	4.32		25-50
	4.33		25-50
111	4.35		25-50
	4.36	L & R	30-50 each
	4.37		40-80
113	4.39		25-45 each
114	4.42		30-50
	4.43		20-40
115	4.45	T	75-150
		B	10-15
	4.46		10-15
117	4.48	L	150-300
		R	40-60
	4.49		40-60
118	4.50		60-90
	4.51		150-250
119	4.52		40-60
	4.53		40-60
121	4.57		15-25
	4.58		15-25
124	4.62		15-25
	4.63		40-60
	4.64		40-60
125	4.66		30-50
	4.67		30-50
	4.68		20-30
126	4.70	T	100-150
		BL	40-60
		BR	60-90
127	4.72		20-25
	4.73		30-50 each
	4.74		20-30
128	4.75	L	30-50
		C	30-50
		R	30-50
	4.76	L	30-50
		R	30-50
	4.77	L	30-50
		R	30-50
129	4.78		20-30
	4.79		75-125
	4.81		75-150
130	4.82		20-30
	4.83		20-30
	4.84		20-30
	4.85		20-30
	4.86		20-30
	4.87		20-30
131	4.88		20-30
	4.89		20-30
	4.90		20-30
	4.91		20-30
	4.92		20-30
	4.93		20-30
132	4.94		20-30
	4.95		30-40
	4.96		60-80
	4.98		60-90

Page	Item	Pos	Price
133	4.99		20-30
	4.100		20-30
	4.101		20-30
	4.102		20-30
	4.103		30-40
134	4.104		25-40
	4.105	T	20-25
		B	25-40
	4.106		40-60
	4.107		15-25 each
135	4.108		25-35
	4.109		20-30
	4.110		20-30
	4.111		20-30
136	4.112		40-60
	4.114		20-30
137	4.115		20-30
	4.116		10-20
	4.117		20-30
	4.118		10-20
138	4.119		10-20
	4.120		10-20
139	4.121		75-125
140	5.1		400-600
	5.2		400-600
141	5.3		400-600
	5.4		400-600
142	5.5		400-600
143	5.6		400-600
144	5.8		75-125
145	5.9		75-125
	5.10		50-75
	5.11		50-100
	5.12		50-100
146	5.13		50-75 set
	5.14		30-50
147	5.15		30-60
	5.16		30-60
148	5.18	L	30-50
		R	40-60
	5.19		30-50
149	5.21		50-75
	5.23		30-60
150	5.24		50-75
	5.25		40-60
	5.26		40-80
151	5.27		100-150
	5.29		40-60
152	5.30		15-25
	5.31		40-60
	5.32		30-50
153	5.33		25-40
	5.34	L	8-12
		R	8-12
	5.35	L	8-12
		R	8-12
154	5.36	R	8-12
		T	6-8
		BL	4-6
	5.37		10-15
	5.38		8-12
155	5.39		4-6
	5.40		5-7
	5.41		6-8

Page	Item	Pos	Price
156	5.42	BL	6-8
		TL	8-12
		TR	6-8
		BR	8-12
	5.43		10-15
	5.44	L	8-12
		R	6-8
157	5.45		10-15 each
	5.46		8-12
	5.47		50-75
158	5.48	L	50-100
		R	50-100
	5.49		25-45
159	5.50		40-60 each
	5.51		20-30 each
	5.52		25-40
	5.53		20-30
160	5.54		25-35
	5.55		40-80
161	5.57		10-15
	5.58		10-15
	5.59		10-15
	5.60		10-15
162	5.61		50-75
	5.62	L	30-60
		R	30-60
	5.63		30-60
163	5.64		8-12
	5.65		8-12
165	6.1	L	100-150
		TR	30-60
		R	50-80
166	6.3		75-125
167	6.5		500-800 set
168	6.8		300-500 each
	6.10		60-90
169	6.11		100-150
170	6.13		4,000-7,000
171	6.15		4,000-7,000
172	6.17		3,000-5,000
173	6.19		3,000-5,000
	6.20		600-1,200
173	6.21		20-30
174	6.22		200-400
	6.23		150-200 each
175	6.24		25-50
	6.25		25-50
176	6.26	L	30-50
		R	30-50
	6.27		25-40
177	6.28	TL	15-20
		BL	20-30
		TC	75-100
		BC	10-15
		R	30-60
	6.30	T	15-20
		B	15-20
178	6.31		600-900
179	6.32		25-40
	6.33		25-40
180	6.34		25-40
	6.35		25-40
	6.36		25-40
181	6.37		50-100

Page	Fig.	Pos.	Value		Page	Fig.	Pos.	Value
182	7.1		250-350				C	250-350
	7.2		200-300				R	200-300
184	7.3		150-200			8.18	L	150-250
185	7.4		150-200				CL	200-300
186	7.7		300-500				CR	150-250
	7.8		300-500				R	150-250
187	7.9		100-150		203	8.20		50-100
	7.10		250-400			8.21		100-200
	7.11		150-300		204	8.22		100-200
188	7.12		75-125			8.23		150-250
189	7.15		100-150		205	8.24		200-300
190	7.17		1,500-2,500		206	8.26	L	150-200
191	7.18		100-150				R	250-350
	7.20		50-100			8.27		75-125 each
192	7.21		2,500-5,000		207	8.29	L	250-350
193	7.25		2,500-5,000				R	100-150
194	7.28		800-1,200			8.30		100-150 each
195	7.31		100-150			8.31	L	75-125
							C	75-125
196	8.1		150-300				R	150-200 set
197	8.3		150-300		208	8.32		2,000-3,000
	8.4		250-350		209	8.33		50-75
198	8.6	L	125-175			8.34		50-75
		R	125-175		210	8.35		50-100
	8.7	L	125-175		211	8.37		100-150
		R	100-150		212	8.40		30-60
199	8.8		100-150			8.41		50-100
200	8.10		75-125			8.42		25-40
	8.11		100-150		214	8.48		10-20 each
201	8.13		40-60			8.50		75-125
	8.14	L	25-50		215	8.51		30-50
		R	50-75			8.53	L	40-60
	8.15		100-150				R	40-60
	8.16		60-90		216	8.54		100-150
202	8.17	L	100-200		217	8.55		100-150 set

Index